Giant Pandas: Born Survivors

Giant Pandas: Born Survivors

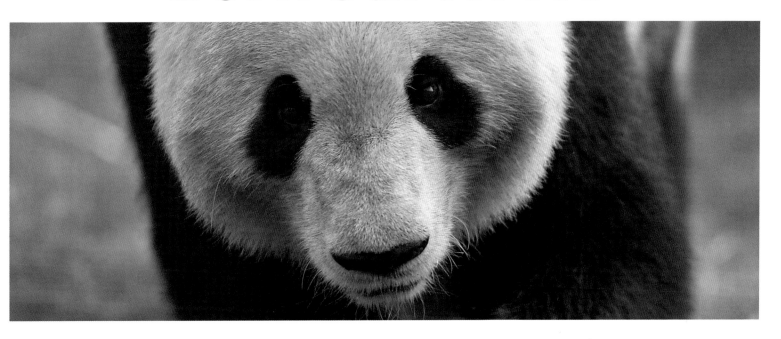

Zhang Zhihe and Sarah M. Bexell

VIKING
an imprint of
PENGUIN BOOKS

VIKING

Published by the Penguin Group
Penguin Group (Australia)
250 Camberwell Road, Camberwell, Victoria 3124, Australia
(a division of Pearson Australia Group Pty Ltd)
Penguin Group (USA) Inc.
375 Hudson Street, New York, New York 10014, USA
Penguin Group (Canada)
90 Eglinton Avenue East, Suite 700, Toronto, Canada ON M4P 2Y3
(a division of Pearson Penguin Canada Inc.)
Penguin Books Ltd
80 Strand, London WC2R 0RL, England
Penguin Ireland
25 St Stephen's Green, Dublin 2, Ireland
(a division of Penguin Books Ltd)
Penguin Books India Pvt Ltd
11 Community Centre, Panchsheel Park, New Delhi – 110 017, India
Penguin Group (NZ)
67 Apollo Drive, Rosedale, North Shore 0632, New Zealand
(a division of Pearson New Zealand Ltd)
Penguin Books (South Africa) (Pty) Ltd
24 Sturdee Avenue, Rosebank, Johannesburg 2196, South Africa
Penguin (Beijing) Ltd
7F, Tower B, Jiaming Center, 27 East Third Ring Road North, Chaoyang District, Beijing 100020, China.
Penguin Books Ltd, Registered Offices: 80 Strand, London WC2R 0RL, England

First published by Penguin Group (Australia) in association with Penguin (Beijing) Ltd, 2012

10 9 8 7 6 5 4 3 2 1

Text copyright © Zhang Zhihe and Sarah M. Bexell, 2012

The moral right of the authors has been asserted

Book design by Max Zhu © Penguin Group (Australia)
Printed and bound in China by South China Printing Company

National Library of Australia
Cataloguing-in-Publication data:
Zhang, Zhihe, 1965-
Giant Pandas: Born Survivors/Zhihe Zhang, Sarah M. Bexell.
9780670080946 (pbk.)
Giant panda – Conservation. Giant Pandas – Pictorial works.
Bexell, Sarah M.

599.789

penguin.com.cn

This book is dedicated to the memory of Dr JoGayle Howard of the Smithsonian Conservation Biology Institute of the National Zoological Park in the United States for her commitment to ensuring the survival of the world's most critically endangered species. She will be dearly missed by friends and colleagues as well as the animals who would not be here had it not been for her help.

Contents

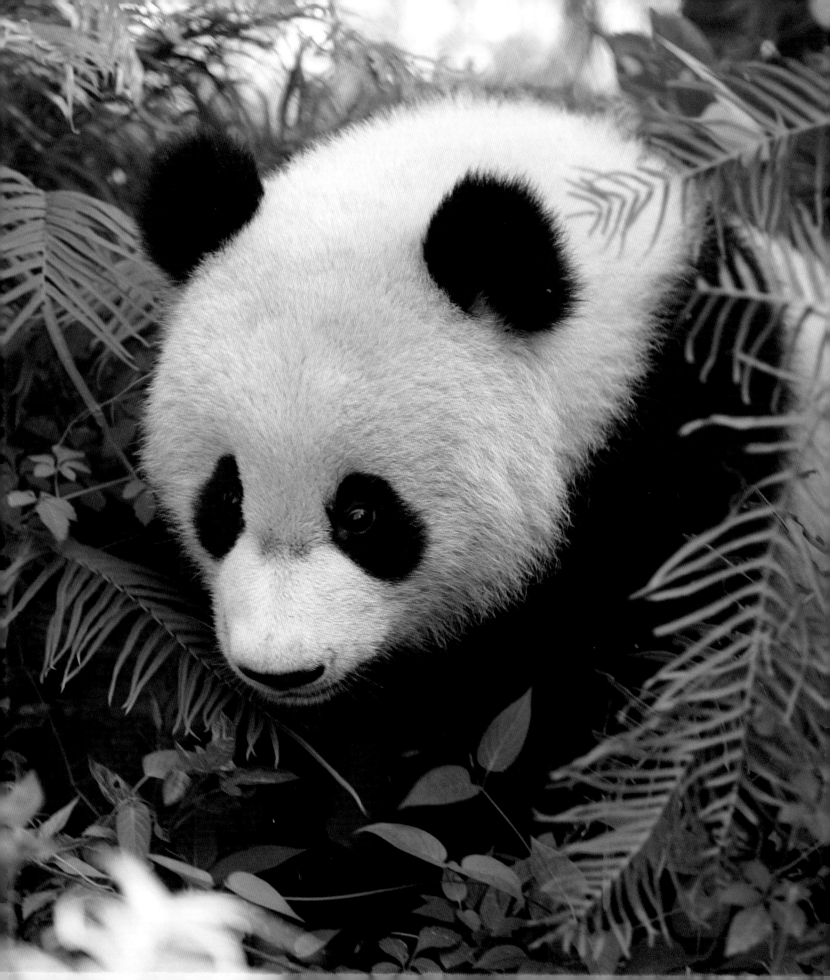

Foreword

For most of my long career in conservation I have been lucky enough to work alongside giant pandas. I have witnessed their population's tragic decline due to the destruction of their habitat since the 1960s.

However, through all of that hardship, I have learned to share my life with one of the most elusive and bashful creatures on the planet, seeing all facets of their existence – courtship rituals, mothers caring for cubs and young venturing out on their own for the first time.

I am hopeful that through continued efforts by my colleagues, both domestically and internationally, we humans will save enough room for giant pandas to persist well into the future. It is time for us to consider the well-being and survival of all the Earth's precious creatures. Please enjoy this book and take its messages to heart. The pandas need you.

Professor Hu Jinchu
Sichuan Province, China

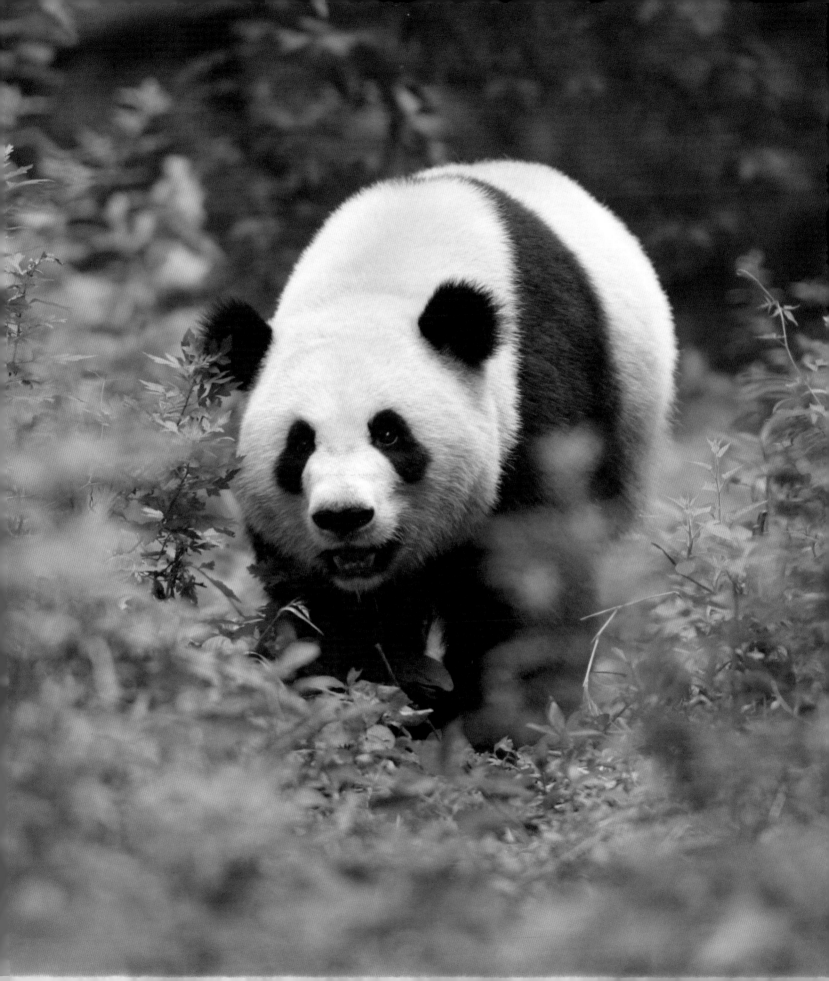

Help Wanted

Dear Readers,

Welcome to this joint effort to share one of the world's most beloved yet misunderstood species, the giant panda. We hope this volume will be entertaining and allow for introspection into your own life so that you, too, can help the beautiful others that share this little planet. To begin with, we would like to tell you about the journey that brought us together and compelled us to reveal the truth about giant pandas.

We began working together in 1999. Zhang Zhihe had recently joined the staff of the Chengdu Research Base of Giant Panda Breeding as vice director; while Sarah was conducting giant panda behavioural research at the Chengdu Panda Base for Zoo Atlanta in the United States. Moved by the panda's plight, Sarah soon signed on to help the Chengdu Panda Base develop the largest zoological education department in China. Shortly after, Zhang Zhihe became the director of this globally recognised conservation institution.

We had an immediate mutual respect for, and interest in, each other's work. We also understood how crucial our respective areas of expertise were for the protection of giant pandas and their habitat. Zhang Zhihe specialises in veterinary medicine and genetics and, as you will enjoy in this book, he has honed his photographic eye to take some truly astounding images that capture the essence and character of individual pandas. Sarah's areas of expertise are in animal behaviour, conservation and humane education, the human-animal bond and international biodiversity conservation. As our careers have developed, so too have our friendship and mutual admiration.

Many species are in desperate need of help, so why focus on giant pandas? A major reason giant pandas are important to us is their universal appeal and recognition. We are interested in global conservation, and no species seems to attract more attention and concern. By increasing awareness of the needs of giant pandas, we hope to foster a global conservation ethic. If we cannot rally humanity for a creature as universally appealing as the giant panda, what hope is there for the future of our planet as we know it today?

We have both been blessed to have spent time with giant pandas. As you will learn in this book, there is more to a panda than an adorable face and a roly-poly body. They have beautiful personalities and individual behaviours. Their habitat is some of the most striking and mysterious, hosting a multitude of other plant and animal species. Once you have the privilege of spending time with a giant panda on their own terms, you become hooked, but not more so than with any other species on Earth if you give them the time.

Over the past ten years, the Chengdu Panda Base has developed from a virtually unknown research and conservation institution into a bustling international

4

tourist and education base. Throughout, it has maintained its status as a research and conservation facility. Recent achievements include a captive population of 108 giant pandas and sixty-four red pandas, state-of-the-art naturalistic exhibits that encourage more natural behaviour and activity levels, close to a million visitors annually from home and abroad, the largest conservation education department in a zoological institution in China, and regular field programmes with the local rural population living closest to giant pandas and their habitat. If that were not enough, our facility has nearly doubled in size and we have broken ground for a new reintroduction research site.

We would like to acknowledge Jo Lusby, Managing Director of Penguin Group (China), for making this book come to life. We would also like to acknowledge Mike Tsang, our editor, for his infinite patience! Thanks go to Steffan Leyshon-Jones, Max Zhu and Nathan Manning for making this book so gorgeous and enchanting. We deeply thank photographer and giant panda expert Yong Yan'ge for sharing his amazing photographs of wildlife in their natural home and for his years of dedication to their protection. The creatures of the world need more people like him. We also thank Professor Zhang Anju, founder and designer of the Chengdu Panda Base, for his vision and over

thirty years of work protecting giant pandas and other threatened species. None of our work would have even begun without the constant support of the Chengdu municipal government. Its commitment is unique and has no equal throughout Western China – a region still entrenched in development. Lastly, we would like to thank Wei Ling for her friendship and also for working tirelessly to coordinate photographs, meetings and travel arrangements necessary to make this book possible. And of course, we must acknowledge the giant pandas that have shared their lives with us.

This book represents one of our most important endeavours: reaching out to the general public to inspire you and appeal for your help. Although it may be difficult to admit, we are the problem and it is imperative that we stop simply talking about solutions and actually take action in our daily lives. We can be a better species if we choose to be, foresight gives us this opportunity and our compassion makes it essential. Our survival and perpetuity depend on it. Please join us in learning about the mysteries of giant pandas and get back to us with ways that you plan to help our imperilled and beautiful world.

Wishing you peace,
Zhang Zhihe and Sarah Bexell
bornsurvivors@panda.org.cn

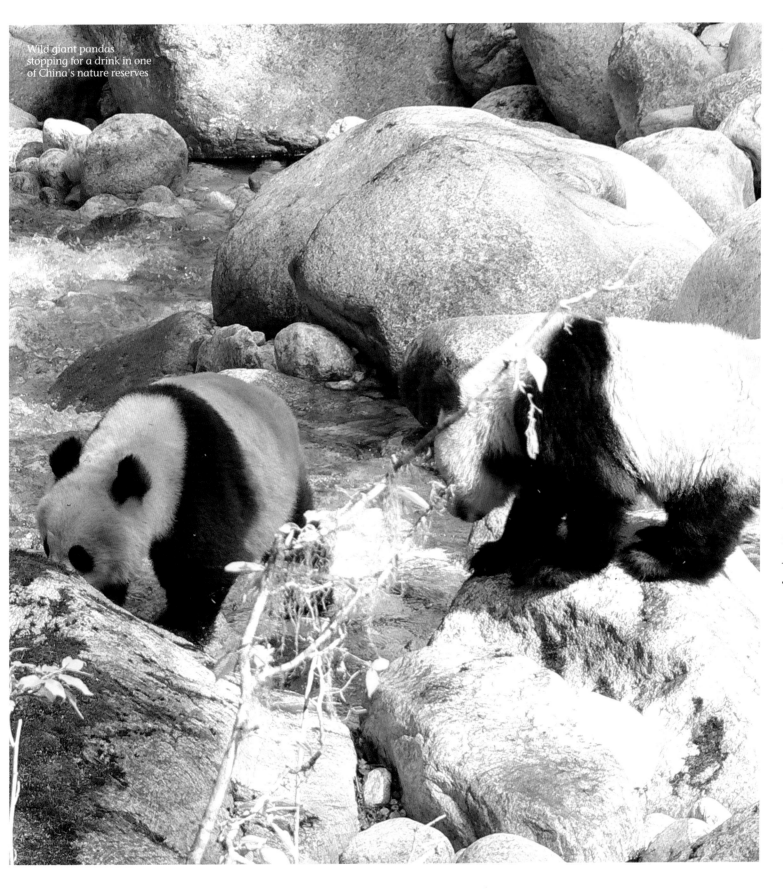

Wild giant pandas stopping for a drink in one of China's nature reserves

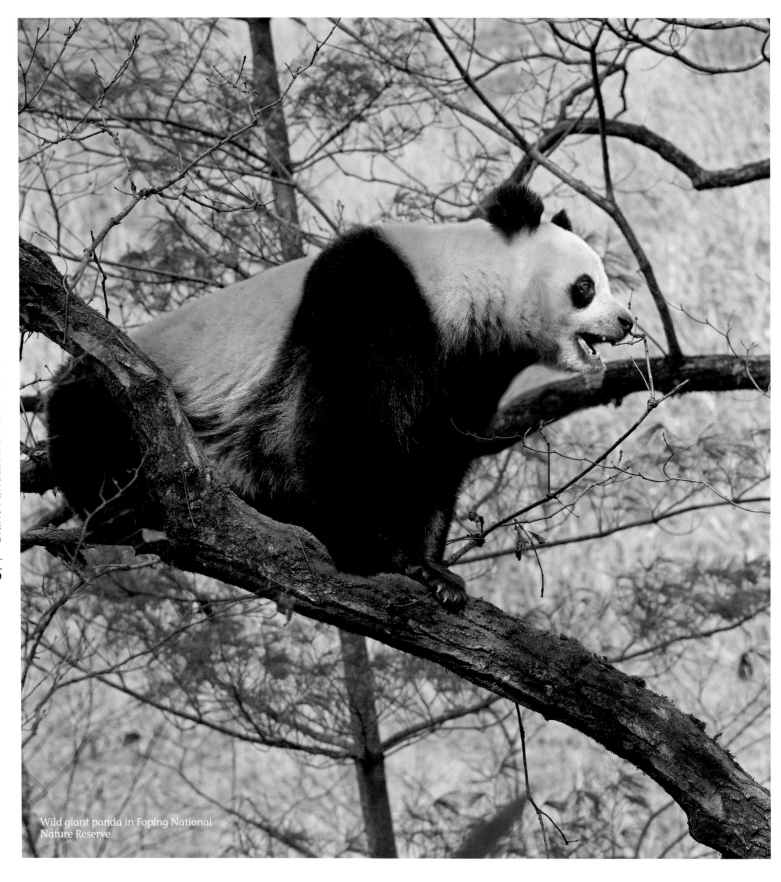

Wild giant panda in Foping National
Nature Reserve

Introduction

Although giant pandas are among the most easily recognised wildlife species in the world, they still remain one of the most misunderstood. Their seemingly peaceful and adorable appearance endears them to all who see them. They engender in us the desire to protect them, yet we are failing them and countless other species as a result of the current anthropogenic, or human-induced, global mass extinction event. Misconceptions are rife when it comes to these unique creatures. While most of these are harmless, if not amusing, some pose real dangers not only to giant pandas but also to other endangered species and limit our own understanding of the current state of this beautiful planet, our only home.

Our intrigue with how best to save these bears is ongoing. For decades, conservationists and scientists have felt that having a greater understanding of animals and their habitats was all that was needed in order to save them. It is now abundantly clear to all of us that this task is more complex and formidable than originally believed. Understanding our own psychology is the primary factor in saving endangered species, as well as preserving our own existence. Regardless of what happens, life on Earth will continue and it is up to us, as a species, to ensure that it will remain a hospitable place for us. How can we say we love animals yet continue to allow global extinctions of certain species to take place? How can we let even the most beloved of animals flirt with their own demise, leaving us no choice but to initiate captive breeding programmes that may put these animals at high risk once they are reintroduced into the wild, when it would be cost-free, simple and humane to avoid these tragedies in the first place?

Our journey to a better understanding of animal conservation has been painful at best, and answers to environmental protection still evade conservationists and concerned citizens the world over. No longer can environmentalism be left solely to khaki-clad hippies and conservation professionals. Protecting the environment should be the primary interest of every single human being. It is now the job of conservationists to explain and suggest changes in our behaviour that are mandatory for our health and survival. Getting humanity to reverse its dangerous ways and stop gambling with our future is the challenge. Can giant pandas help save us from ourselves?

Exploding Myths

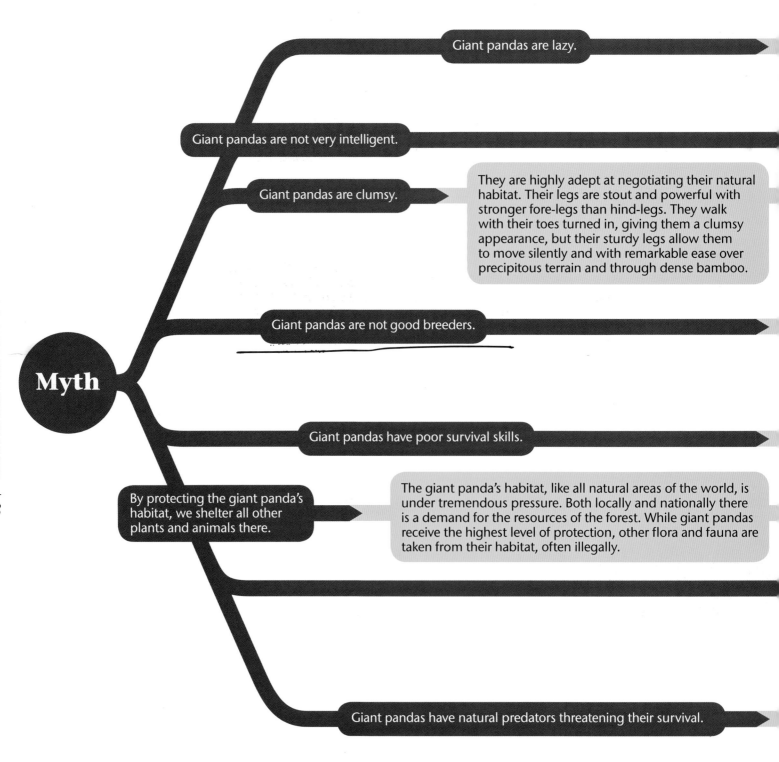

Myth

Giant pandas are lazy.

Giant pandas are not very intelligent.

Giant pandas are clumsy.

They are highly adept at negotiating their natural habitat. Their legs are stout and powerful with stronger fore-legs than hind-legs. They walk with their toes turned in, giving them a clumsy appearance, but their sturdy legs allow them to move silently and with remarkable ease over precipitous terrain and through dense bamboo.

Giant pandas are not good breeders.

Giant pandas have poor survival skills.

By protecting the giant panda's habitat, we shelter all other plants and animals there.

The giant panda's habitat, like all natural areas of the world, is under tremendous pressure. Both locally and nationally there is a demand for the resources of the forest. While giant pandas receive the highest level of protection, other flora and fauna are taken from their habitat, often illegally.

Giant pandas have natural predators threatening their survival.

This is based on observations of captive animals that do not need to forage for their food, the main activity of wild pandas. Giant pandas are active over half the day, on average 14.2 hours, or 59 per cent of each day.[1]

Each species is wise to the environment it evolved in, many of which are extremely inhospitable to humans.

When left alone in their natural environment, pandas are extremely adept breeders. Difficulties arise due to inadequate captive environments. The panda's penis size is often mentioned as a factor in unsuccessful breeding. Like many animals, pandas have diminutive penises, but size is not important for reproduction. What matters is that the male's anatomy fits with that of the female and that they live species-typical lives in order to learn proper mating rituals and methods. You might be interested to know that they are endowed with sizeable testicles!

They would do quite well if their habitat had not been decimated by humans. While we should not see the extinction of wild giant pandas in our lifetimes, scientists acknowledge that many of the giant panda's traits leave them at high risk.[2]

Fact

Giant pandas have been rescued at the expense of other species.

They have been rescued because they needed to be, but not more so than any other species humans have decimated.

In the past, leopards, yellow-throated martens, clouded leopards, dhole and Asiatic golden cats were a threat to panda cubs. Today, these carnivores are so few in number that predation isn't considered a serious threat to panda survival.

Myth

Eating bamboo is a poor survival strategy.

Giant pandas often need to be rescued from the wild.

Scientists have already saved giant pandas from extinction.

Giant pandas are bad mothers.

Females produce more offspring than can survive to ensure the continuation of the species, but this is not because they are bad mothers. In fact, this has been a survival strategy for many species including humans. Giant panda mothers are very attentive and raise some of the most vulnerable infants.

Captive breeding and reintroduction programmes will help us to rescue plants and animals from extinction.

Humans care about pandas and behave responsibly toward them.

It is okay to hold a giant panda cub if you visit China.

Giant pandas are not bears.

Giant pandas are specialists: animals that survive on a narrow diet and have specific habitat needs. Therefore, they are much more vulnerable to environmental fluctuations. Before humans encroached on them, pandas had the best dietary survival strategy – consume the most plentiful food source around!

In the past, cubs have been taken from their mothers through a mistaken rescue attempt. Once cubs reach a certain age, their mothers will 'park' them in a safe place and go to forage in the forest, sometimes for up to three days.

Pandas remain extremely vulnerable due to human intrusion into their native and preferred habitat. Major advancements in breeding techniques have secured the captive population; however, much greater effort is now needed to preserve them in the wild. Sadly, the media often portray the success in captive breeding as saving giant pandas.

While some reintroduction programmes have been successful, most have not. Part of a successful conservation programme includes animals being allowed to live undisturbed lives and retain their natural behaviours and survival skills. Captive breeding may serve as a hedge against extinction, but it should never be thought of as a successful conservation programme unless it includes the preservation of habitat and animals in the wild.

Fact

Many humans do care, but many do not. We need to help all of humanity understand the severity of the current global mass extinction event.

It is not okay to hold a giant panda cub or any wild animal species when you travel. Holding an infant puts it at high risk of disease and seriously compromises its social growth and development. You could contract a disease or be seriously injured by the innocent animal. These creatures are not toys for our amusement but honourable individuals that deserve our respect.

They *are* bears. They are part of the *Ursidae* family along with polar bears, black bears and brown bears.[3]

Natural History of the Giant Panda

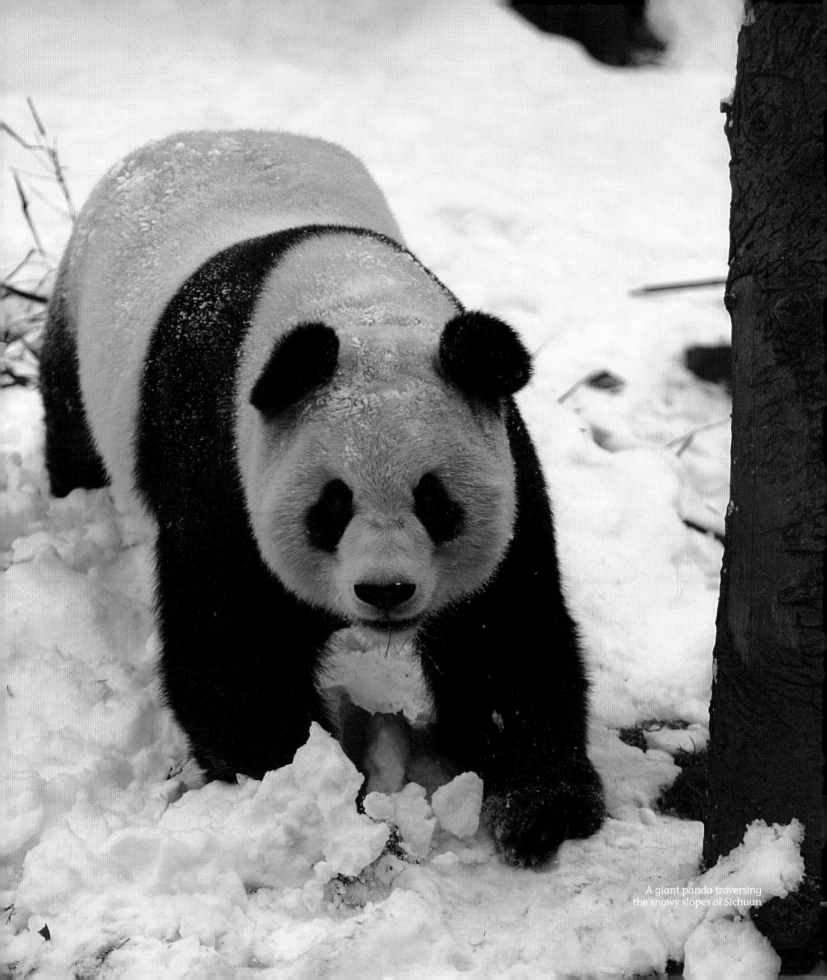

A giant panda traversing
the snowy slopes of Sichuan

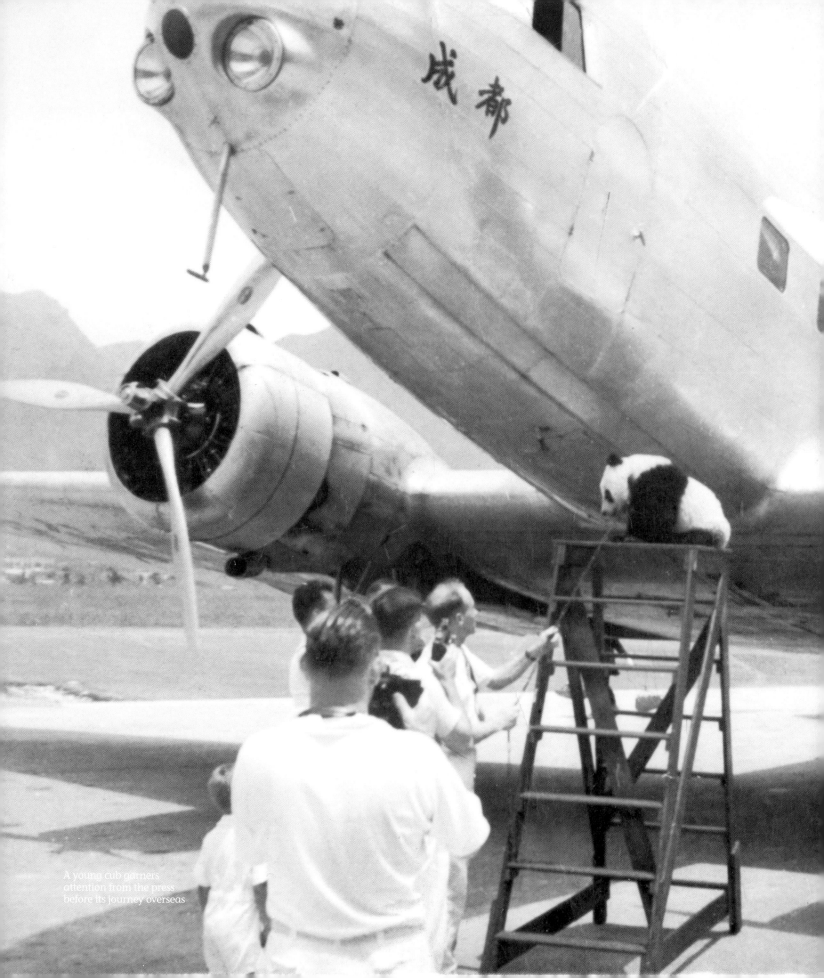

成都

A young cub garners attention from the press before its journey overseas

Discovery of Giant Pandas by Western Science

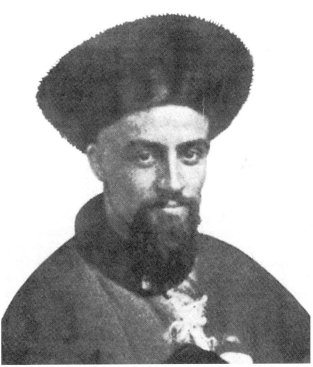

Father Jean Pierre Armand David (pictured above), a French priest and naturalist, was the first Western explorer to discover and document giant pandas in 1869.[1] He was a famous naturalist for the Musée d'Histoire Naturelle in Paris. During the twelve years he lived in China, he named and introduced sixty-eight new bird species to the West, as well as over a hundred insects and other mammals, including Père David's deer and the golden snub-nosed monkey. He sent a panda specimen back to Henri Milne Edwards at the Musée d'Histoire Naturelle, who, in 1870, published a paper declaring the panda a new species that eventually, came to be called *Ailuropoda melanoleuca*.

Past and Present Distribution

Giant panda fossils were first unearthed in Burma in 1915 and in China in the early 1920s. So far, fossils have been discovered at more than a hundred sites, covering most provinces in eastern, southern, central and northwestern China, and extending into Vietnam, Laos, Burma, and northern Thailand.[2] Most of these discoveries have been made in China, in forty-eight localities in fourteen provinces and autonomous regions.[3] To date, four giant panda species have been discovered, with two species, *Ailuropoda microta* and our modern *Ailuropoda melanoleuca*, identified as living from the mid-Pleistocene onward (the Pleistocene was a period of geologic time from 2.58 million to 11 700 years ago). During the Pleistocene, the giant panda enjoyed a wide distribution from northern Burma to eastern China, and even as far north as the region around the country's capital, Beijing.

The habitat and range of giant pandas was studied and reviewed by world-renowned wildlife biologist George Schaller and his prominent Chinese colleagues Hu Jinchu, Pan Wenshi and Zhu Jing in their seminal 1985 publication *The Giant Pandas of Wolong*. This book still informs much of the research being conducted to save giant pandas and their habitat.

Today, pandas survive solely along the eastern edge of the Tibetan Plateau in six mountain ranges within Sichuan, Shaanxi and Gansu provinces, their habitat totalling about 23049.91 square kilometres.[4] These six mountain ranges are the Qinling, Min, Qionglai, Daxiangling, Xiaoxiangling and Liang Mountains. The largest single area still remaining for wild giant pandas is in the Min Mountain range at 9603.13 square kilometres. These areas are highly fragmented due to human habitation and activities such as mining, resource collection, forestry and agriculture. Within each of these locales giant pandas only exist in suitable habitat. On occasion they may be found at altitudes as high as 4000 metres, but this is very rare. It is important to note that their lower altitudinal limit has been determined by human encroachment, which has destroyed the forest and its bamboo to such an extent that today, no pandas persist below 1300 metres.[5] With most valleys inhabited by humans, many panda populations are isolated in narrow belts of bamboo no more than 1000–1200 metres in width. Therefore, their actual geographical range is much smaller than generally depicted on maps. For example, Wolong Nature Reserve was established with an area of approximately 2000 square kilometres, but according to past estimates, if cultivation, alpine areas and other unsuitable panda habitats were eliminated, only about 500 square kilometres (25 per cent) remained for giant pandas and sympatric wildlife.[6] Notably, some panda habitat, for example, in neighbouring Jiuzhaigou Nature

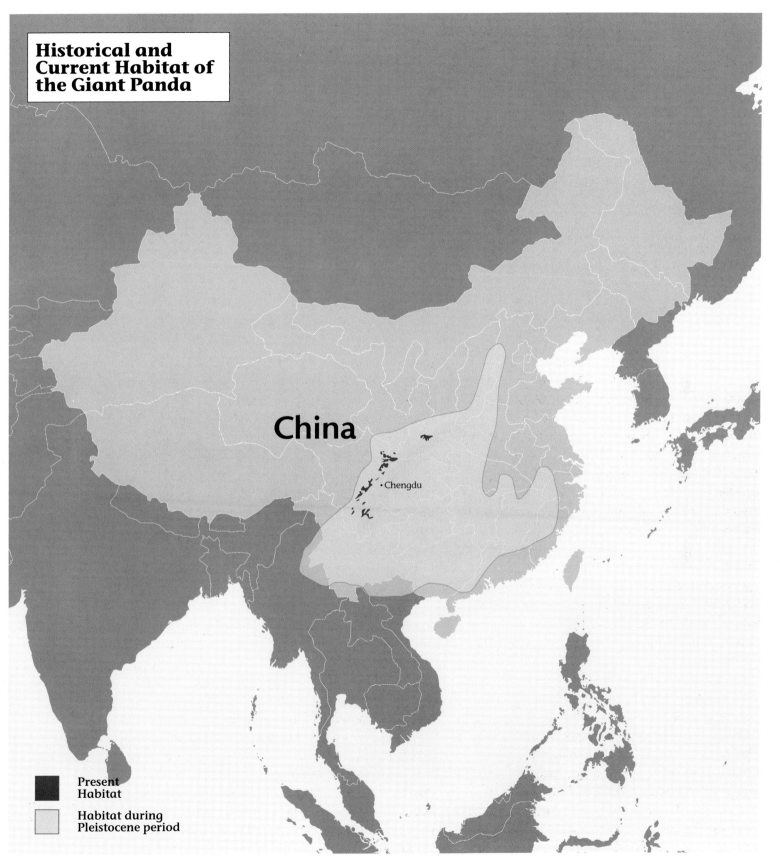

Historical and Current Habitat of the Giant Panda

China

•Chengdu

Present
Habitat

Habitat during
Pleistocene period

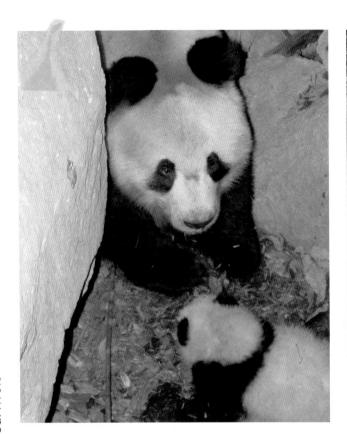

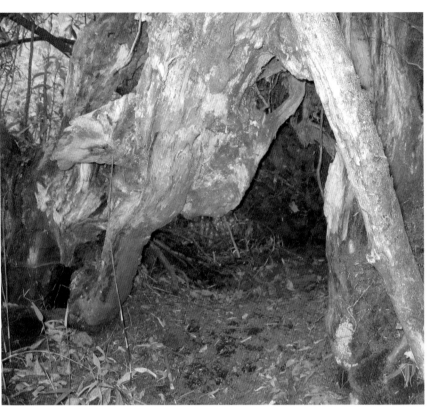

Reserve, may hold only two giant pandas today.[7] So, although the panda's total range encompasses 23049.91 square kilometres, probably less than 20 per cent represents habitat in which they persist.[8]

In the Qionglai and Liang Mountains, the giant panda occupies a vast habitat with good landscape connectivity where relatively large populations of pandas remain. However, the habitat in the Qinling Mountains is heavily fragmented due to deforestation, cultivation, road or railway construction and other human activities. Meanwhile, the Xiaoxiangling Mountains have witnessed the most severe habitat fragmentation. Three isolated panda populations are clinging on there, each with a very small population size.

Schaller and his colleagues explained that the drastic decrease in panda range is attributable to climatic change in the Pleistocene, and mainly to human activities during the post-glacial Holocene (the geological epoch that started about 12000 years ago and continues today). From fossil tooth structure we know that pandas became specialised in subsisting on bamboo at the beginning of the Pleistocene. During the Holocene giant pandas were broadly distributed south of the Yellow River, China's second longest river. There is evidence to suggest that during the past 2000 years, giant pandas lived in Henan, Hubei, Hunan, Guizhou, and Yunnan – all provinces from which they have since vanished. This range reduction has been well documented by Chinese scholars since the middle of the nineteenth century. According to local records, as recently as 1850 giant pandas still existed in western Hubei and Hunan as well as in eastern Sichuan. The general consensus is that such rapid contraction must be ascribed to human population growth and land use rather than climate change. Forests were cut down for timber and land was converted to fields and pastures. Pandas were hunted, their pelt sought throughout the world for its beauty. Locally, the pelt was used as a sleeping mat, which, aside from being incredibly soft, was said to predict the future (a peaceful sleep indicated

Above left: A mother and cub in their den
Above right: Entrance to a panda den

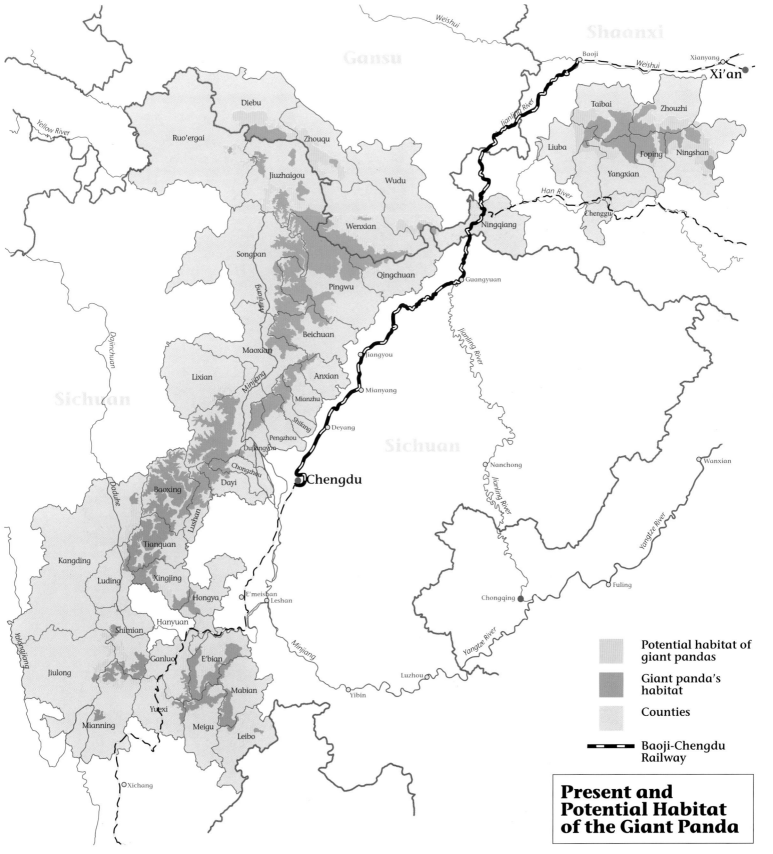

Potential habitat of giant pandas

Giant panda's habitat

Counties

Baoji-Chengdu Railway

Present and Potential Habitat of the Giant Panda

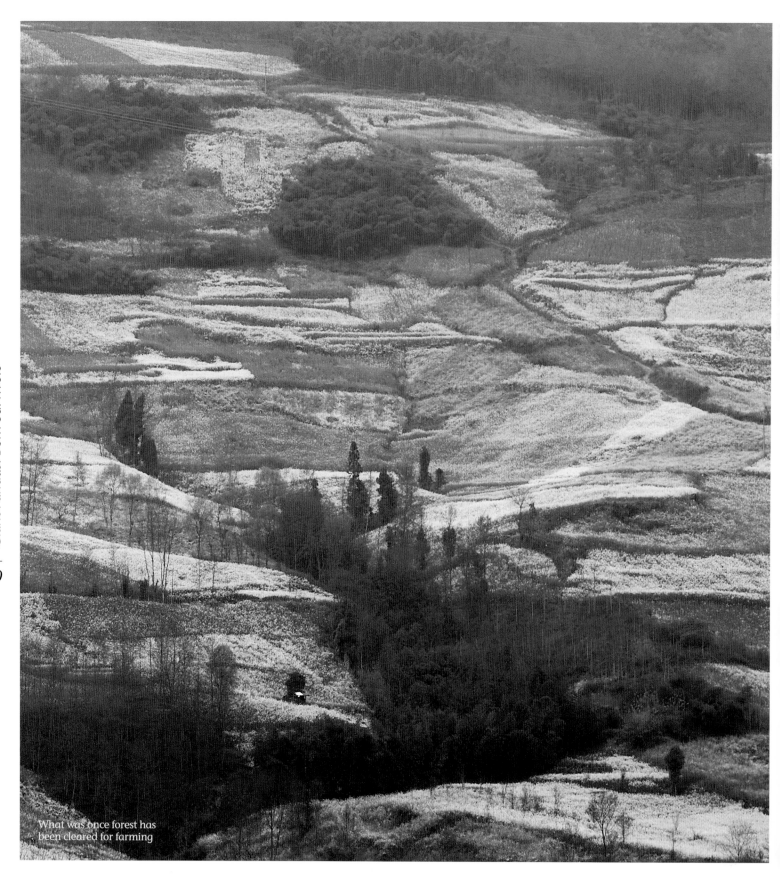

What was once forest has been cleared for farming

Modern day Chengdu at night

A local village at harvest time

Population and habitat of wild giant pandas

Mountain range	Habitat areas/km²	Population size
Qinling	3529.14	275
Min	9603.13	708
Qionglai	6101.22	437
Liang	2204.12	115
Daxiangling	810.26	29
Xiaoxiangling	802.04	32
Total	23049.91	1596

Source: the third national survey for the giant panda.
Habitat areas include areas inside and outside nature reserves.

Province	Number of nature reserves	Total nature reserve area/ km²	Habitat area/km²
Sichuan	32	16925.71	8193.64
Shaanxi	5	1844.75	991.88
Gansu	3	2987.34	1247.8
Total	40	21757.8	10433.32

Source: the third national survey for the giant panda.
Habitat areas include areas inside and outside nature reserves.
Number of nature reserves has increased since this survey

good fortune) and keep away ghosts. In more recent years, enormous cities such as Chengdu, Dujiangyan and Mianyang have grown exponentially, demanding not only space, but vast amounts of resources as well.

Sichuan already had 45 million people at the start of the twentieth century. As the human population grew, the giant panda's range continued to shrink. Construction of the Baoji-Chengdu Railway and resulting development near its tracks on the hills of northern Sichuan, between 1950 and 1980 pushed the panda's range almost 100 kilometres westward. Giant pandas now cling to a small vestige of their former range, their habitat continues to disappear as local people push ever higher up the mountain slopes, investors procure the natural resources of the area, and the people of China strive to improve their lives. This phenomenon is not unique to China and its relationship with nature. It is happening in every corner of the globe.

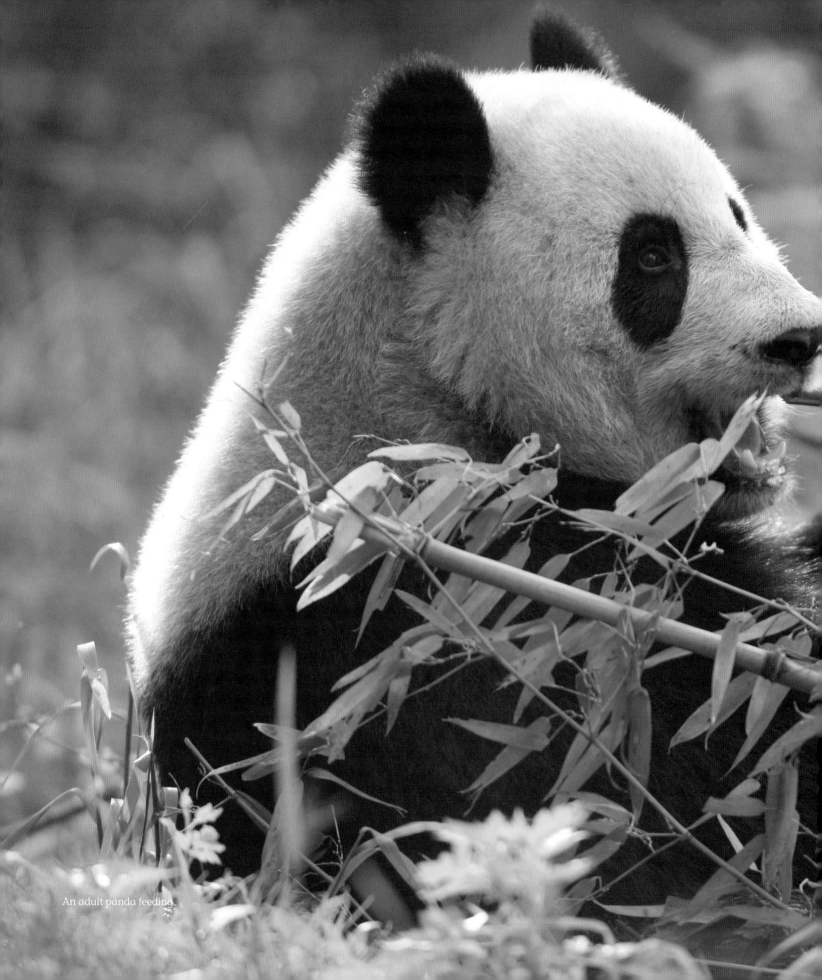

An adult panda feeding

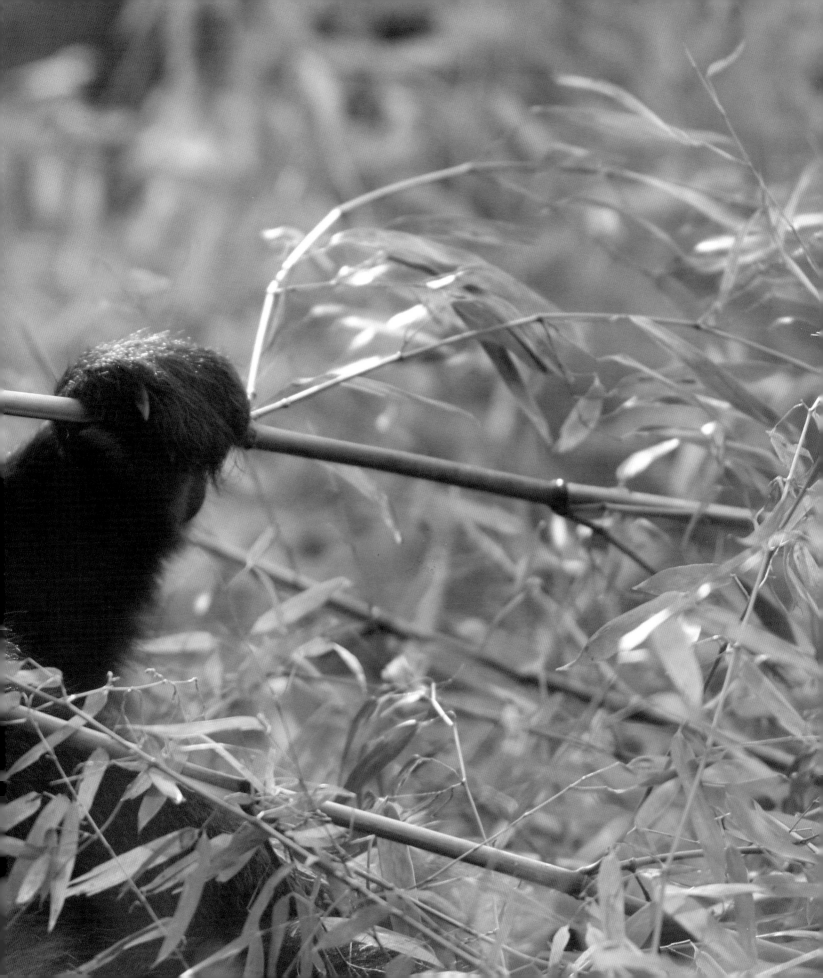

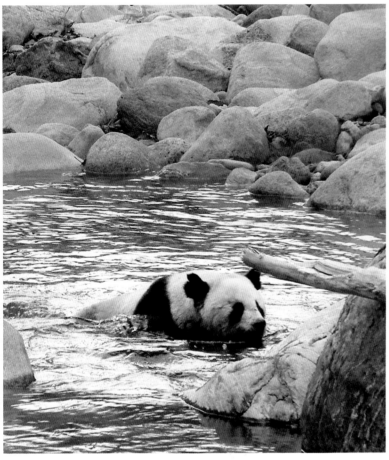

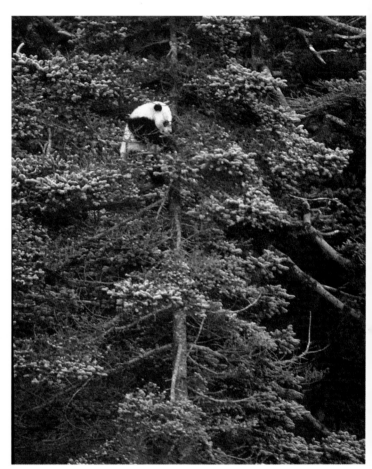

Contrary to popular belief pandas are active creatures

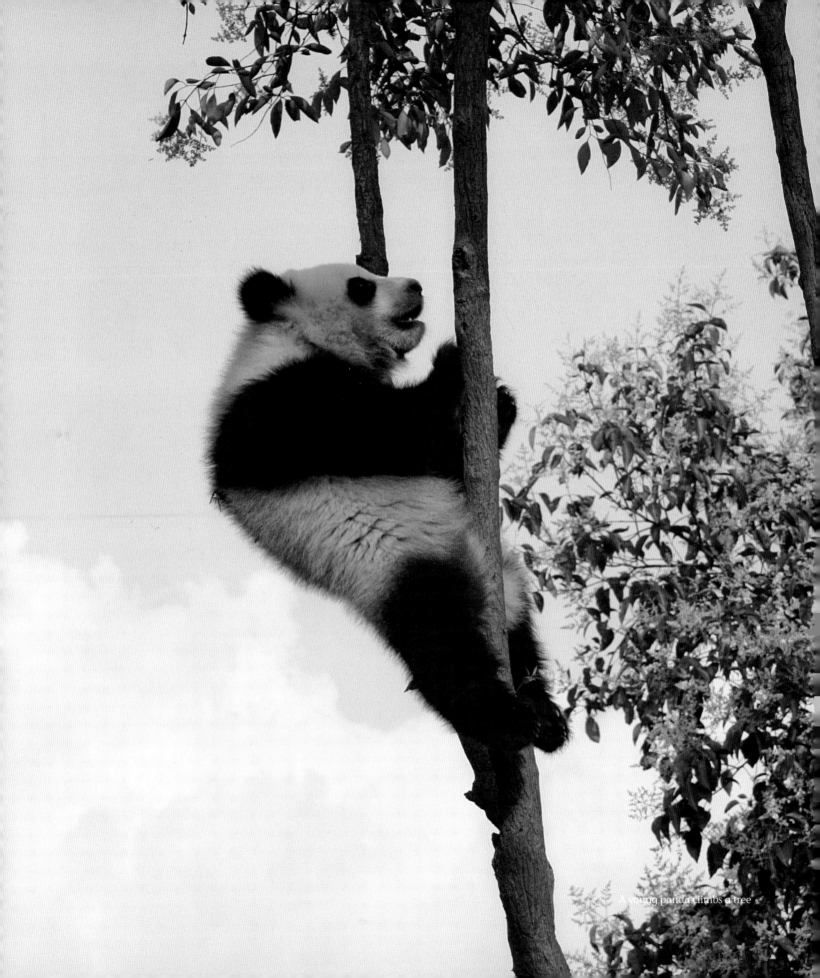

A young panda climbs a tree

To which family do giant pandas belong?

Everyone experiences the same curiosity and confusion when it comes to which taxonomic group giant pandas belong. This bewilderment is understandable because scientists themselves are still in some disagreement. Giant pandas have been an enigma since they were first documented by Western science – that is until DNA analysis techniques improved significantly. The mystery was finally solved by Dr Stephen O'Brien and his team in 1985, when his research showed the giant panda belonged to the *Ursidae*, or bear family, although there are still some who dispute this conclusion.[9]

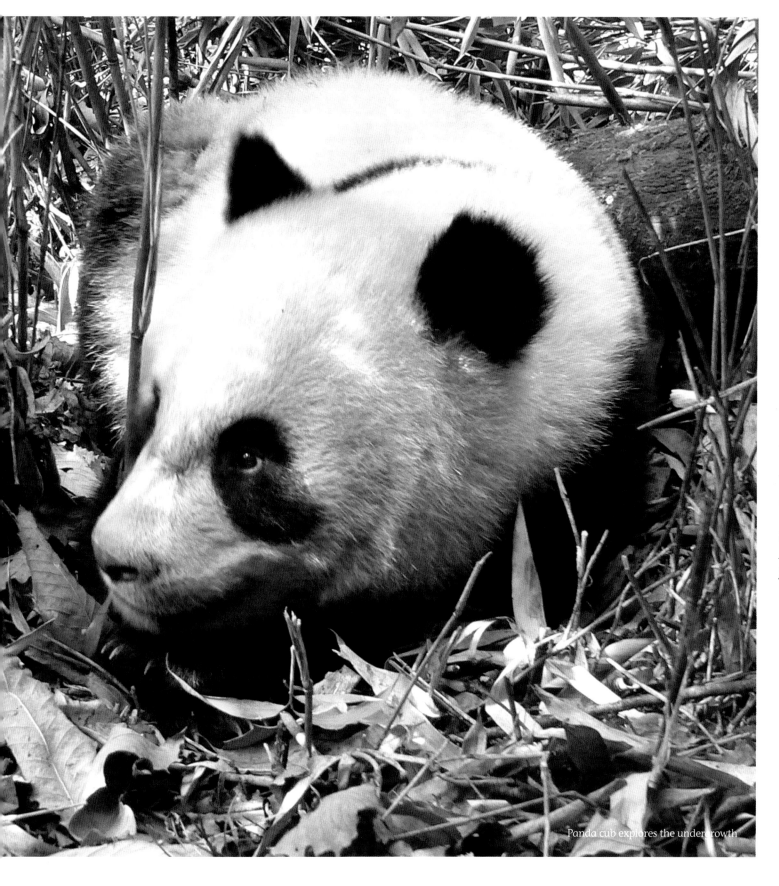

Panda cub explores the undergrowth

The Life of a Giant Panda

A panda cub moving nimbly through its natural habitat

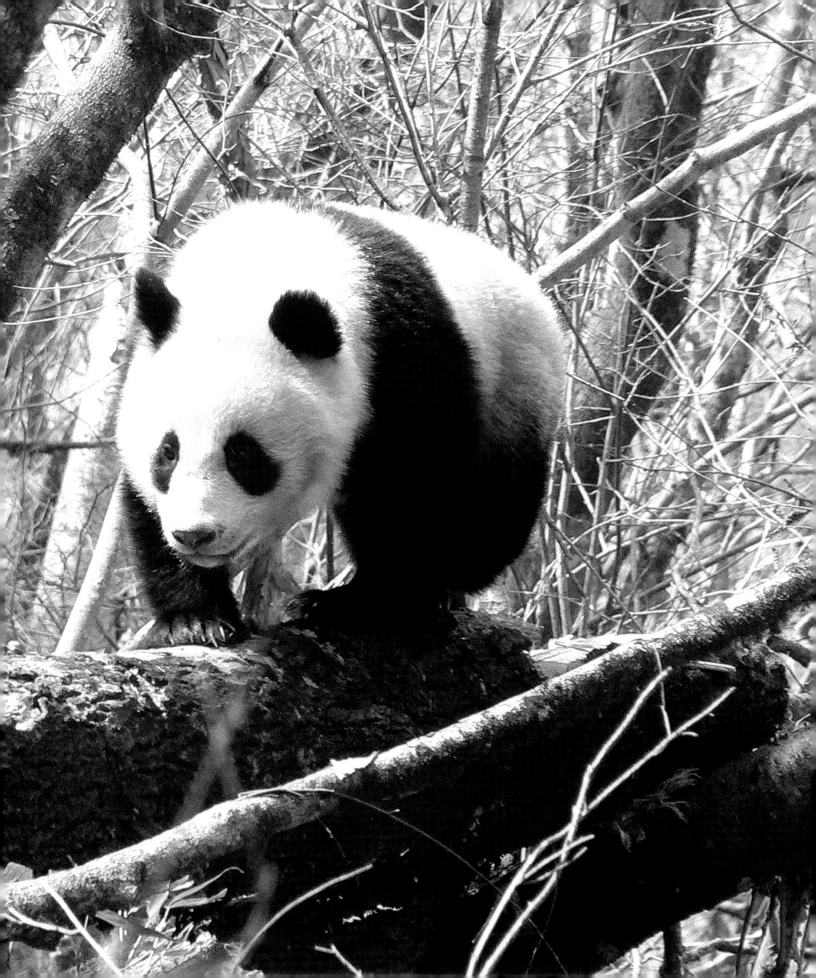

Range of Individuals

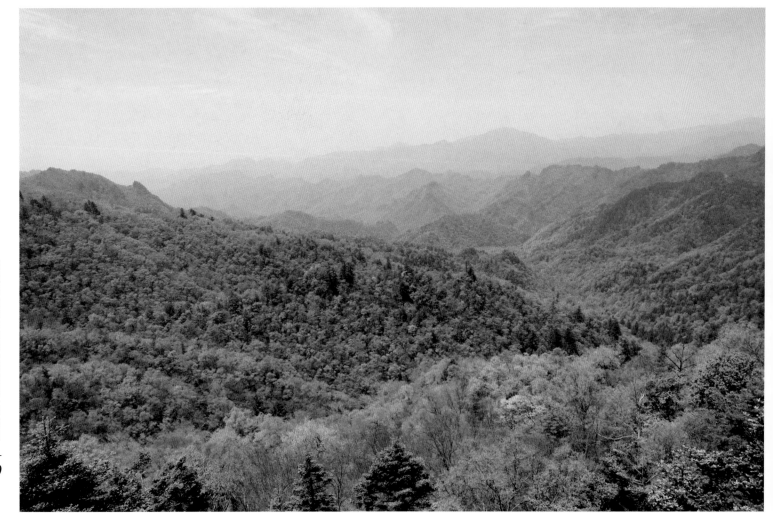

Researchers have found that individual giant pandas occupy a small and relatively stable home range of about 3.9–6.4 square kilometres, which may overlap among pandas of both sexes and all ages. Females and males have different territory management systems. The former tend to be more dispersed than males and each female has a core area within which she concentrates most of her activity. Males, on the other hand, roam widely and visit the home turf of both females and sub adults.

The core areas of females tend to be well wooded with relatively level terrain. It is thought that females select these areas because the bamboo growing beneath a consistent canopy is more nutritious, the large trees provide den sites and travel over this terrain uses up less energy. The key factor influencing male movements is the presence of females, which encourages them to wander. Both males and females prefer old-growth forest, of which little is left. Protection of this type of forest is vital for giant pandas' survival in the wild.[1]

Above and opposite page:
The panda's natural forested habitat deep in west China

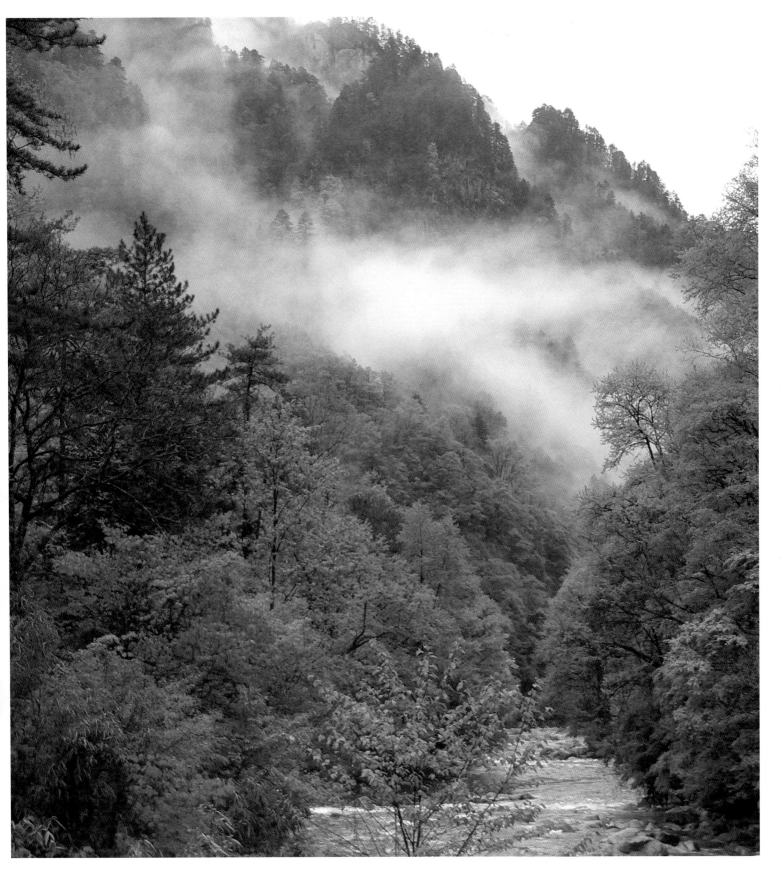

Mating and Conception

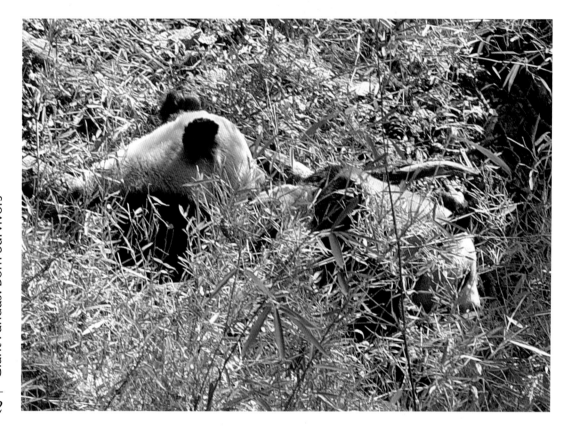

Left: Wild giant pandas mating in Foping Nature Reserve, Shaanxi Province
Right: Huzi and Chunniu vocalising to each other after mating. If Chunniu gives birth, Huzi will not participate in raising their cub (see following page)

Giant pandas are generally assumed to be seasonally monoestrous, meaning they come into oestrus once a year, in early spring. However, a weak autumn oestrus occasionally occurs, although successful mating rarely takes place, with only one recorded case in captivity in Japan. The entire oestrus period can last from about 12–25 days but peak receptivity lasts only around 2–7 days and averages about three days. The female's behaviour alters during this time in correlation with changes in her hormonal levels. For adults, the years are punctuated by annual mating seasons and the population of giant pandas depends on the success of these brief springtime rituals.

Behavioural changes begin about 1–2 weeks before peak receptivity. Females decrease their food consumption, increase their scent marking and bleating, and become increasingly restless. As peak receptivity nears, females engage in behaviours such as walking backwards, anogenital rubbing, increased chirping vocalisations and interaction with other pandas. Females present their anogenital regions to males and exhibit a type of behaviour called tail-up lordosis. They will lift their tail high in the air while holding the front part of their body closer to the ground. In addition, there will be swelling and reddening of both the vulva and nipples.

Males locate receptive females primarily by scent and vocalisations. They may remain near oestrus

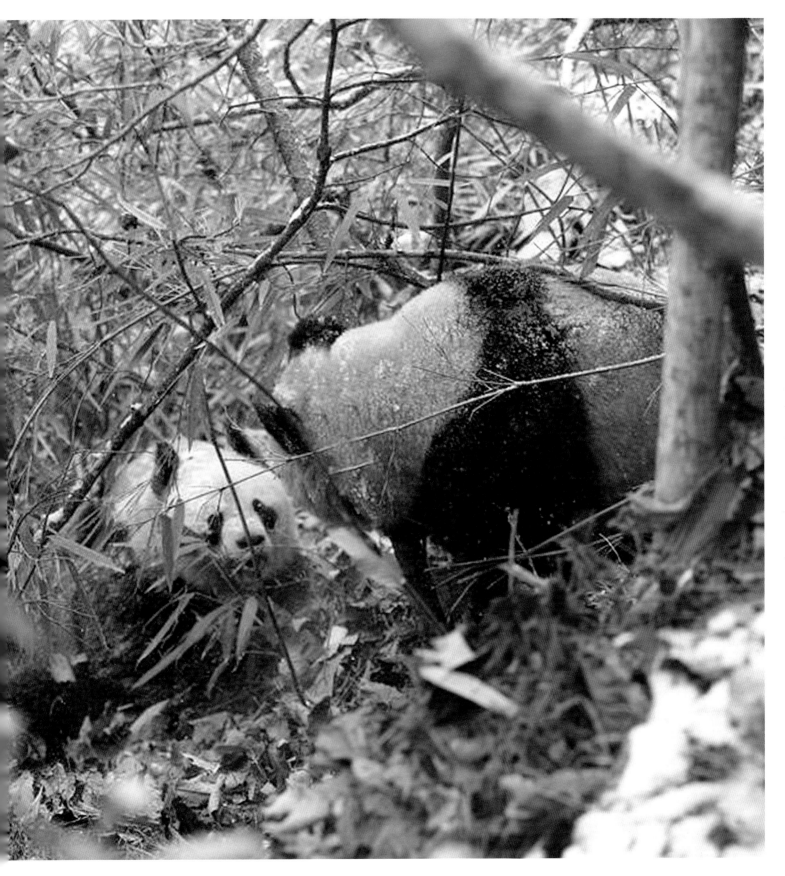

females for several days, which is thought to aid in synchronising reproductive states. This synchronisation through scent marking, vocalisations and behavioural changes leads to better compatibility, essential for successful mating.[2] In contrast, the failure of most captive giant pandas to copulate is associated with a seeming indifference by males or aggressiveness by either party, even when the female is in heat and openly solicits male attention. Factors leading to this failure to copulate include poor nutrition, inadequate surroundings and a lack of satisfactory choice of mates.

34

It is widely agreed among captive breeding specialists that reproductive failures in captivity are due to an inability on the part of humans to provide a setting conducive for natural mating, *not* due to a problem with giant pandas. The captive population of giant pandas allows for the examination of behavioural and physiological processes that are nearly impossible to study in the wild. While the techniques used to assist the captive population to reproduce do help bolster their numbers, these techniques also enable behavioural deficiencies to accrue in captive individuals.[3] With the captive population still serving as insurance against extinction – and reintroduction remaining as a possibility – it is essential to encourage normal behaviour to allow pandas to breed naturally.

During the breeding season of 2011, professor Yong Yan'ge made a remarkable observation in the Qinling Mountains of Shaanxi Province. While carrying out his annual recording of wild panda behaviour, he witnessed a female, named Chunniu, who went into oestrus, retreating to safety high up in a tree where she was soon joined by a highly attentive male named Huzi.

She remained safe in her tree for an astonishing seven days while Huzi waited very patiently for access to Chunniu. He prominently staked his claim to her through scent markings and vocalisations. During this period, neither of the pandas ate or drank and both were vigilant to their task at hand. Then one day, Yong Yan'ge spied an interloper, a male named F2 who had most likely been going about his own business when he happened upon the weary Huzi. The two males fought viciously. Huzi, who was tired from fasting and waiting patiently, sustained injuries and made a rapid retreat. Then it was F2 who began to stage his hopes for Chunniu. However, Chunniu was not so easily won over and she stayed in her tree.

In time, and with some rest, Huzi returned for Chunniu with renewed vigour and determination. He then initiated an attack on F2 and triumphed. Only then did Chunniu come down from her tree to mate with the dedicated and committed Huzi. This was the first time researchers had observed such a lengthy courtship. (see previous page)

Top right: Scent marking a log
Far Right: Captive giant panda engaging in anogenital rubbing during oestrus
Right: Female exhibiting tail-up lordosis during oestrus at the Chengdu Panda Base

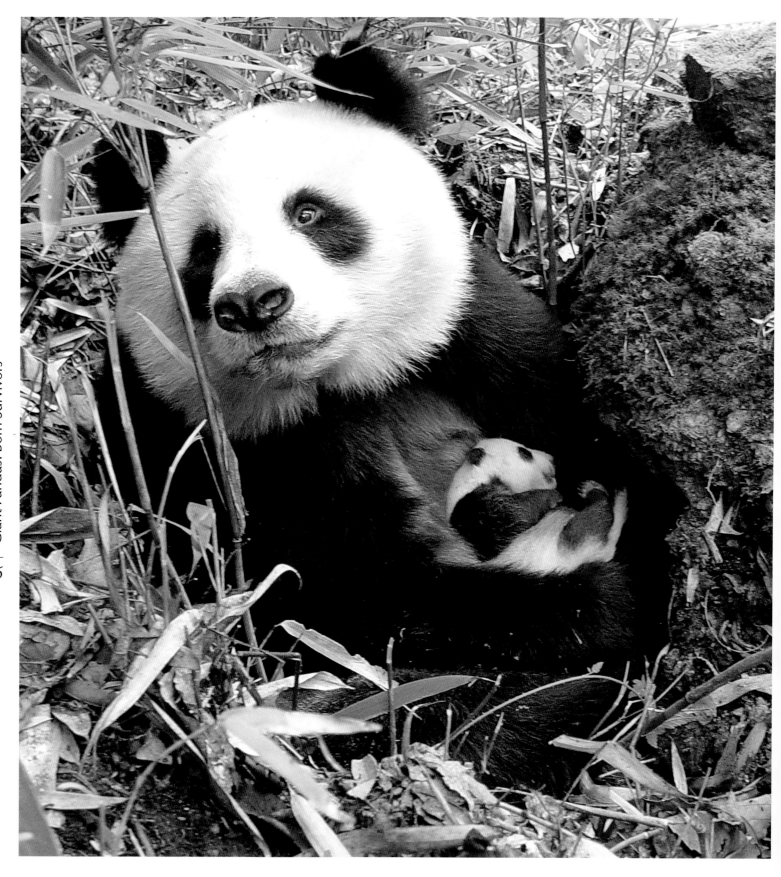

Birth

The birth of a giant panda, as with the birth of all living things, is a fascinating phenomenon of nature. Similar to their bear cousins, pandas are born in an extremely altricial form – meaning that they are born in an underdeveloped state requiring constant parental care and feeding – at approximately 1/900th of their mother's weight.[4] Mating generally occurs between March and May. On average, the gestation period for pandas in the wild lasts 144 days, it can range from 83–200 days. For pandas in captivity, gestation averages 142 days for a single birth and 132 days for twins, although there was one case of a captive female in Japan giving birth 324 days after her last copulation. The wide range in gestation periods is due to an interesting phenomenon found in all bear species (and many other mammals) called delayed implantation or embryonic diapause.[5] This means the embryo does not implant during the period immediately following fertilisation, but remains in a state of suspended growth, allowing the birth to occur under the most favourable conditions possible. Metabolic and environmental cues are critical in determining the length of the suspended growth.

Births generally occur in August and September. These new arrivals have an average weight of 104 grams when born in the wild (this figure can be as much as 170 grams) and 120 grams when born in captivity. Mothers usually give birth to one or two cubs. In fact, a second infant is born in about half of all panda litters. When twins are born in the wild, both cubs rarely survive, as the mother does not usually have the ability to rear the two of them successfully. Consequently, when twins are born, one is often abandoned shortly after the birth, or does not survive the first weeks of life. It is hard for a female to hold, suckle and carry a pair of cubs, and lactation also greatly increases her energy requirements. With reduced feeding efficiency while transporting young, and a greater energy demand, the female has difficulty caring for twins for six or more months before they can start foraging for themselves.

Cubs are extremely vulnerable at birth and are completely dependent on their mother for warmth and food for approximately 30 weeks. In the wild, giant panda cubs remain with their mother for 1.5–2 years, and females typically give birth approximately every 3 years.

Opposite page:
Wild giant panda mother cradling cub in a rock crevice in Foping Nature Reserve

Mother-Cub Behaviour

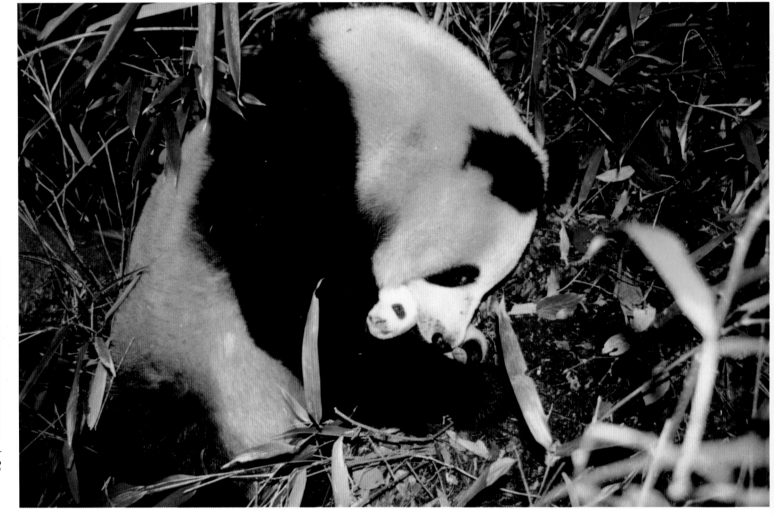

Giant pandas are solitary as adults. As such, the mother-cub relationship is the predominant and critical social influence on developing cubs.

Giant pandas are nurturing and playful mothers. Only a handful of scientists have had the opportunity to study mother-cub interactions, examine how mothers care for their young and research panda cub development.

When a female gives birth, she immediately takes her tiny infant into her paws and begins to lick the cub clean. The cub will suckle milk for the first time and rest within two hours of being born. During the first few days of the cub's life, and even up to 13 days after birth, the mother will not leave her den. Throughout the first 6 weeks, cubs rest on their mother's body nearly continuously, as this is critical for warmth and security. Females will reposition their cubs in response to its vocalisations, to facilitate suckling, to comfort them and to lick the anogenital area to stimulate the elimination of bodily waste in the first 14 weeks of life.

Above: The intimate behaviour between a giant panda mother and her cub in the wild
Opposite page: A cub learning to climb under the watchful eye of its mother

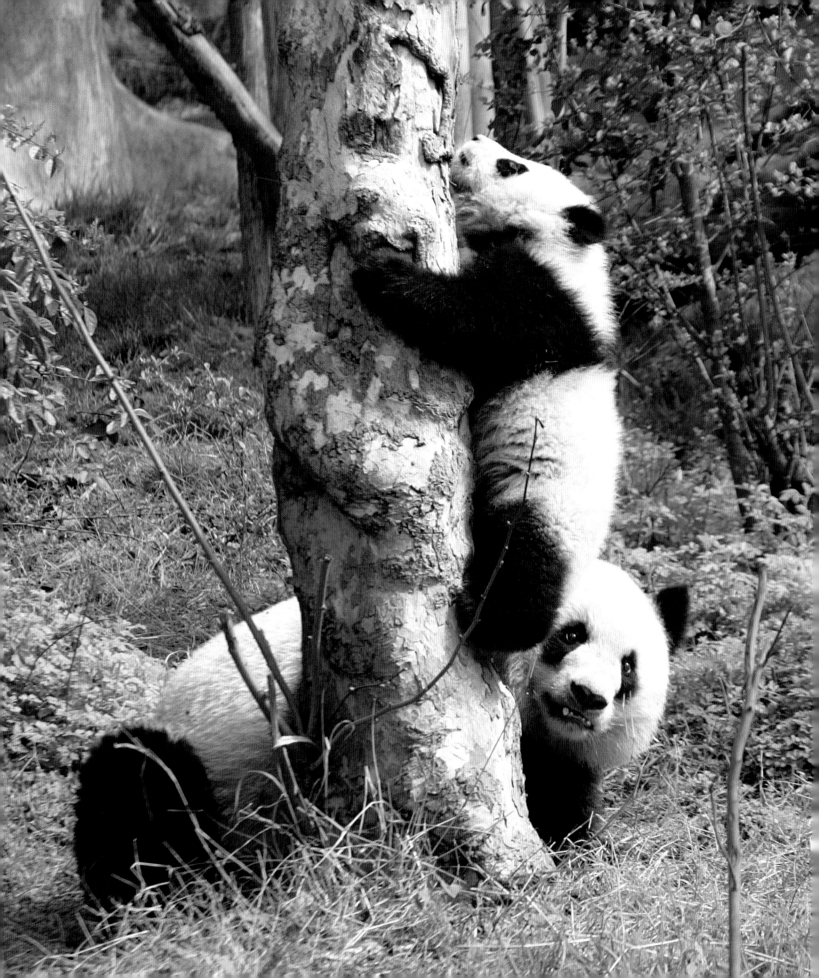

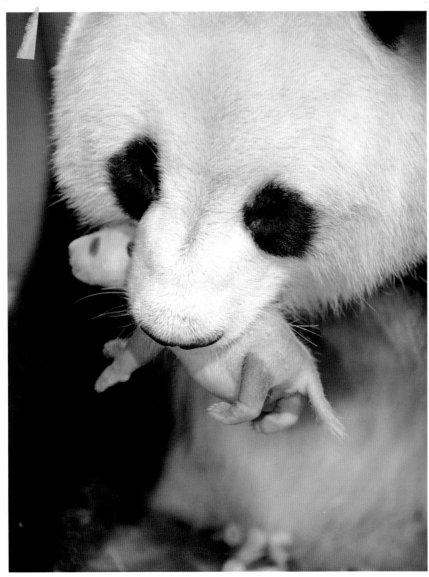

Above and right:
Tender moments
between mother
and cub

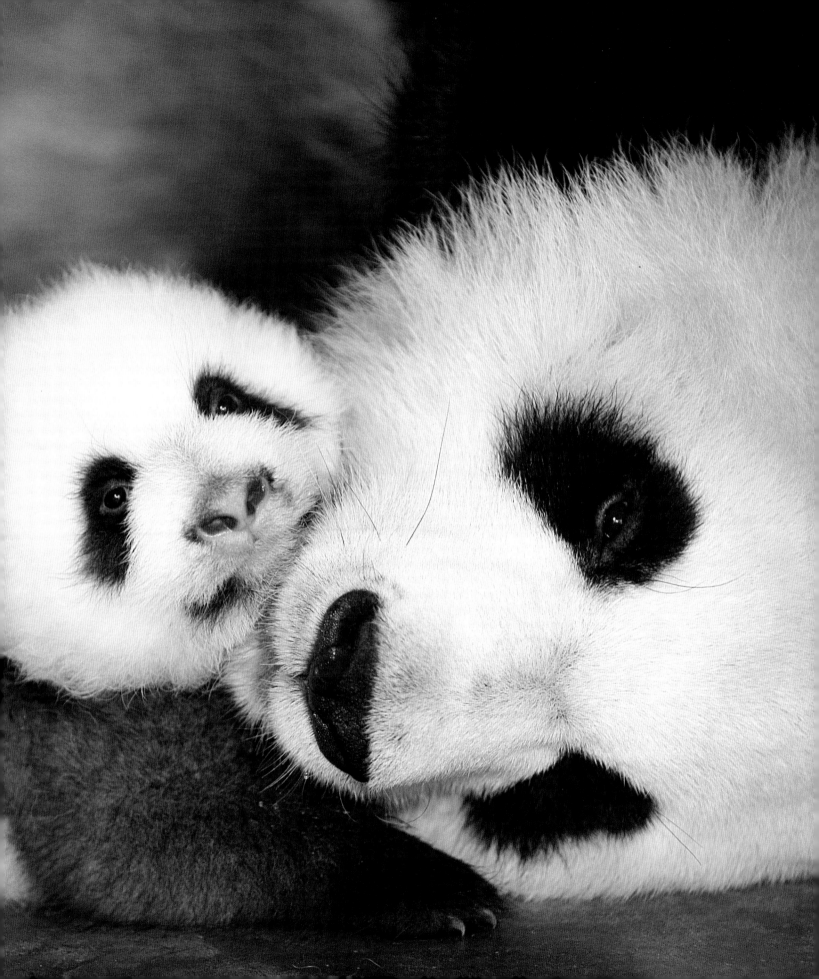

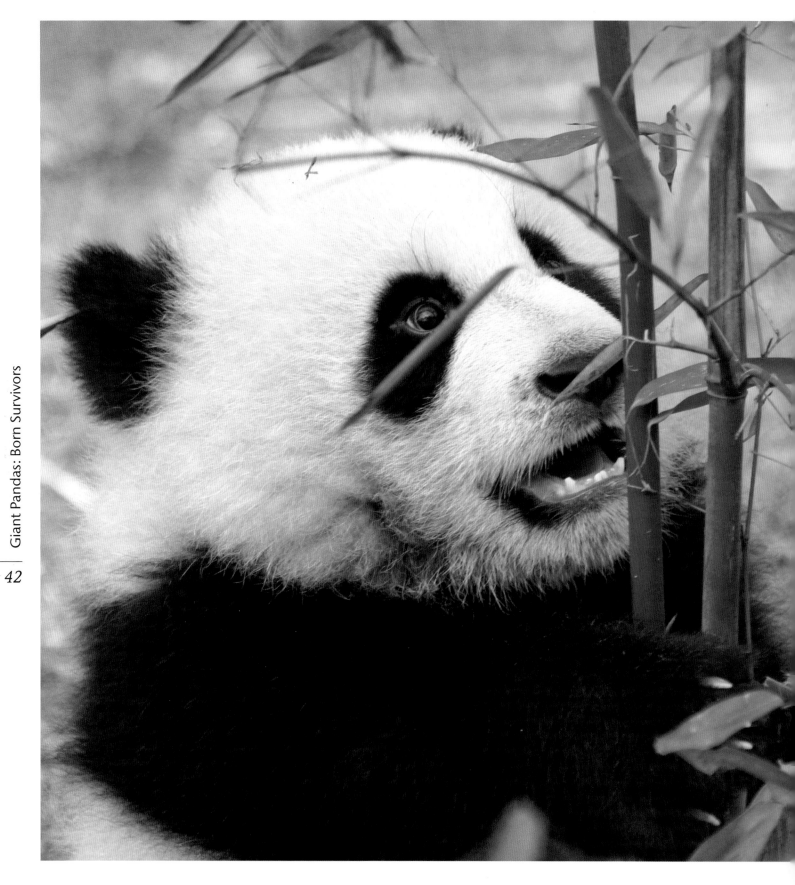

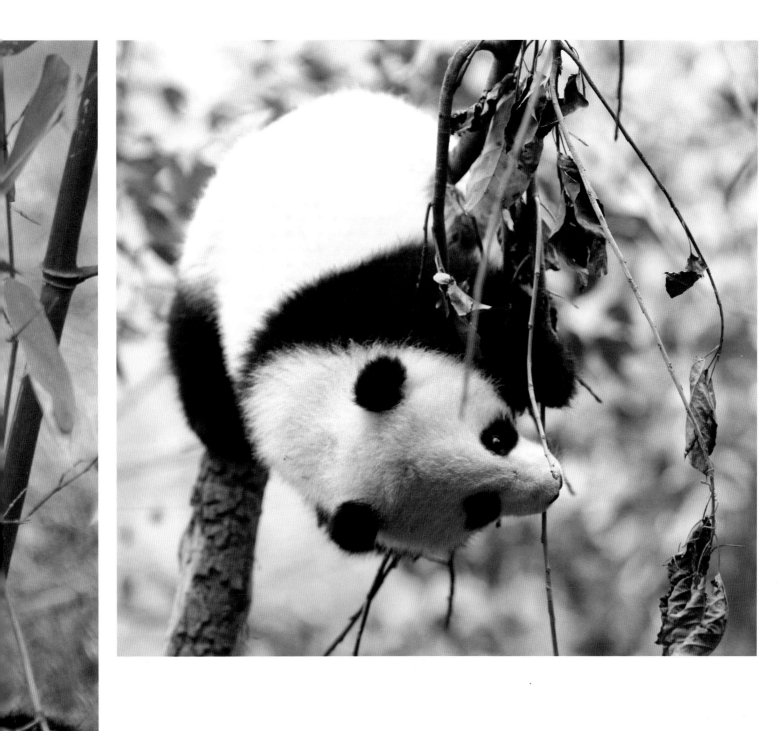

Above: A cub
hanging safely from
a tree
Left: Investigating
bamboo is a very
important activity
for young

Milestones in Development

At birth, giant panda cubs look nothing like one would expect. They are pink with a light covering of white fur. They have a long tail that takes first-time observers by surprise. It is only at about 10–14 days that their black colourations begin to appear. At approximately 40 days of age their eyes begin to open and at 50 days their eyes are fully open. At about 65 days they begin teething. They spend almost all of their time on or next to their mother until they learn to scoot around on their own at about 4 months of age. As with human mothers, panda mothers must be highly vigilant of the movements of their cub. At about 5 months cubs are mobile and able to walk. They are curious and exploratory, sniffing and investigating everything around them. At 5–8 months they will learn to climb, although some start even earlier at 4.5 months. Climbing is critical for their safety and it is at this stage that the mother can begin foraging for longer periods on her own. Her cub will climb high into a tree and stay there, sometimes for up to three days, safe from predators, while she is free to search more widely for food.

Play between mother and cub is crucial for panda development. It has been well documented in most mammals that play is vital for building strength, as well as learning to hunt and acquiring species-appropriate behaviours. At about 6–7 months giant panda cubs will begin to observe their mother eating bamboo. They will then start to play with bamboo, often biting, chewing and manipulating it without actually swallowing it. At around 9 months weaning begins and cubs start ingesting bamboo while still nursing from their mother. At 11 months most cubs are weaned. Cubs will stay with their mother until they are between 1.5–2 years of age, sometimes even until 2.5 years of age. At this time the cub will disperse to find his or her own territory.

Prior to separation from their mothers, cubs learn critical survival skills such as procuring and feeding on bamboo, vocalisations and their meanings, as well as how to respect the territories and social structure of other pandas.

Observations of mothers with cubs in the wild are extremely rare because pandas are so elusive and live in such remote and difficult areas to traverse. Therefore, the majority of observations of cub development have been of captive giant pandas.

Young male pandas tend to spend more time play-fighting with their mothers than female cubs.[6] This finding concurs with other studies that demonstrate young males of many species engage in higher levels of play-fighting than females. As described earlier, wild giant panda males congregate and compete for access to females in oestrus, with the dominant male winning the chance to mate. Play-fighting may be especially

Right: Panda mother playing with her cub. This involves lots of biting, nipping, chasing and scratching

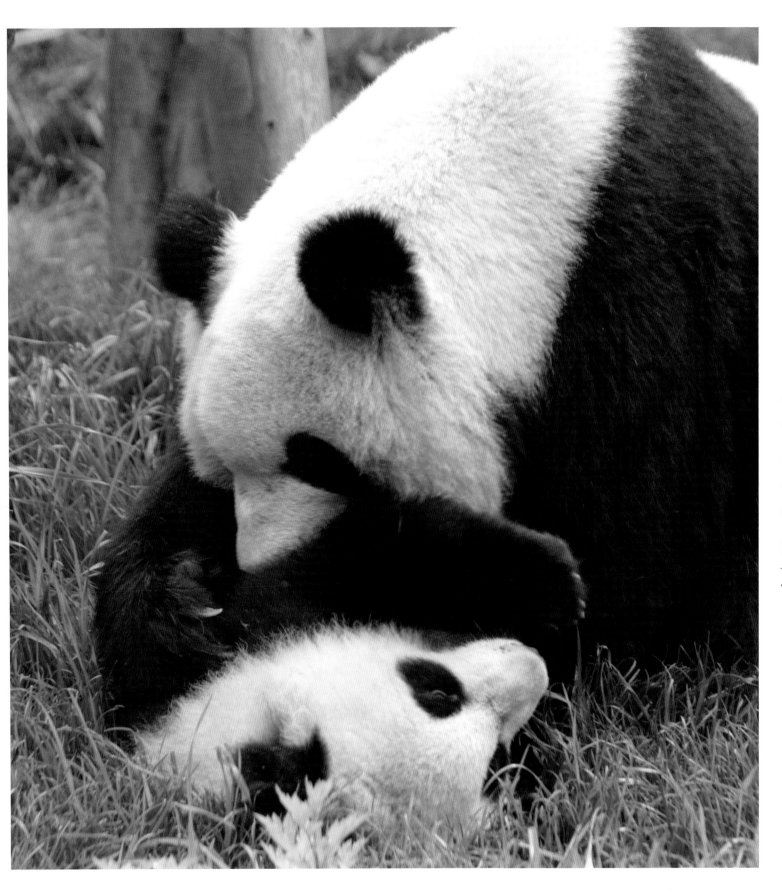

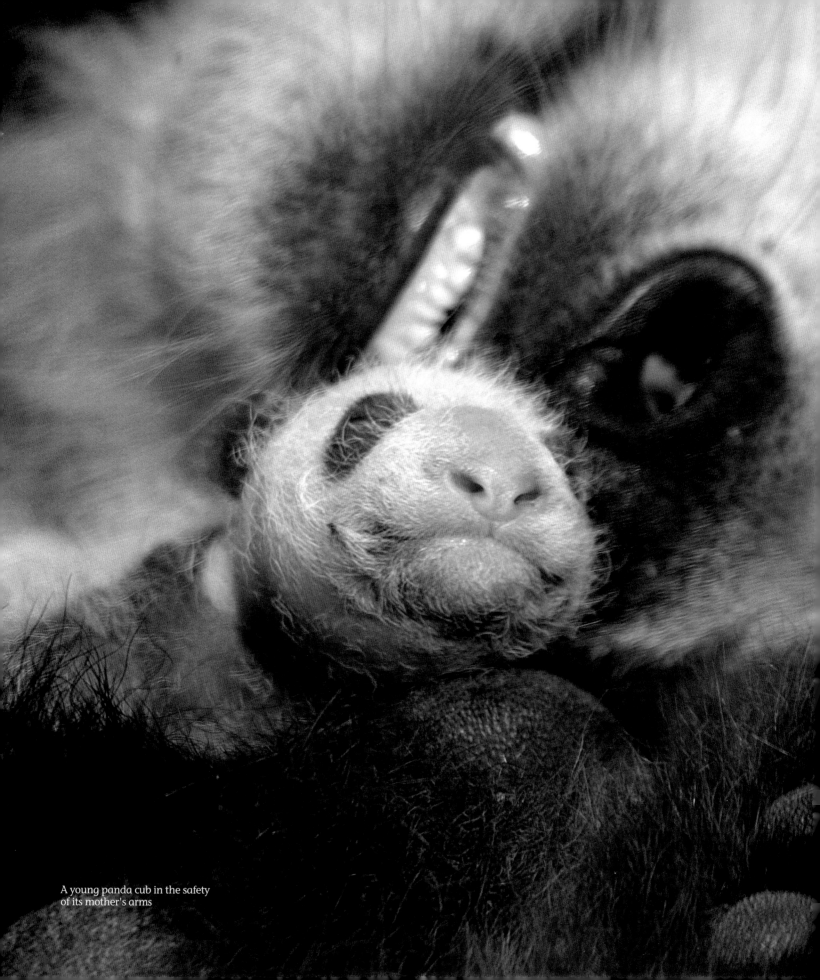

A young panda cub in the safety of its mother's arms

important for male cubs because it prepares them for future breeding encounters.[7]

Far fewer captive males breed than captive females do. Behavioural scientists have suggested that providing captive giant panda males the opportunity to engage in regular competitive interactions might improve reproductive behaviour. Currently, the two primary captive breeding centres in Chengdu and Wolong are trying to give male pandas opportunities to get close to, and interact with, other males through sight, sound and smell (but without physical contact that could result in serious injuries) during breeding season. It is believed that it would also be best to provide opportunities for young males to engage in more play-fighting with their mothers, as it may be critical for male reproductive success. Recently play-fighting has been tried with several of the Chengdu Panda Base's young captive male pandas. [8]

Mothers in only a few carnivore species have been found to solicit and stimulate play with their cubs. However, it has been noted that as giant panda cubs mature, mothers continue to direct the same level of play behaviour toward them as when they were younger.[9] In many other species, as cubs mature, play between siblings increases. However, as giant panda mothers are normally the only playmates available for their cubs, they appear to take a more active role than most carnivore mothers in stimulating their offspring to play.

In addition, mothers may also encourage their cubs to manipulate and play with bamboo. Researchers found that cubs raised by their mothers spent more time than peer-reared cubs (peer-rearing is a common practice in captive populations where cubs are raised in groups with other pandas of the same age) familiarising themselves with bamboo.[10] Giant panda cubs begin to manipulate bamboo at about 4 months but do not begin to ingest it until they are 11 months old. This period of handling, prior to feeding on bamboo, suggests that young cubs acquire feeding skills during this phase. The fact that mother-reared giant panda cubs spend more time manipulating bamboo than peer-reared cubs suggests that social learning of feeding behaviour occurs between mothers and cubs.[11]

Why
Bamboo?

Abundance

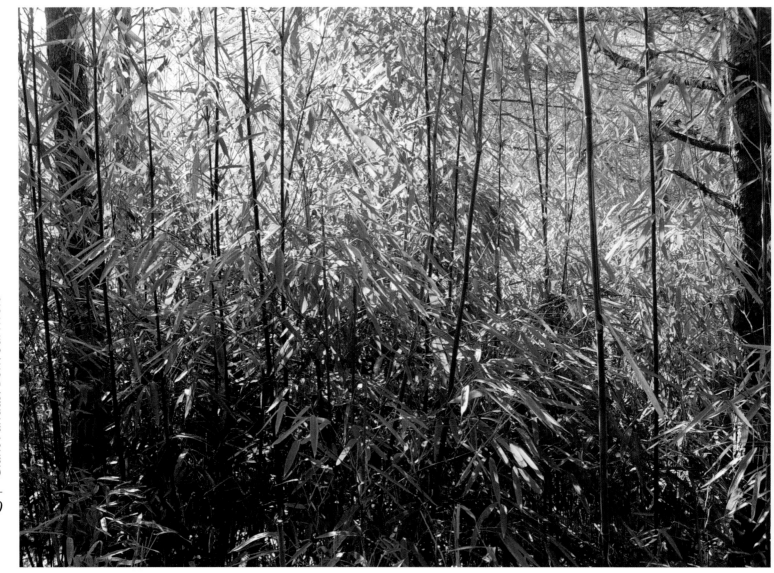

A major reason giant pandas focus their dietary efforts on the laborious task of consuming bamboo is simply that there has always been an abundant supply. We know that in the past, giant pandas were most likely carnivores and later became specialists in bamboo consumption. Many bear species rely on what we call a 'boom and bust' diet, meaning when a certain food source such as acorns, berries or fish is abundant, they gorge themselves to build up fat reserves for leaner times. Giant pandas went for the reliable food source / within their homeland, bamboo, which is available and plentiful all year round. Due to its low nutritional value, this food source prohibits hibernation, common among most bears. Therefore, pandas have to stay awake all year to continue eating.

Above: A small bamboo thicket
Opposite page: Wild giant panda eating in Foping Nature Reserve

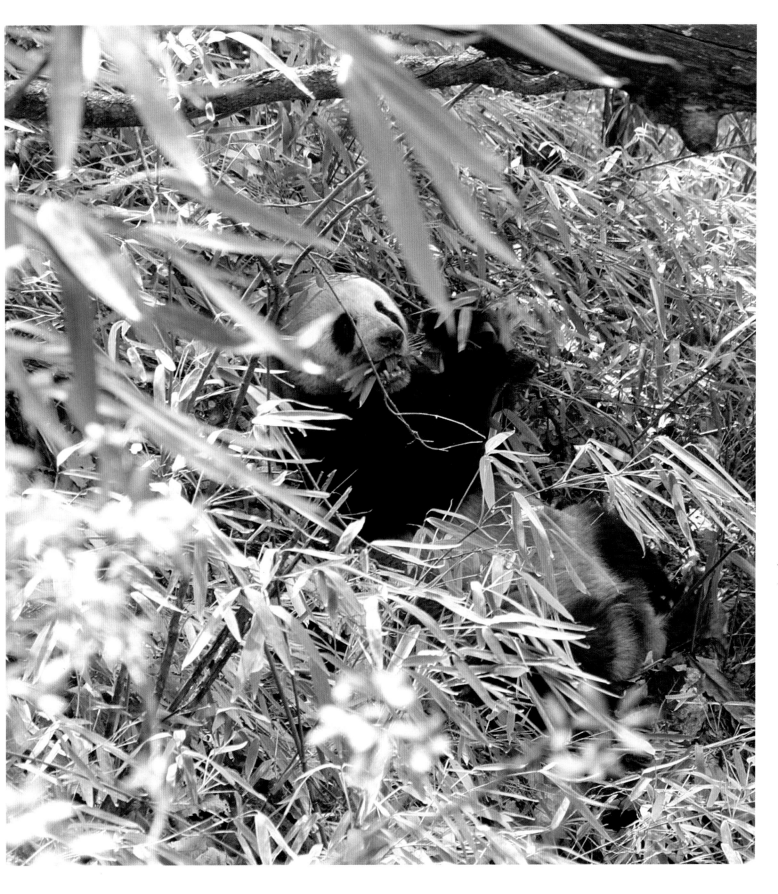

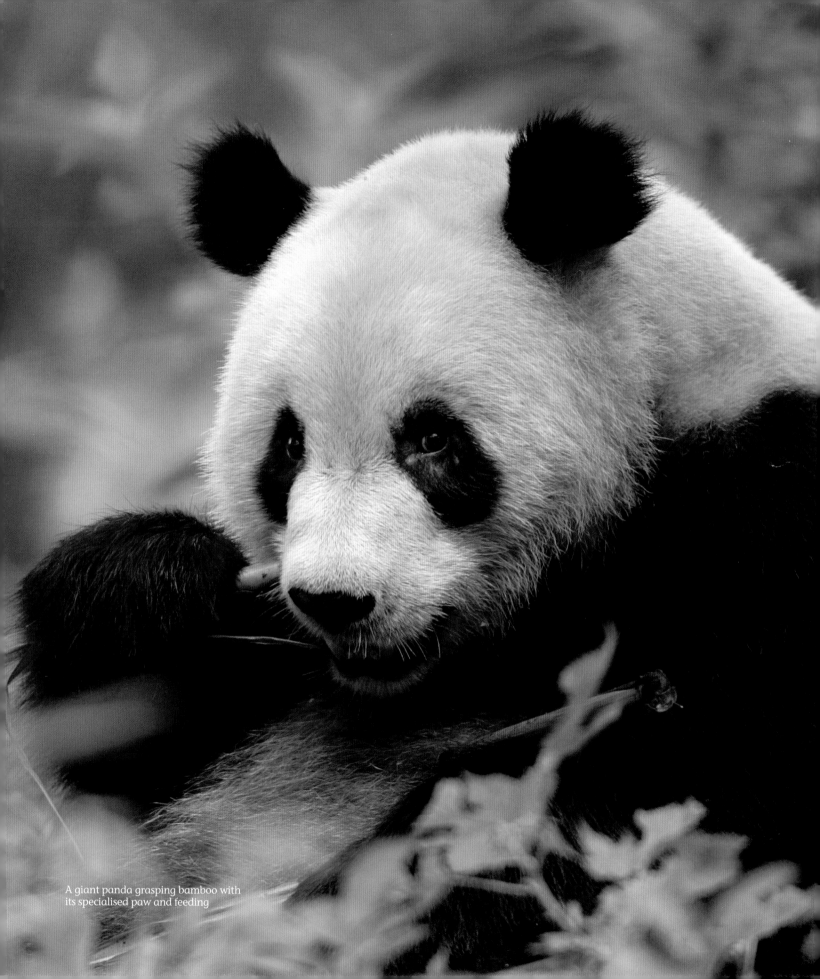

A giant panda grasping bamboo with its specialised paw and feeding

Specialist

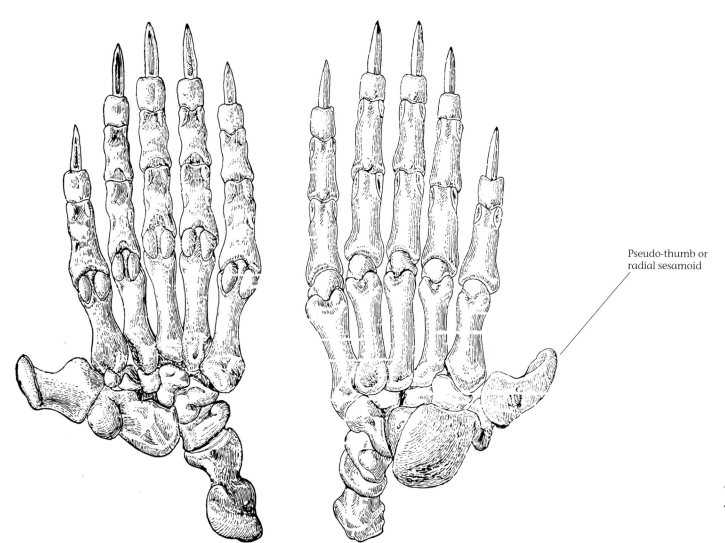

Pseudo-thumb or radial sesamoid

With this very particular diet, pandas have, over time, developed special physical features that help them process and consume bamboo. One of the most noticeable and helpful adaptations is an elongated wrist bone (you have this bone as well, it is called the *radial sesamoid*), which acts as a sort of thumb that allows pandas to grab and hold objects just like we do. Pandas use this elongated bone, or pseudo-thumb, primarily to grasp, break off and process bamboo, but they can also use this handy 'thumb' to hold other items that might interest them.

Giant pandas also have features that are similar to some other specialised herbivores such as gorillas. They have a very pronounced sagittal crest, or ridge of bone that runs down the centre of their skull which provides support for powerful muscles for chewing. These muscles are so large that they have caused their cheekbones to become quite pronounced, extending out to allow space for those enlarged muscles used for eating. This, together with their fluffy fur, is part of the reason why pandas always have such large cute cheeks!

The Skeleton of the Giant Panda

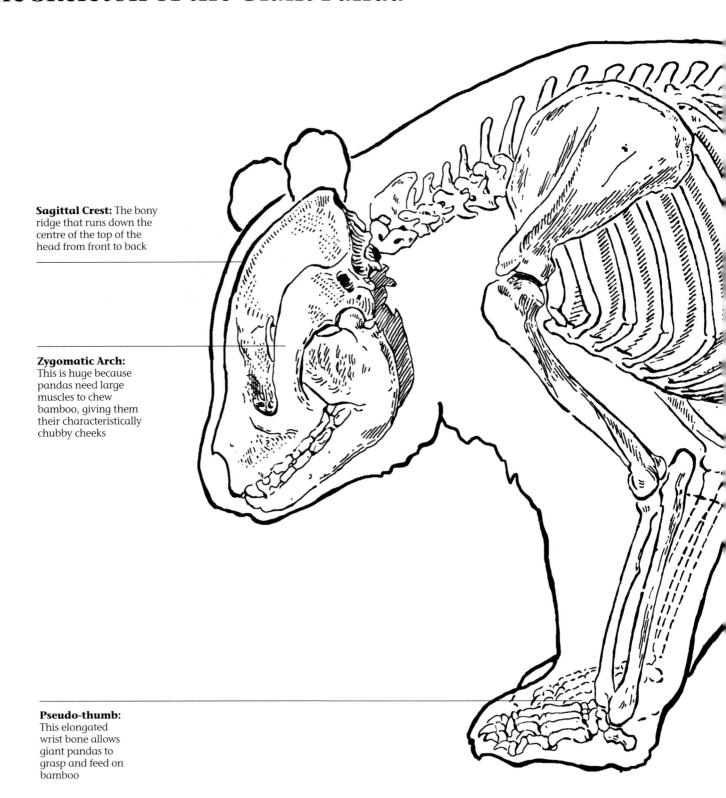

Sagittal Crest: The bony ridge that runs down the centre of the top of the head from front to back

Zygomatic Arch: This is huge because pandas need large muscles to chew bamboo, giving them their characteristically chubby cheeks

Pseudo-thumb: This elongated wrist bone allows giant pandas to grasp and feed on bamboo

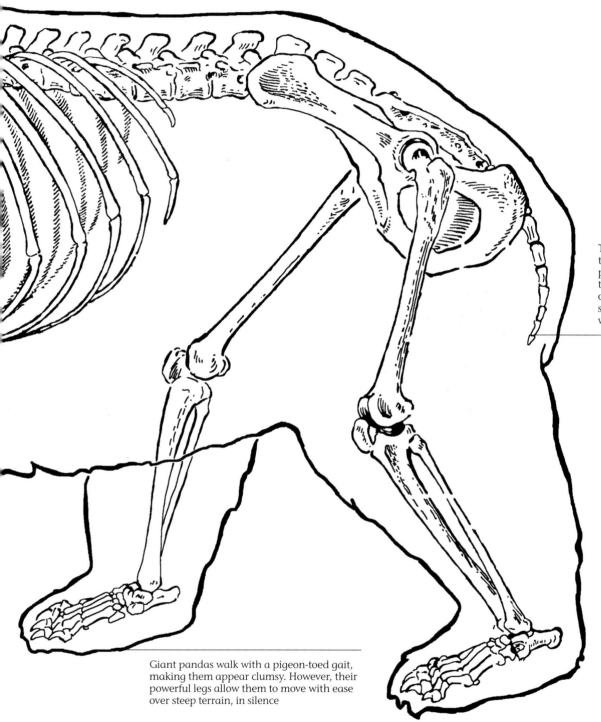

Tail: At about 10–15 cm long, this relatively short and furry tail protects the glandular area of the rump. Pandas hold their tails close to their bodies, except when scent marking to communicate with other giant pandas

Giant pandas walk with a pigeon-toed gait, making them appear clumsy. However, their powerful legs allow them to move with ease over steep terrain, in silence

Top left: Bamboo producing seeds
Bottom Left: Flowering bamboo species
Top: Bamboo shoot emerging

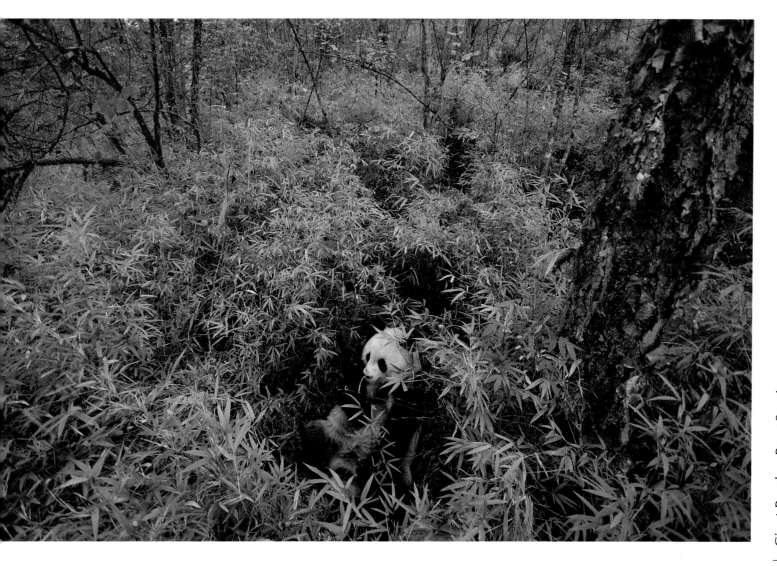

Bamboo Flowering

Between 1974–76, umbrella bamboo, especially favoured by giant pandas, and other bamboo varieties flowered, produced seeds and died over large areas of the Min Mountains in northern Sichuan. Bamboo flowering is normal and allows for new growth. It usually occurs at long intervals, in some species only every forty or more years. Luckily for giant pandas, their favoured bamboo species flower at about sixty-year intervals.

Usually bamboo reproduces asexually by sending up shoots from root-like rhizomes. Bamboo rhizomes are horizontal stems that send out roots and shoots from their nodes. Because umbrella bamboo is the panda's favoured food source, its temporary demise following the flowering caused severe starvation among pandas and at least 138 pandas died. To make matters worse, bamboo flowering also occurred in the Min and Qionglai Mountain ranges during the summer of 1983. From 1974–83, in total, about 250 pandas died as a result. These deaths, in part, led to the establishment of two captive breeding centres in Sichuan Province.

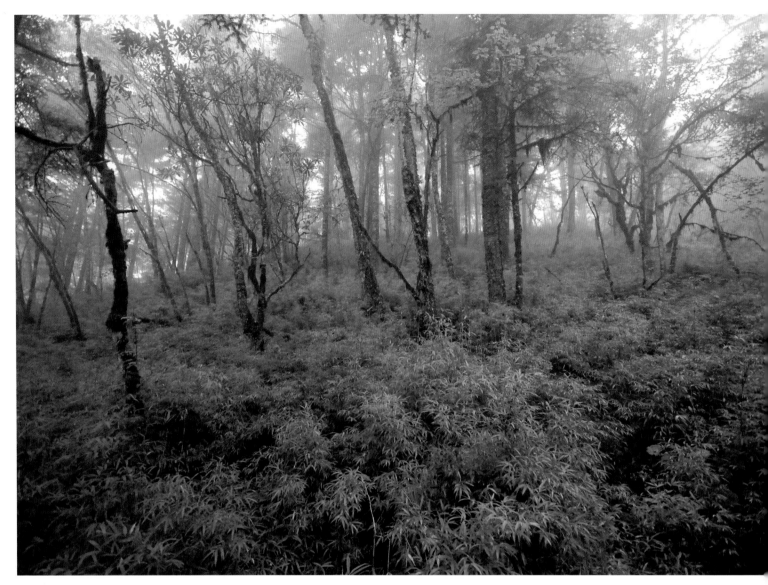

The verdant habitat of the giant panda

A river valley in Motianling Provincial
Nature Reserve, Shaanxi Province

Habitat

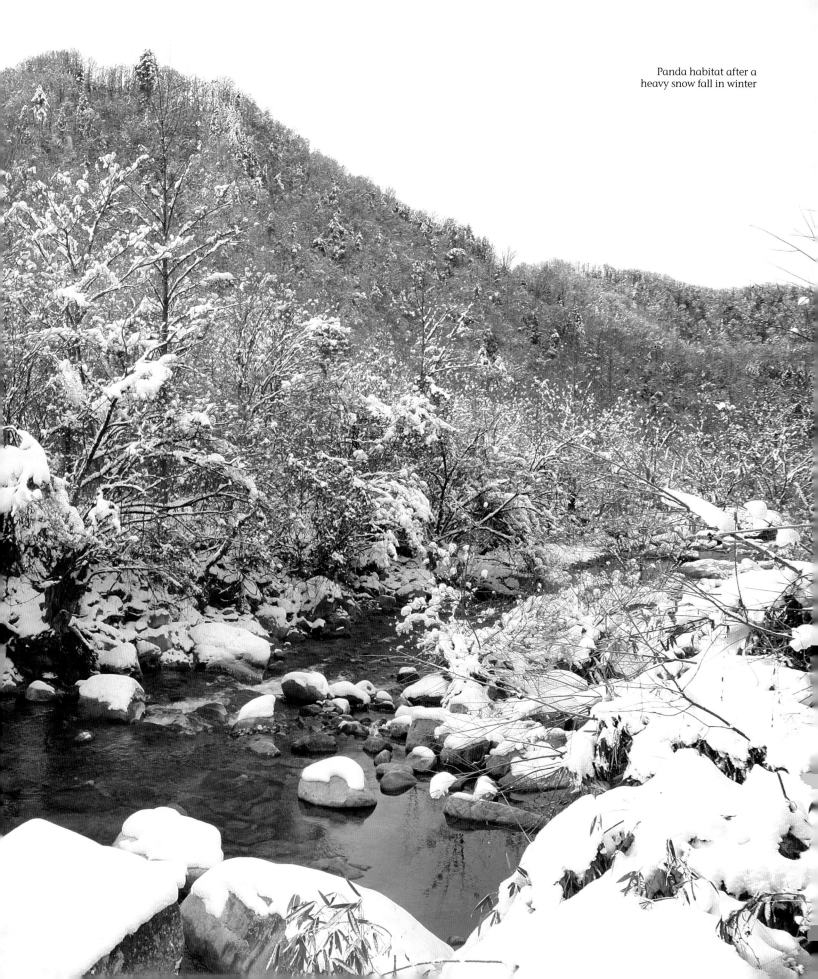

Panda habitat after a
heavy snow fall in winter

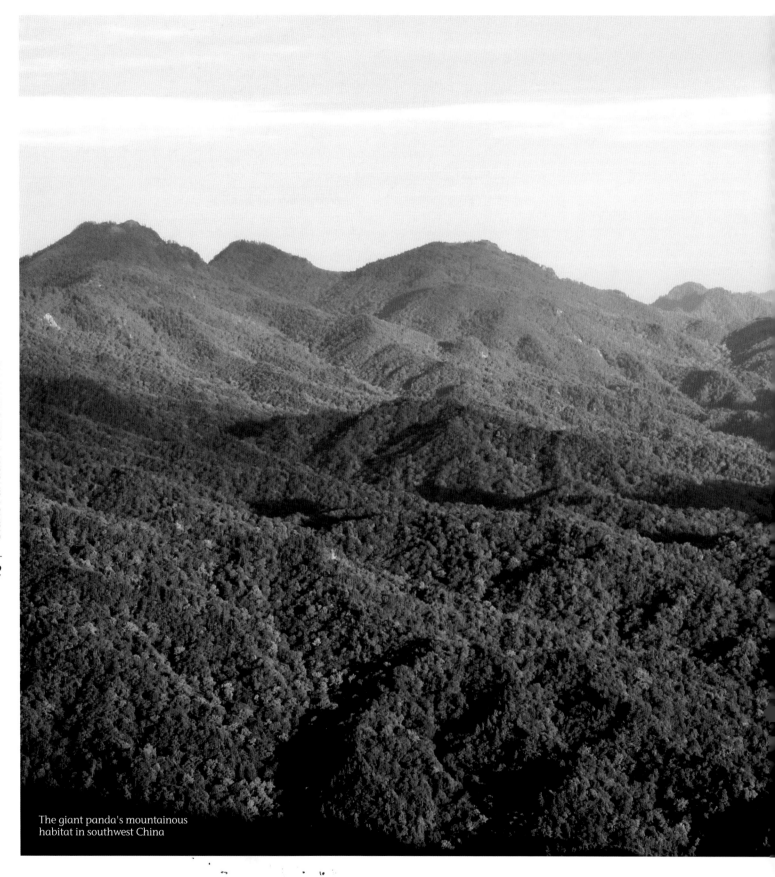

The giant panda's mountainous
habitat in southwest China

Southwest China

Southwest China is a biodiversity hotspot with high levels of species diversity and significant endemism. An endemic species is one that can only be found in a single region on Earth. These areas are considered to be very fragile and under extreme threat from human activity.

Giant pandas used to live in lowlands before human settlement drove them into the mountains. They now depend on high-altitude, temperate and mature forests. In fact, the lack of human residents was a major factor that made the mountains of southwest China ideal for giant pandas.

There have been three surveys of the wild giant panda population, although numbers of possible cubs could not be accounted for in any of the surveys. The first national survey was conducted from 1974–77, and counted approximately 2459 giant pandas in the wild; the second survey, from 1985–88, recorded approximately 1114 individuals; while the most recent, from 1998–2002, observed approximately 1596 individuals. The State Forestry Administration of the People's Republic of China began a fourth survey in June 2011 and new figures are expected to be available in 4–6 years. At the end of the 2011 birthing season there were 333 pandas in captivity, which means wild individuals still outnumber their captive counterparts.

The Region

Chengdu, the capital of Sichuan Province, is affectionately known as the 'Hometown of Giant Pandas' and is the hub of panda research, attracting renowned academics such as George Schaller, Hu Jinchu, Ulysses Seal, Don Lindburg, JoGayle Howard, David Wildt and Devra Kleiman, to name but a few. Chengdu lies within the Min Mountain region where some of China's earliest civilisations germinated.

Chengdu is a Chinese city with a history of 2300 years. It is now a political, economic, cultural and industrial centre. It covers an area of around 12000 square kilometres and has 14 million inhabitants. With a pleasant climate and rich natural resources, it has, since ancient times, been praised as a land of abundance.

The city is situated within one of the most bio-diverse hotspots in the world. The region is home to seventy-three rare animals and 2000 rare plants, many of which are found in the four state nature reserves located within the jurisdiction of Chengdu. With an elevation that ranges tremendously from 350–5600 metres, Chengdu is the only city that has jurisdiction over captive as well as wild giant pandas.

The Min Mountain range has a long history and strong ethnic diversity. Minorities such as Tibetan, Qiang, and Yi account for 9 per cent of the population, with Han making up most of the area's population. Most minorities live in the high altitude regions of Songpan, Maoxian and Jiuzhaigou counties where they have survived for centuries.

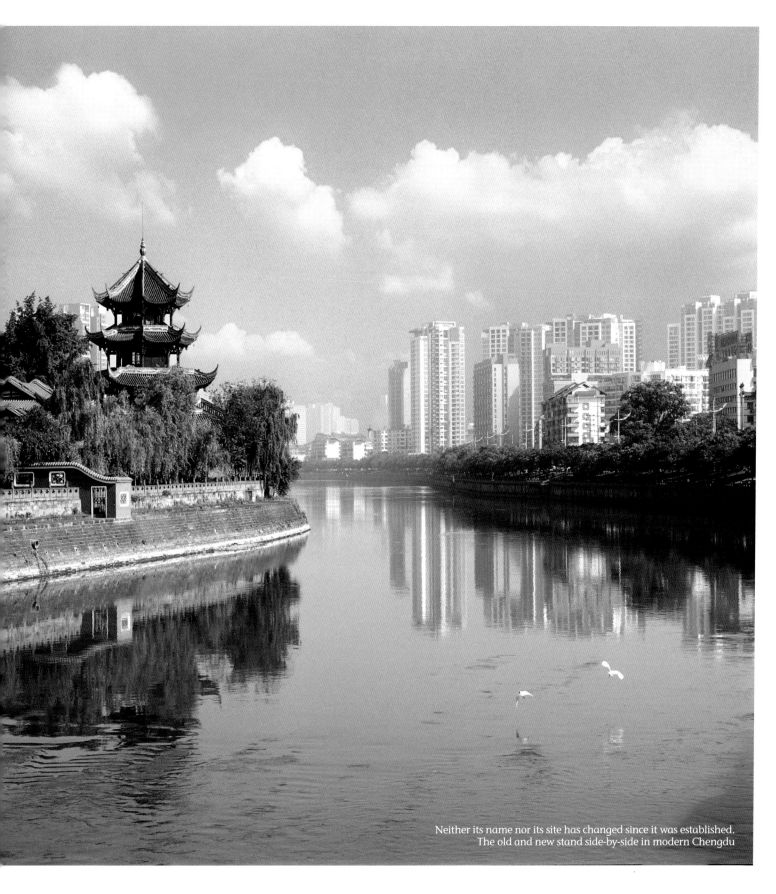

Neither its name nor its site has changed since it was established.
The old and new stand side-by-side in modern Chengdu

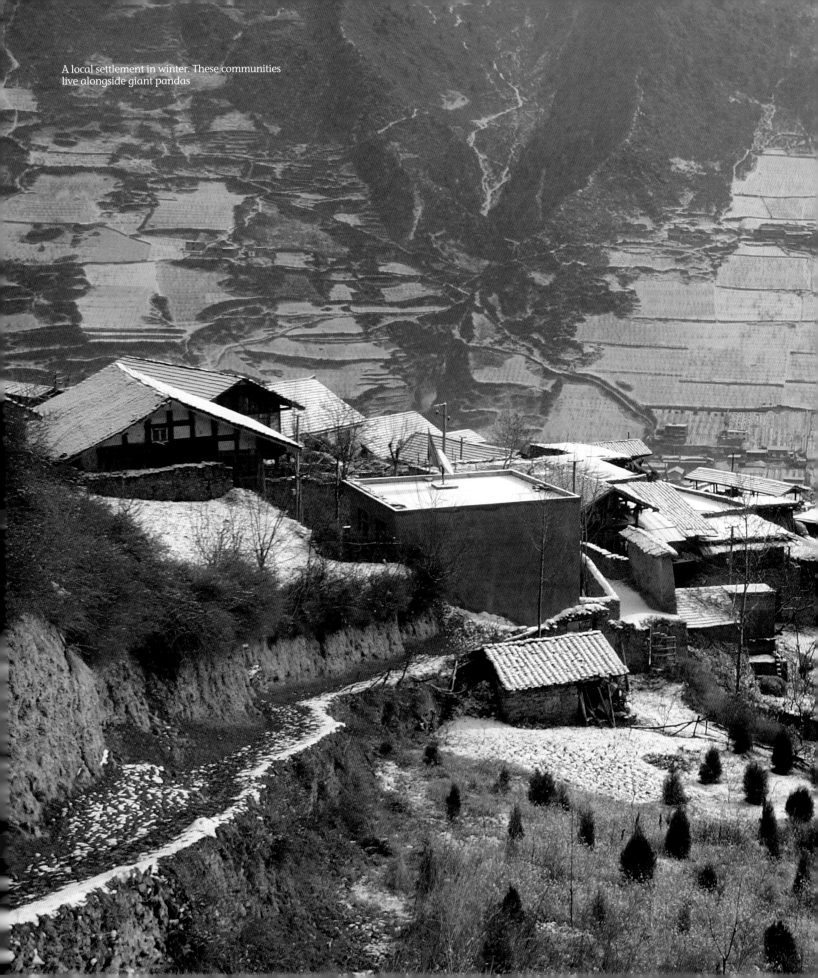

A local settlement in winter. These communities live alongside giant pandas

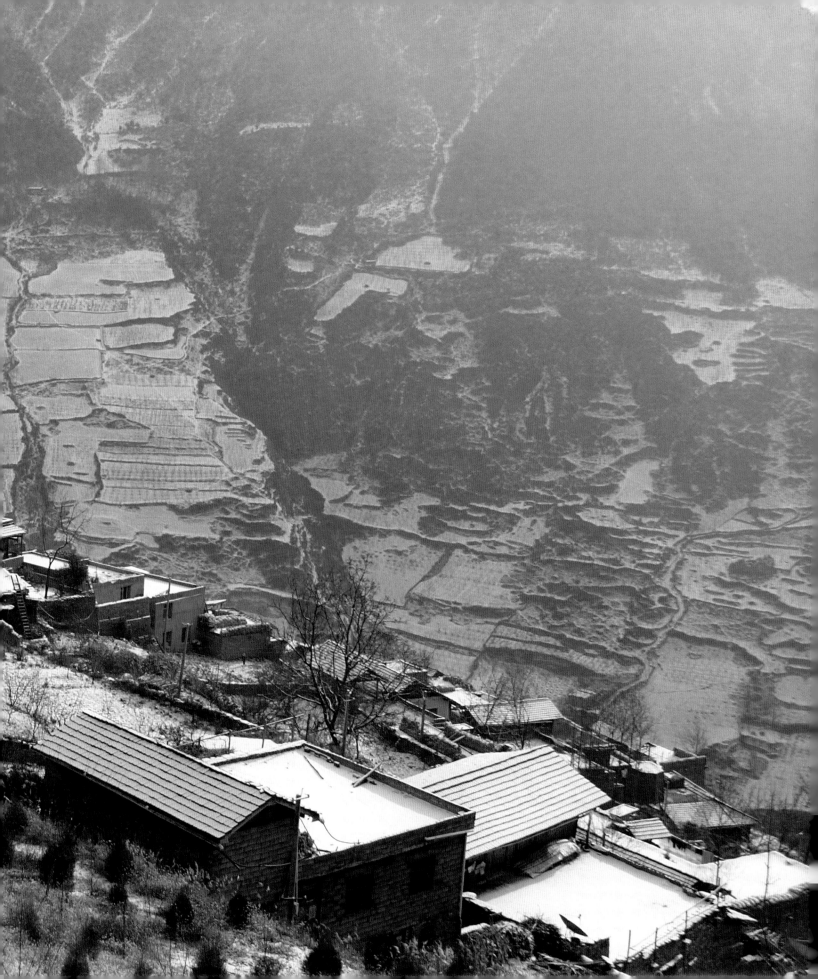

A serene lake up in the Qinling mountain range

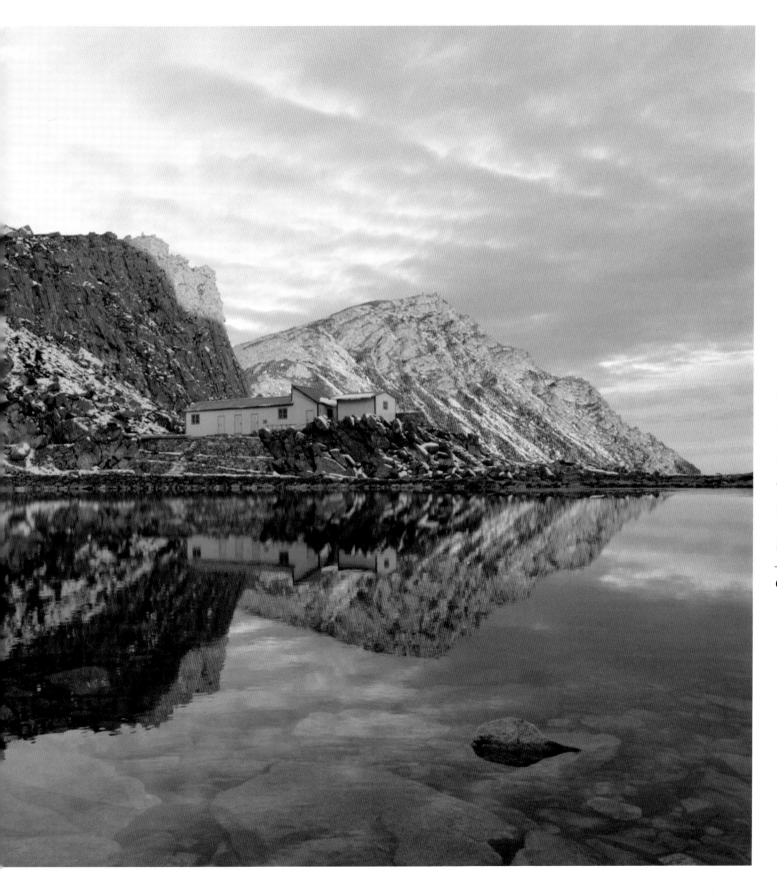

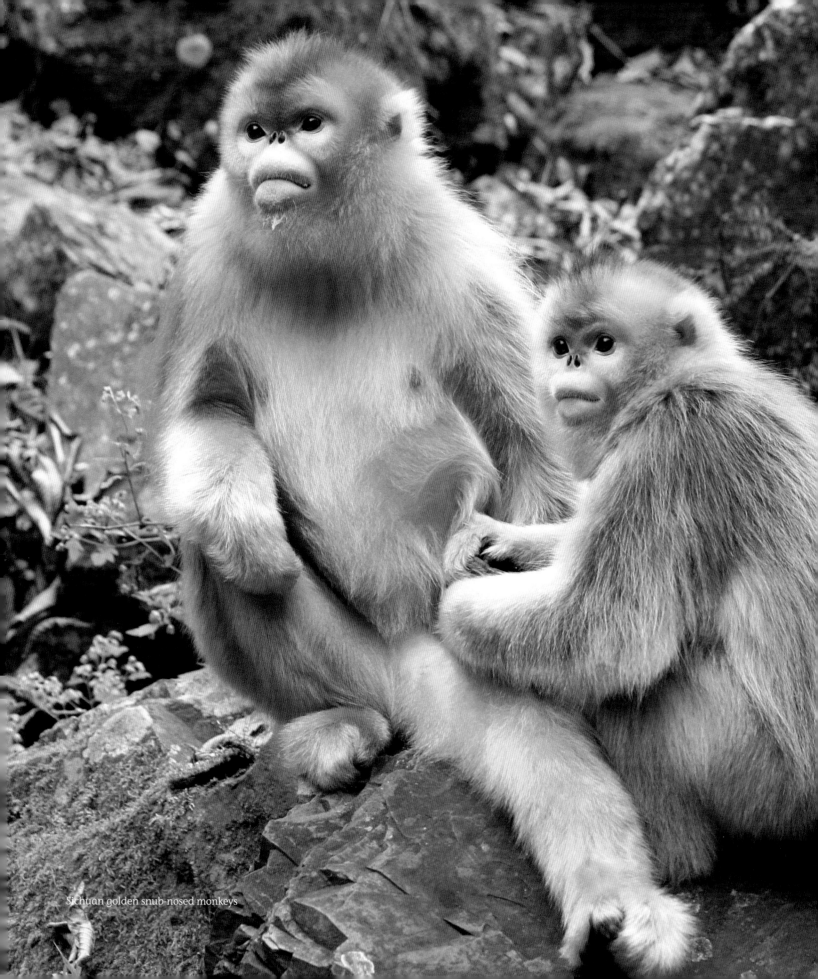

Sichuan golden snub-nosed monkeys

Neighbours of the giant panda

The more famous animal species that share this habitat with giant pandas include Sichuan golden snub-nosed monkeys (*Rhinopithecus roxellana*), takin (*Budorcas taxicolor*), red pandas (*Ailurus fulgens*) and golden pheasants (*Chrysolophus pictus*). There are also many rare and endemic plants – about 12000 species within the giant panda habitat – with the dove tree (*Davidia involucrata*) and highly diverse rhododendron species characterising the mysterious and verdant landscape. Of course the plant that defines these mountains is bamboo, which makes up the understory, while evergreens and deciduous trees make up the overstory.

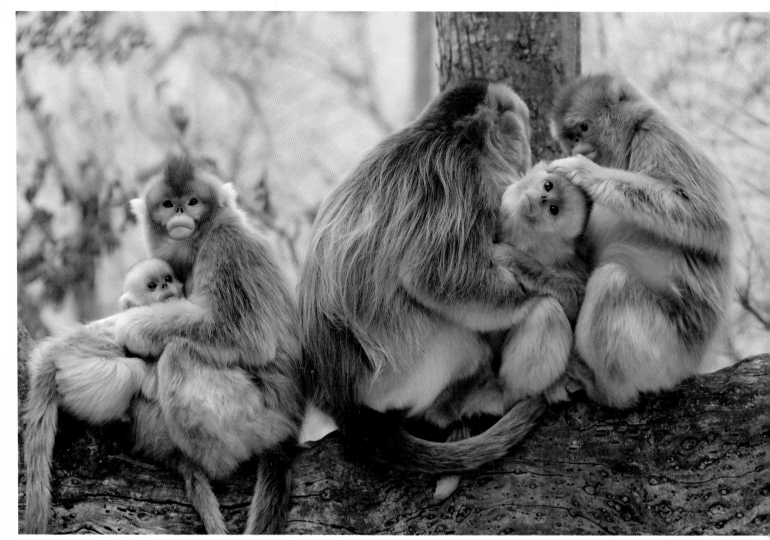

Above:

Sichuan Golden Snub-nosed Monkey
(*Rhinopithecus roxellana*)
Chinese: 金丝猴
Pinyin: jīn sī hóu

The charismatic Sichuan golden snub-nosed monkey is a major contributor to the unique and stunning beauty of the mountains of southwest China. With their strikingly beautiful golden fur and robin-egg-blue eye patches, they are a great source of pride for China. Their method of communication is one of the most intriguing of all mammals. They utter a variety of vocalisations without moving their mouth, making them the ventriloquists of the region. These monkeys are listed as endangered and their population has halved over the past four decades, due mainly to deforestation.[1] Overall, their population is still in decline, with fewer than 20000 individuals thought to survive in the wild.

Opposite page:

Red Panda
(*Ailurus fulgens*)
Chinese: 小熊猫
Pinyin: xiǎo xióng māo

The red panda is the adored counterpart of the giant panda (both having panda in their name is misleading as they are from different taxonomic groups). Like giant pandas, red pandas also survive on bamboo, which makes up 99 per cent of their diet. The habitat of the Sichuan subspecies pictured here overlaps with that of giant pandas. Red pandas are mostly arboreal, or tree dwelling, and are listed as vulnerable to extinction. Their population is estimated at fewer than 10000 mature individuals and falling.[2] Red pandas are primarily threatened by habitat loss and fragmentation, poaching and inbreeding depression.

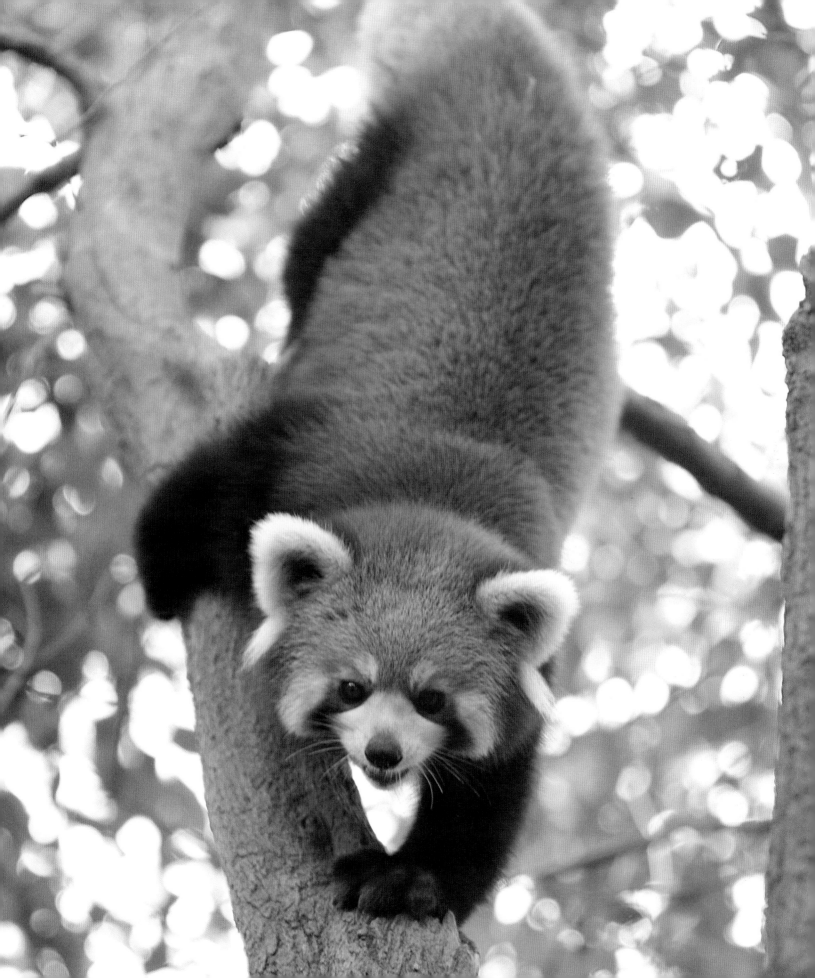

**Golden Pheasants
(*Chrysolophus pictus*)**
Chinese: 锦鸡
Pinyin: jín jī

Golden pheasants are one of the most
spectacularly coloured of all birds. With
their golden crest and rump, vibrant
orange cape and blue tail feathers, they are
hard to forget. Females, as with most bird
species, are less vivid and are primarily
dark brown and buff coloured. Even
though they are eye-catching and lively,
golden pheasants are actually difficult to
see in their native coniferous habitat. They
are omnivorous and feed on the ground,
but roost in trees at night for safety.[3]

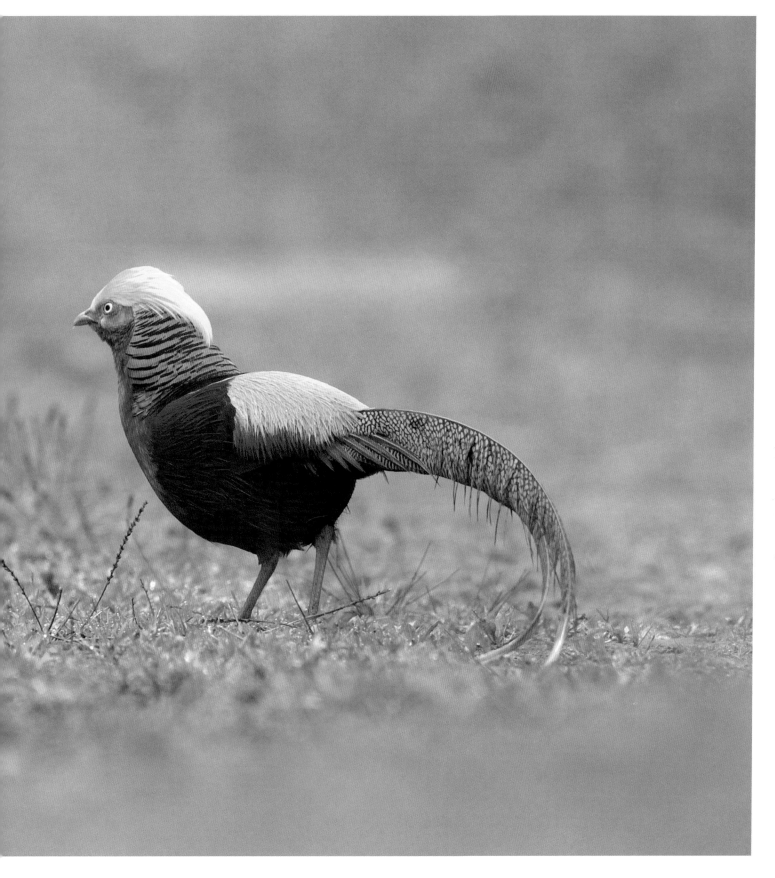

75

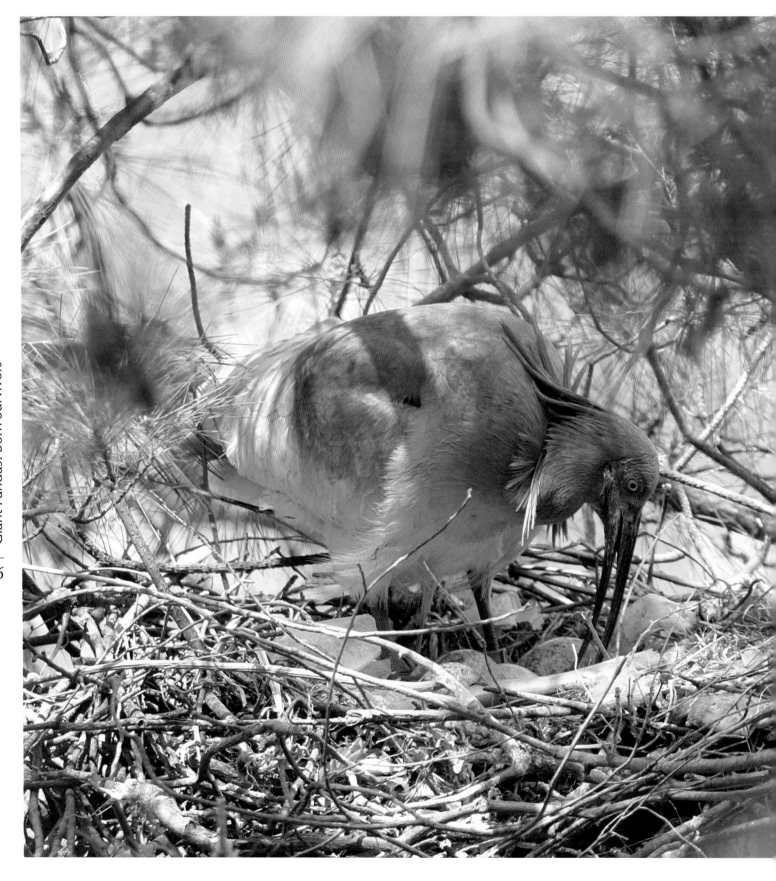

Left:

**Crested ibis
(*Nipponia nippon*) Endangered**
Chinese: 朱鹮
Pinyin: zhū huán

Within part of the giant panda's habitat lie the Qinling Mountains of Shaanxi Province where the remaining crested ibis of the world fight for survival. This species is already extinct within most of its historical range that once included Japan, the Russian Far East, North Korea, South Korea and Taiwan. In 1981, when the crested ibis was teetering on the brink of extinction with only seven individuals left, concerted efforts were made to save the species. Today, approximately 500 individuals are thought to be clinging on in the wild and they are listed as endangered. As of 2011, records show that 803 survive in captivity in breeding programmes.[4]

Below:

**Southwest China Serow
(*Capricornis milneedwardsii*)
Near Threatened**
Chinese: 鬣羚
Pinyin: liè líng

Southwest China serows prefer rugged steep hills and rocky places, especially limestone regions up to 4500 metres, but they will also inhabit flatter terrain. They are herbivores, feeding on leaves and shoots, and are fond of visiting salt licks. They are nocturnal and solitary. Unfortunately, their population is declining significantly due to hunting for their meat, fur and body parts that are used for medicinal purposes. Habitat loss as a result of agricultural expansion is also a threat as well as gradual forest clearance due to firewood collection and small-scale timber extraction. No total estimates have been made of their numbers in southwest China, but due to the increasing human presence and the resulting pressures on the environment, their population is thought to be in decline.[5]

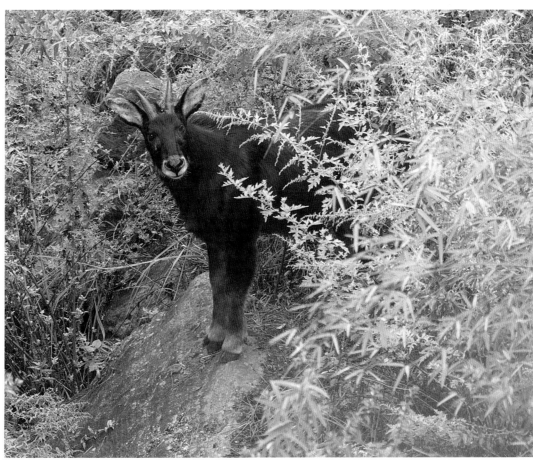

Above:

Takin
(***Budorcas taxicolor***)
Chinese: 羚牛，扭角羚
Pinyin: líng niú, niú jiǎo líng

Takin are another great unknown
of China's southwest. Looking like a
360-kilogram combination of an antelope,
goat and moose, they resemble no other
large mammal on Earth. While appearing
quite ungainly, they can traverse
precipitous mountainsides with ease and
grace. They migrate to different altitudes
depending on the season, spending
summers at high elevation and winters
in forested valleys, all within a range of
about 1220–4270 metres. Takin are listed
as vulnerable to extinction with a declining
population.[6]

Opposite page:

Sichuan partridge
(***Arborophila rufipectus***)
Chinese: 鹧鸪
Pinyin: zhè gū

Sichuan partridges are found only in
China and are extremely rare. They
prefer broadleaf temperate forests and
sloping land near water. Their population
continues to decline due to habitat loss,
severe fragmentation and hunting. Their
numbers are also heavily pressured
by illegal logging and the collection of
bamboo shoots and medicinal plants.[7]

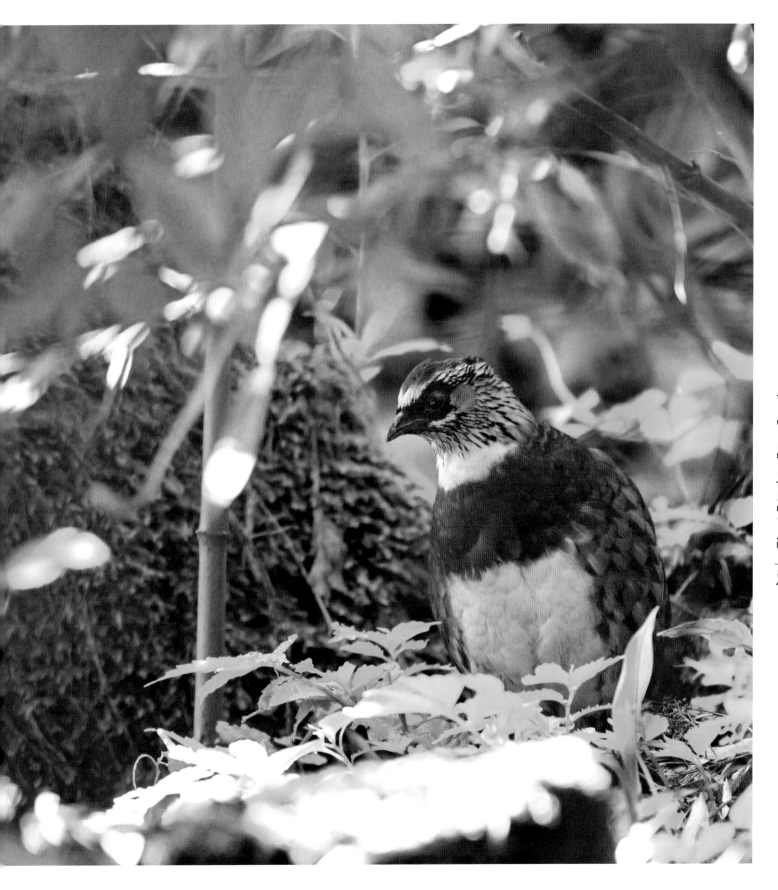

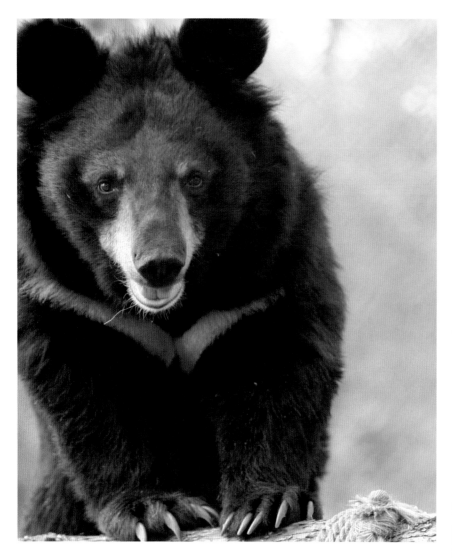

80

Above:

Asiatic Black Bear
(***Ursus thibetanus***)
Chinese: 亚洲黑熊
Pinyin: yà zhōu hēi xióng

Two other bears live alongside pandas,
the brown bear and the Asiatic black
bear. Asiatic black bears, also called moon
bears, are best known for their gorgeous
golden quarter moon of fur just under their
chin. Sadly, they are also known for the
medicinal value of their gall bladder bile,
which has led to these highly intelligent
beings facing inconceivable levels of torture
and contributed, in part, to the decimation
of their wild population. They are listed as
vulnerable and their population numbers
are sliding.[8]

Opposite page:

Yellow-throated Marten
(***Martes flavigula***)
Chinese: 黄鼬
Pinyin: huáng yòu

Yellow-throated martens are beautiful
forest-dwelling creatures with an
omnivorous diet. They primarily consume
squirrels, birds, snakes, lizards, eggs and
frogs, as well as fruit and nectar. They
are usually found in small groups of up
to seven individuals. Forest conversion in
Asia over the past few decades has led to
a decrease in suitable habitat, but so far,
healthy populations remain.[9]

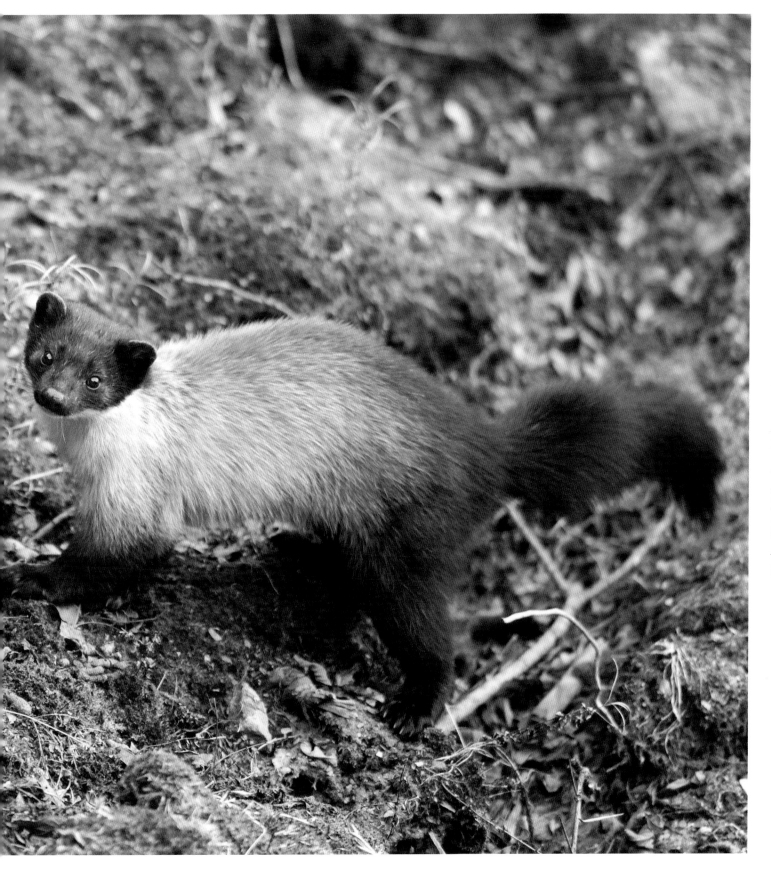

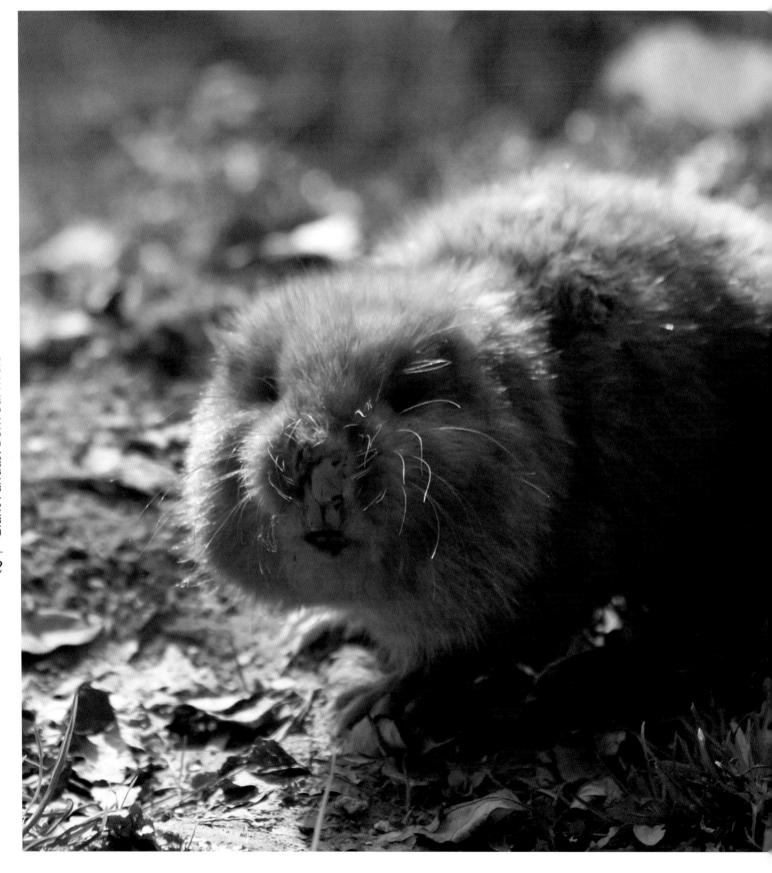

**Bamboo Rats
(*Rhizomys sinensis*)**
Chinese: 竹鼠
Pinyin: zhú shú

Bamboo rats are bulky and slow moving mammals weighing about a kilogram. They have soft, thick, grey fur and live at high altitudes between 1200–4000 metres in intricate, extensive burrow systems. They have large digging claws making them well adapted to subterranean life. They feed primarily on the stem and rhizome of plants and are important to the ecology of their habitat as they aerate the soil and recycle nutrients. If their population grows excessively in number they could adversely affect panda habitat. However, in stable numbers they stimulate production of new shoots by thinning dense stands and therefore are important to the health of pandas and their habitat.[10]

**Wild Boar
(*Sus scrofa*)**
Chinese: 野猪
Pinyin: yé zhū

The wild boar is the ancestor of our domestic pig. The adult males are usually solitary except during the breeding season, when they seek receptive mates. The females and their offspring live in groups called 'sounders'. Each group has one or two dominant members. So far, their population is safe due to their large range, tolerance of human disturbance and their presence in protected areas.[11]

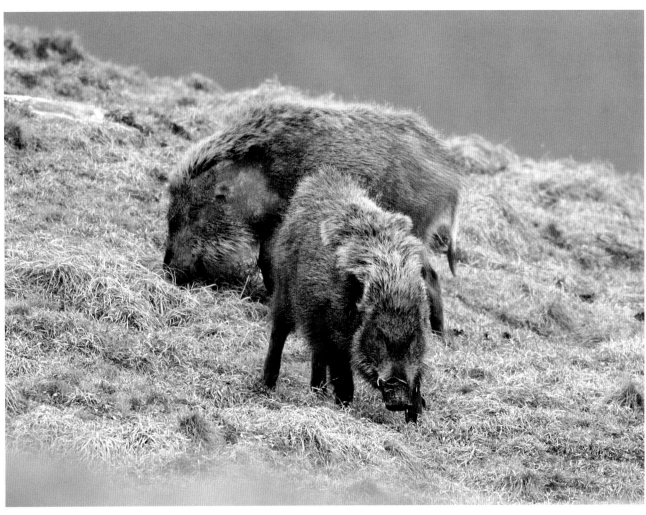

The Role
of the Giant
Panda

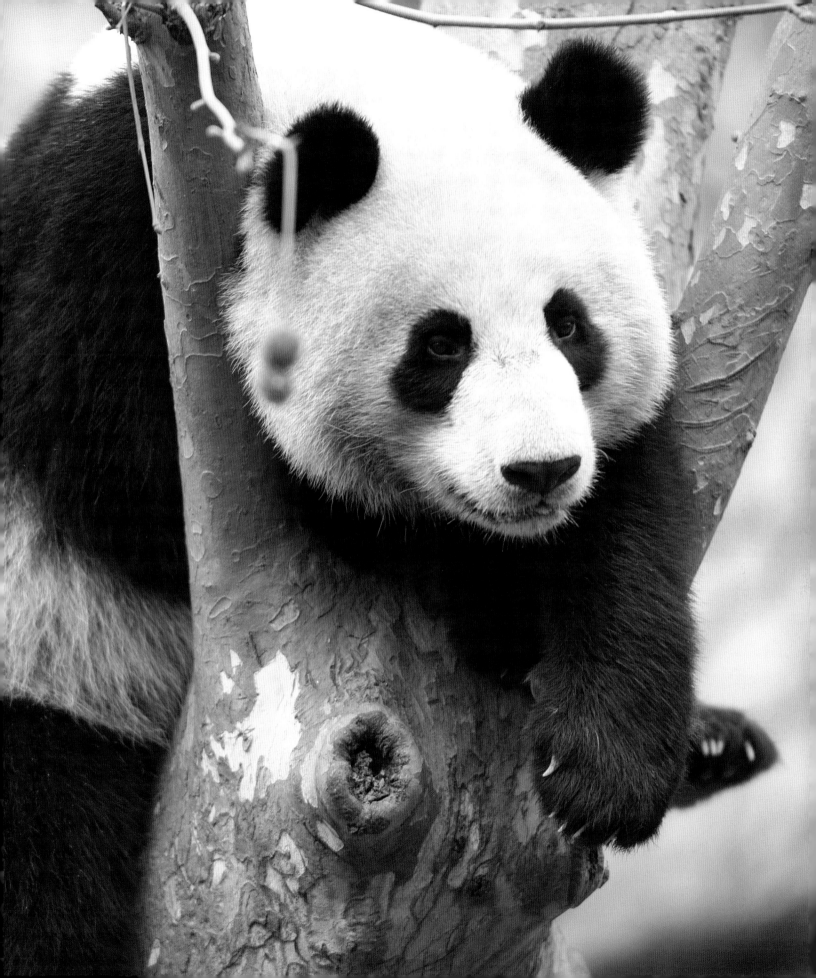

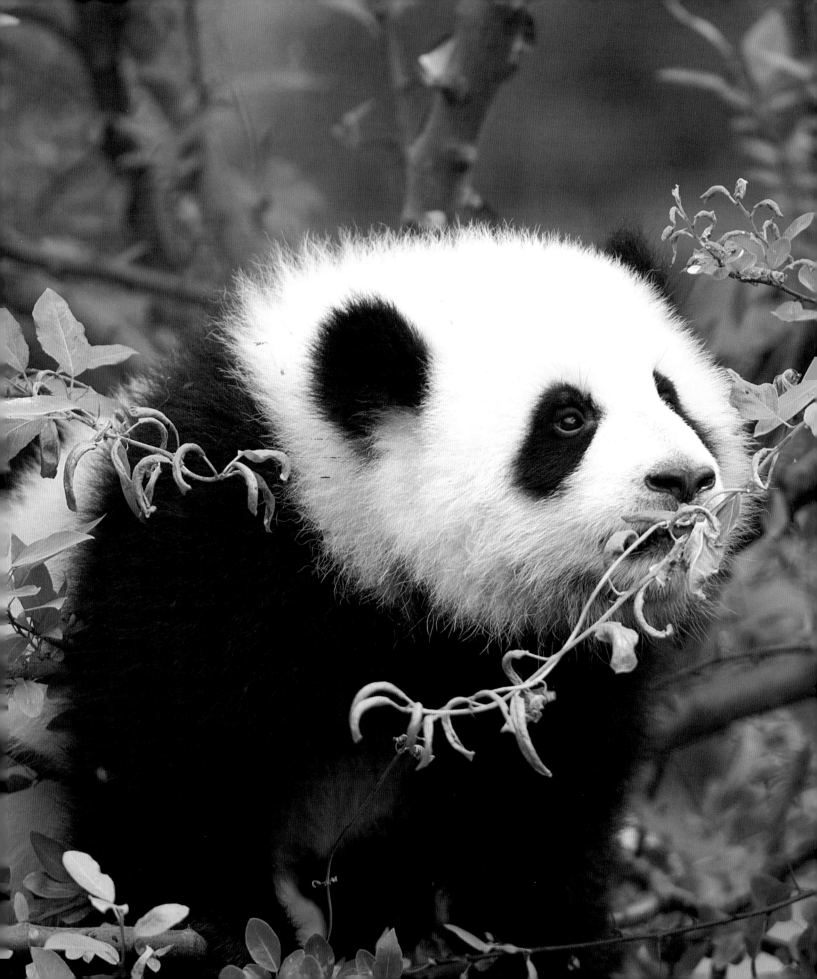

A young panda investigating
his treetop environment

Panda Politics

The Chinese authorities have long known that the iconic, endangered and loveable panda was an ideal tool for international diplomacy. The modern concept of 'panda diplomacy' came about in the late 1950s, as part of efforts to establish the People's Republic of China on the world stage. This ambassadorial role has sometimes been criticized for blurring conservation needs, but zoos around the world continue to vie for the opportunity to host the animals in specially designed state-of-the-art facilities. It is an expensive undertaking – fees for international zoos can be as much as USD 1 million per year – and discussions over the suitability of a host country can take up to ten years. Even if pandas are born overseas they are always considered Chinese nationals and are destined to participate in China's captive breeding programmes. And yet, the boom in visitor numbers caused by their arrival means there is no shortage of foreign institutions lining up for the privilege of giving a home to a pair of pandas.

Our Psychology and Giant Pandas

little regard

A major reason for our affection for giant pandas may be a phenomenon called *neoteny*, the retention of ostensibly immature characteristics into adulthood. These characteristics include a bulging forehead, round cheeks, big eyes, short stubby limbs and the appearance of a chubby body. Behavioural neotenic qualities include playfulness, clumsiness (in the case of pandas, assumed clumsiness) and a perceived peaceful, happy-go-lucky personality.

However, there is a serious side to our relationship with giant pandas. It may not be something that crosses everyone's mind, but, apart from the panda, how many other species do we announce their birth and death as well as keep tabs on the location of each captive individual? The answer is few indeed. While scientists and conservationists appreciate the attention to work being done to promote awareness of captive

panda issues, it is somewhat disturbing that the focus is on one species, and captive animals at that, with little regard to how this species is doing in the wild. Captive breeding alone will not save wild giant pandas, although it might keep them from becoming extinct. One positive aspect of captive pandas and breeding programmes is that it may help us engender a connection between these animals and people the world over – a feat we wish to accomplish for all species. The concern here is that if we get so wrapped up in one species of wildlife, we may neglect others that desperately need our help and protection as well. The lessons we can learn from pandas can help others, as well as ourselves, to survive. However, we need to be careful not to become preoccupied by pandas born in captivity and get back to helping their fellow creatures too.

end

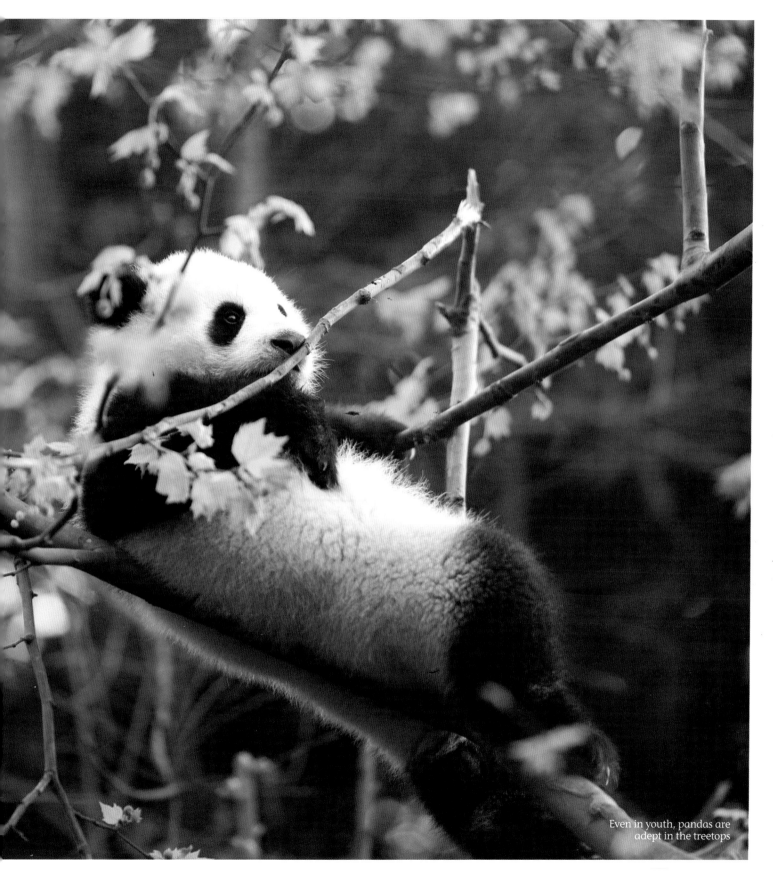

Even in youth, pandas are adept in the treetops

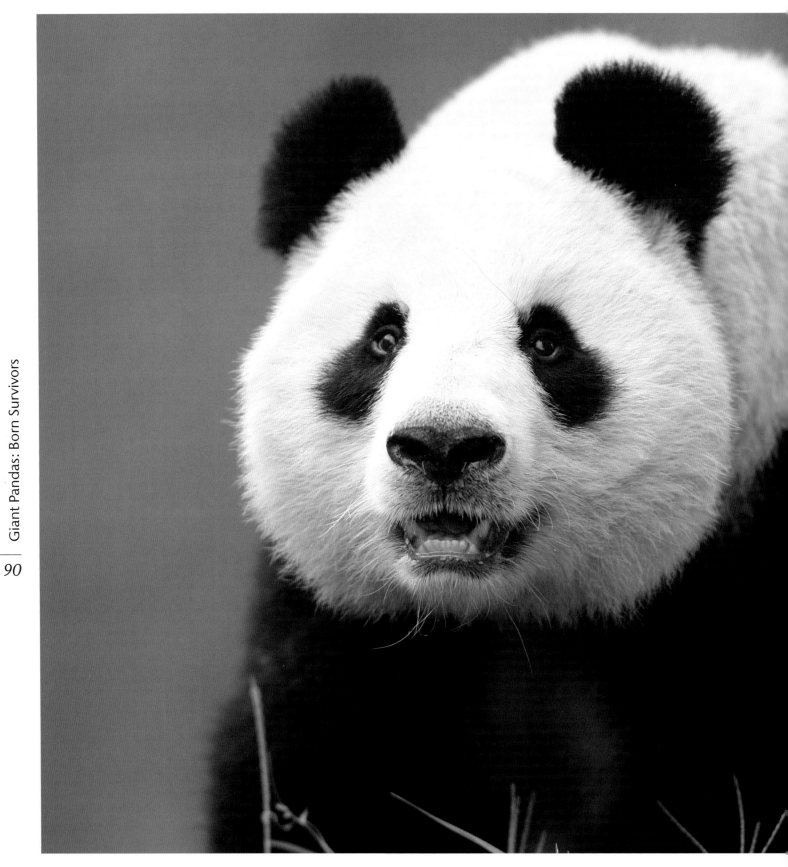

Our Closest Black and White Friends

Cheng Cheng

Cheng Cheng was born on 24 September 1985 to her mother Mei Mei and her father Qiang Qiang. She is one of our oldest giant pandas and she has had an amazing life. She has given birth to eight cubs, seven of whom have survived. Although she is too old to give birth now, she was one of the most fascinating mothers to watch with her cubs. She played often and vigorously with her cubs. We could tell she was teaching them the important things in life, such as how to climb, eat and socialise. She knew how to raise her cubs to be healthy and her son, Shi Shi, is one of the few captive males with the ability to breed naturally.

91

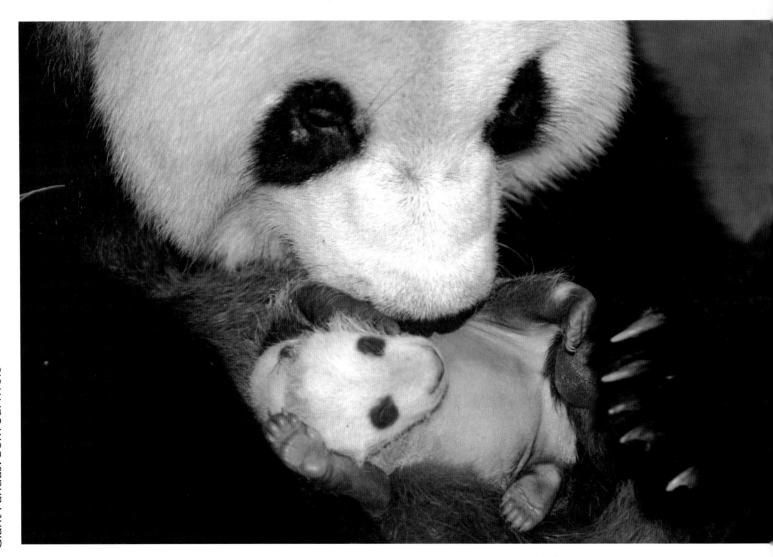

92 **Ya Ya**

Ya Ya was born on 24 August 1990 to her mother Qing Qing and her father Chuan Chuan. She was the first captive twin in the world to survive. As of 2010, Ya Ya had given birth to nine litters with a total of thirteen cubs, twelve of which have survived. Ya Ya is extremely important to the captive population and to the staff of the Chengdu Panda Base because of her willingness to rear both cubs when she gives birth to twins, and because she was the first to help other mothers raise their cubs. Due to her superb mothering skills, the Chengdu Panda Base was able to develop and share the technique of cub swapping so that now, not only do almost all captive-bred twins survive, but so too do cubs that have been rejected by their mother.

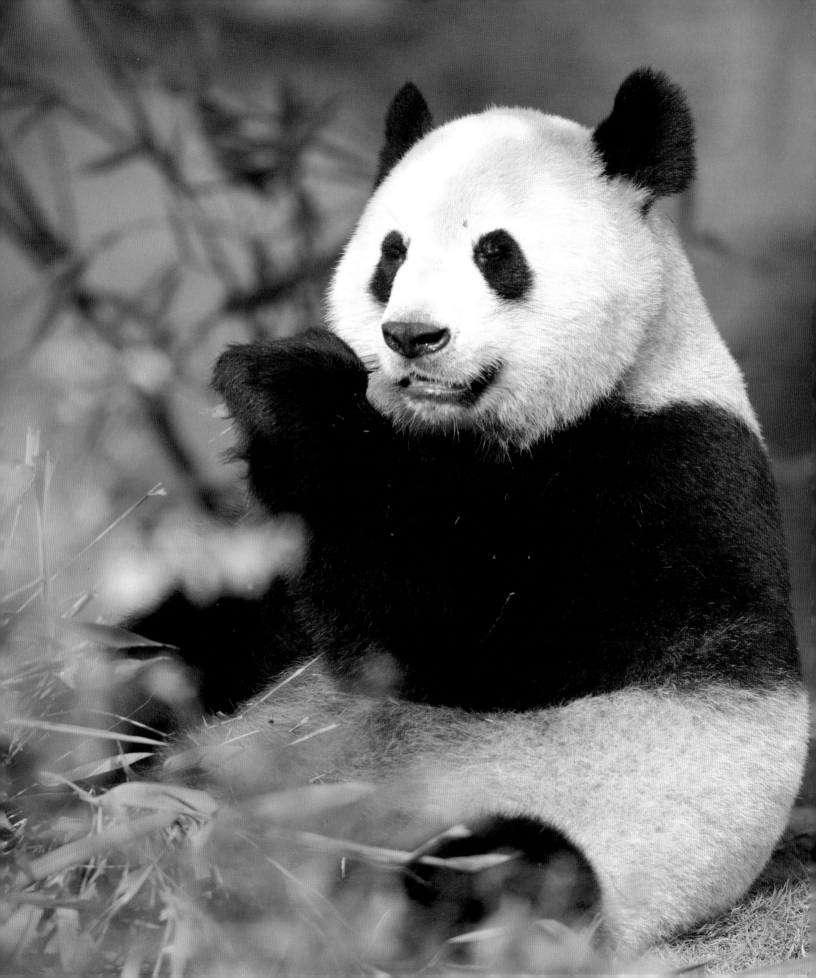

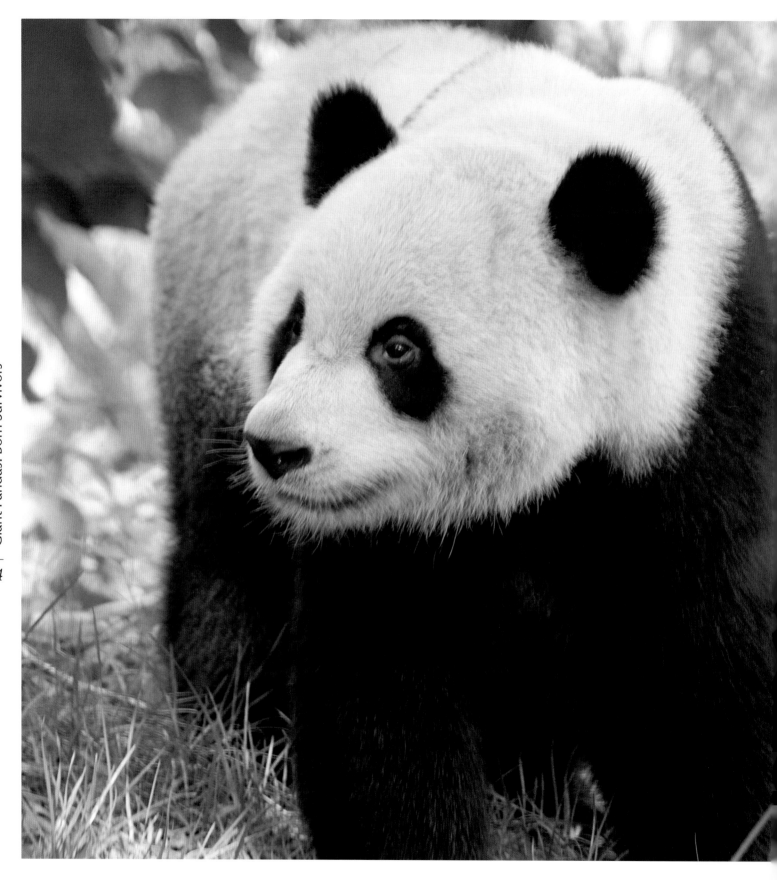

Shu Qing

Shu Qing is one of our excellent mothers. She does, however, have a way of using her cubs to get what she wants. When she is hungry, she will leave her cub on the cold floor and demand food from her keepers by vocalising and banging on the sides of her enclosure. She will not attend to her cub until she gets what she wants. She knows our keepers well enough to know that their priority is the health of her cub.

Shu Qing was born at a Chinese zoo and was initially thought to be a male panda. 'He' was exchanged for a female panda named Ya Laoer from the Chengdu Panda Base. In 2003, our staff discovered that Shu Qing was, in fact, female!

It can be difficult to tell the gender of newborn cubs.

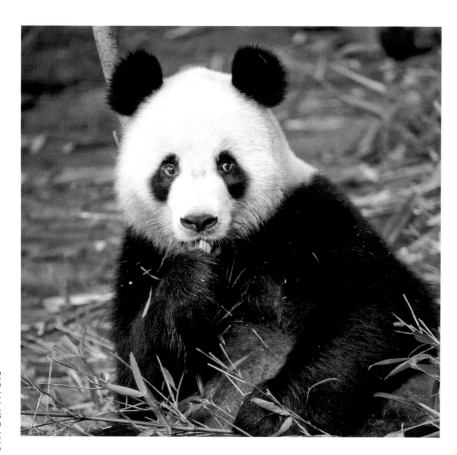

Ya Xing and Yong Yong

As we have established, the time cubs spend with their mother is one of the most important periods in their life.

With the general consensus among scientists that cubs learn some breeding behaviours during the time they spend with their mother, specialist staff at the Chengdu Panda Base have been investigating some practical solutions to allow this to take place among captive pandas. They move sub adult pandas (approximately 2–6 years of age) to the breeding building during the mating season so that they have the chance to be close to different pandas, communicate with others through smell and sound and watch adult pandas mating, just as they would in the wild. Because vocalisations are believed to be crucial for development, staff members also play sounds of natural mating for sub adults so that when it comes time for them to mate, the pandas will not be scared or startled by the noise. These measures give sub adult pandas necessary exposure to the process of natural mating.

One such sub adult is Yong Yong, who was born on 26 August 2004 to Shu Qing. Yong Yong's father, Ping Ping, is from the wild in Shaanxi Province and therefore, his offspring are of high genetic value for the captive population. Scientists at the Chengdu Panda Base attach great importance to cultivating Yong Yong's behavioural competence. Ya Xing, born on 28 August 2002, had been kept in the same enclosure with Yong Yong for several years as a playmate and was exposed to panda behaviour during the mating season. When Ya Xing matured and came into oestrus, she was placed together with Yong Yong. Most adult pandas in this situation would fight, but their years raised in a peer group meant they got along well. Initially they failed to mate successfully – this was, after all, their first experience. Both pandas were patient and didn't leave each other's side for twelve hours until they successfully mated. This event is unique and, as far as is known, could only happen among captive pandas familiar with one another.

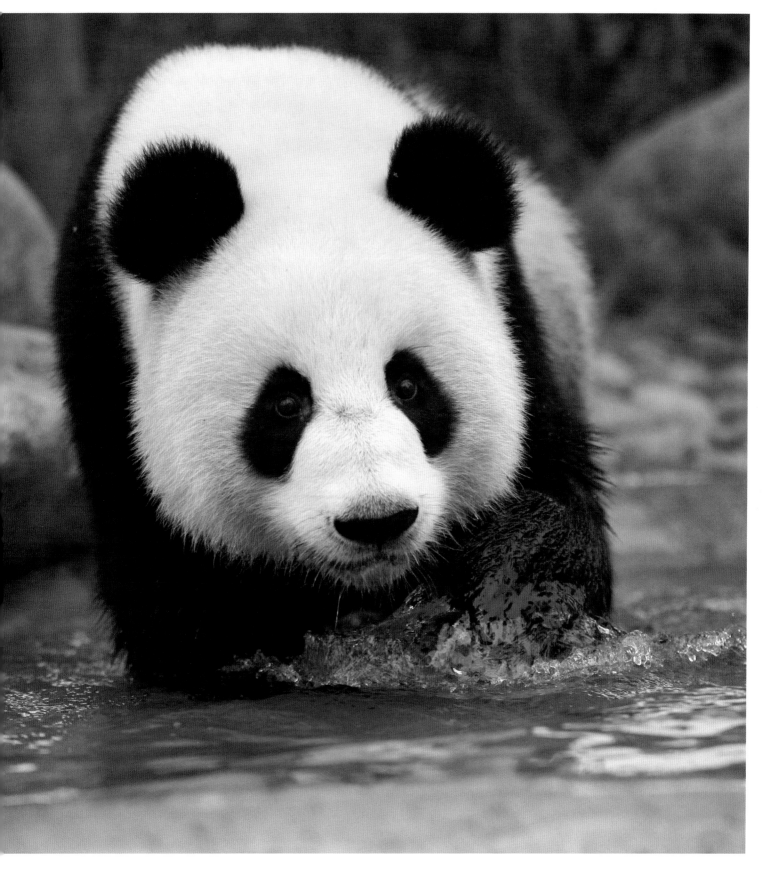

Surrogate Mothers

Cheng Cheng gave birth to Hua Zuiba on 16 September 2003. The mouth of an infant panda is large in comparison to their bodies, but still very tiny. Initially, Hua Zuiba had a hard time nursing from her mother's nipples, so she was switched to another mother, Qing Qing, from whom she could nurse more easily, while Qing Qing's cub, Meng Dou, was nursed by Cheng Cheng.

Cheng Cheng picked Meng Dou up and placed him in her arms, caring for him as if he were her own. This highlights a critical trait of experienced giant panda mothers: they do not care if the cub in their care is their own or that of another female, even a female outside their bloodline. This has enabled caretakers of captive giant pandas to keep many cubs alive who have been rejected by first time mothers.

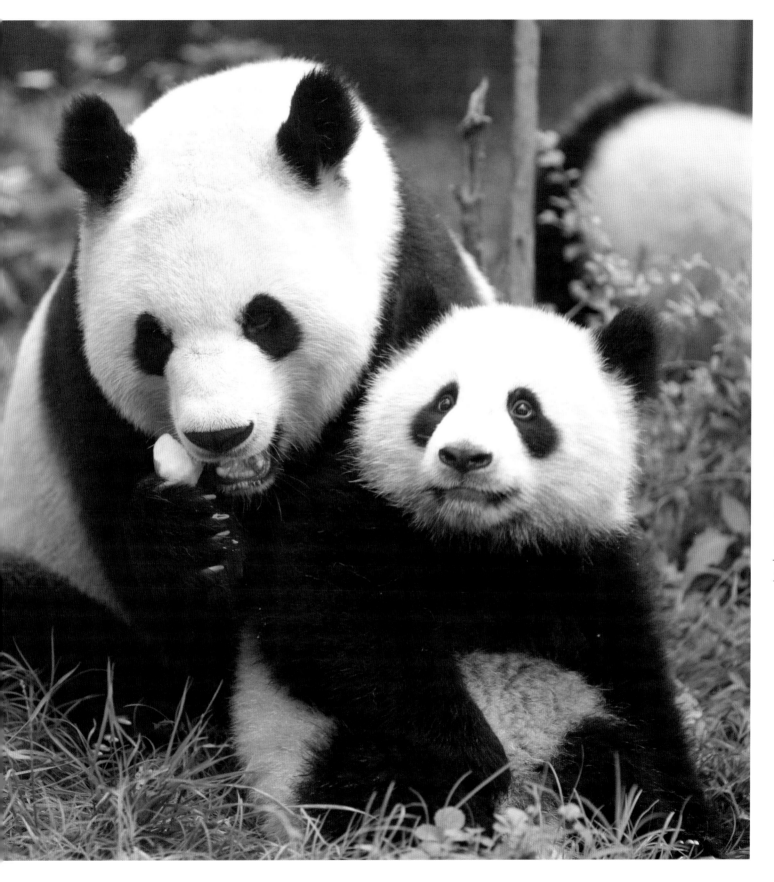

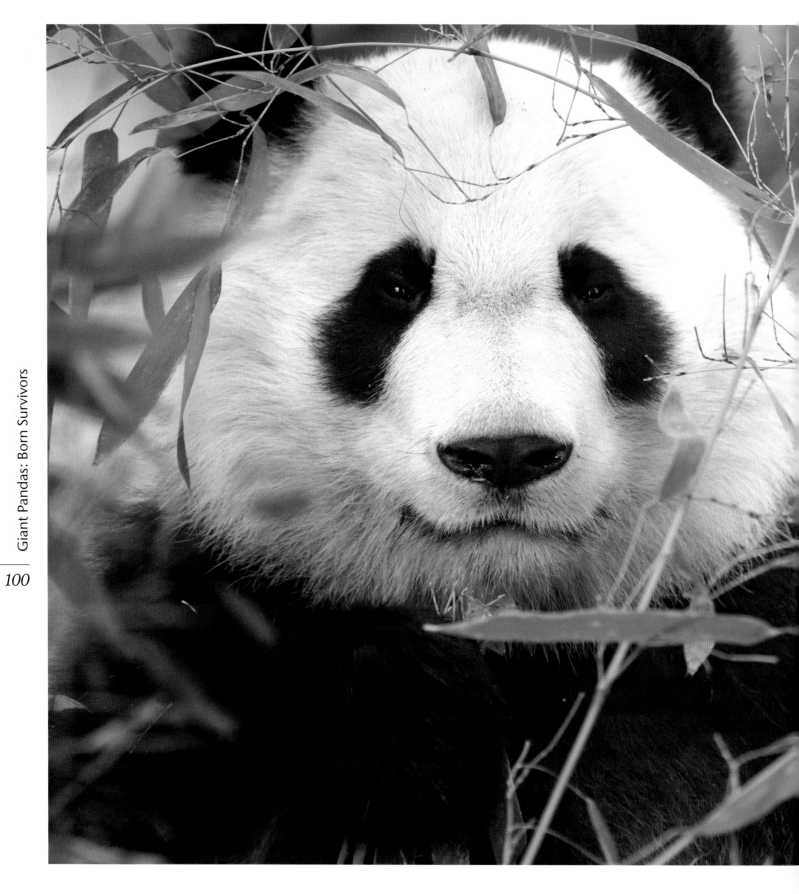

Mei Lan

Mei Lan was born on 6 September 2006 in Zoo Atlanta in the United States. He was the first cub born to Lun Lun and Yang Yang, a pair of giant pandas that moved from Chengdu to Atlanta in November 1999. Mei Lan returned to Chengdu, in February 2010, to join the captive breeding population to help keep genetic diversity as strong as possible.

However, settling in wasn't easy for Mei Lan. In addition to bamboo, our keepers feed giant pandas over 2 years of age roughage cakes made in-house. Unfortunately, when Mei Lan came to China, he had a penchant for a particular type of high-fibre biscuit unavailable in China and he rejected our cakes.

To get around this, our keepers put honey underneath pieces of cake: if Mei Lan wanted to taste the sweet honey, he had to eat some of the cakes first. The keepers gradually increased the size of the cake pieces and soon they tried to feed him whole cakes. At first he refused to eat them unsweetened, so keepers had to soak them in honey before Mei Lan would accept them. Gradually though, Mei Lan got used to eating our cakes. Humans aren't the only ones to experience culture shock.

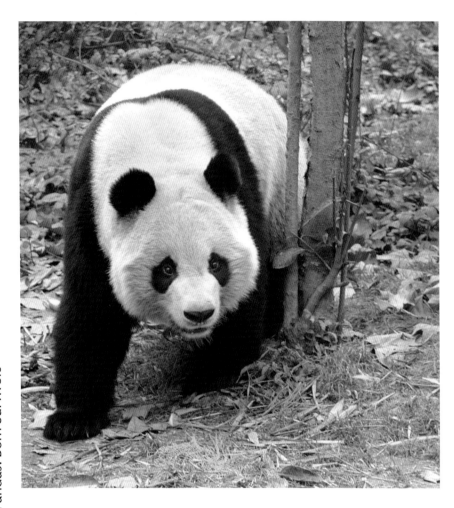

Twins and More Twins

On the 6 and 7 August 2006, twin female giant pandas, Qi Zhen and Qi Yuan, each gave birth to twins within twenty-four hours at the Chengdu Panda Base, a first in the history of giant panda captive breeding.

In March that year, Qi Zhen and Qi Yuan reached oestrus at nearly the same time. The researchers who had been monitoring the twins' oestrogen levels put several male giant pandas that were ready to mate in the adjoining enclosure. After a gestation period of about 150 days, the younger twin, Qi Yuan, gave birth to twins. According to her oestrogen levels, Qi Zhen, the older twin, should have given birth a few days later. However, Qi Zhen went into labour and delivered twins ten hours after Qi Yuan. One of her twins weighed only 51 grams, the smallest cub ever born in captivity in the world.

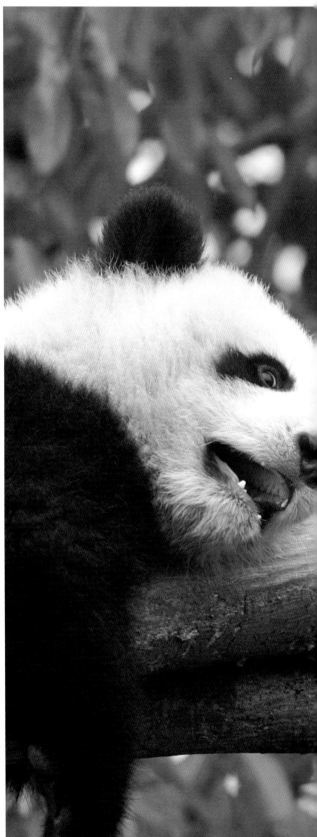

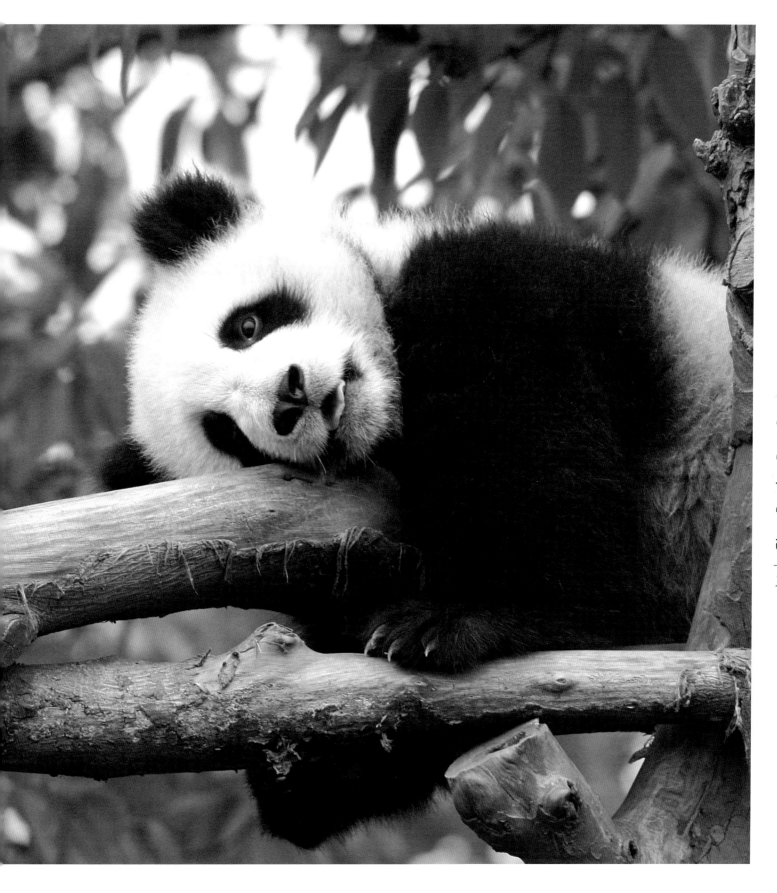

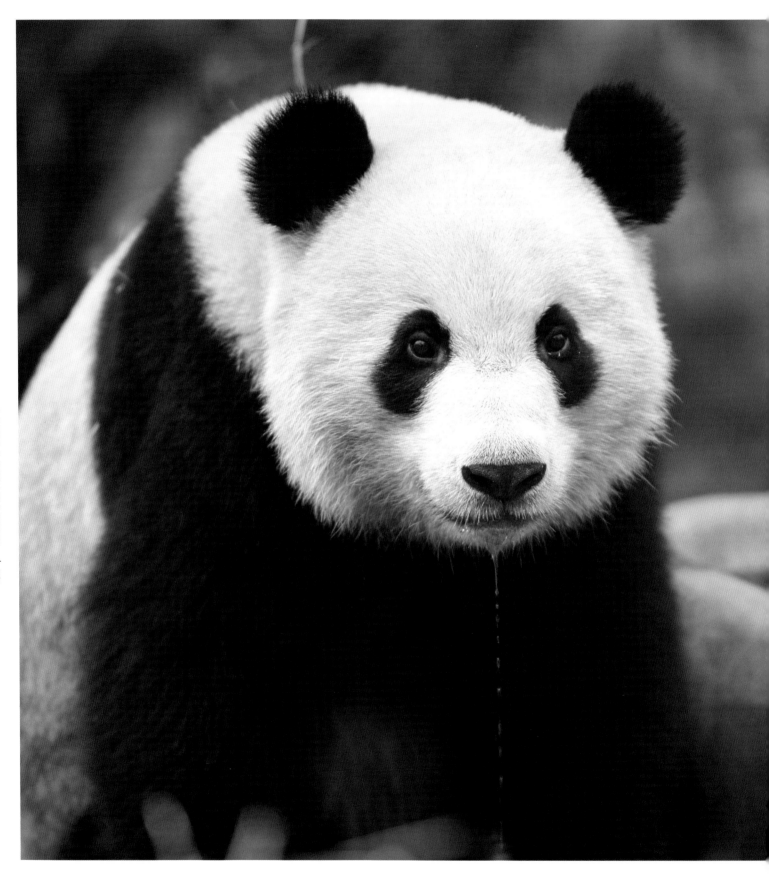

Wu Yi, a.k.a 51 Grams

Wu Yi and his twin brother, Zhen Da, were born on 7 August 2006 to their mother Qi Zhen and their father Lin Lin. Wu Yi had a very rough start in life because he was born weighing only 51 grams (100 grams is the normal birth weight of a giant panda) just one-third of his brother's weight. There was a lot of concern that he would not survive.

Due to his small size, his birth was over very quickly and he ended up on the cold floor. The staff at the Chengdu Panda Base immediately took him out of the enclosure and placed him in an incubator. His body temperature had dropped to under 34°C and he was in extreme danger. Three hours later, however, his body temperature rose back to normal levels.

Because he was too small and weak to be nursed by his mother – it is critical to have mother's milk to survive – our keepers took great risks to get milk from Qi Zhen and patiently fed Wu Yi with a milk bottle made especially for him. It took over an hour for him to drink one millilitre of milk. For the first three days he was dehydrated. The staff of the Chengdu Panda Base worked around the clock to take care of him. Today, what was 51 grams is now 98 kilograms.

Xiang Bing

Xiang Bing was born on 30 June 2007. At 4 months old she was very inquisitive and full of energy, taking every opportunity to run around her enclosure. In fact, her curiosity did not end at the perimeter of her enclosure. She appeared determined to climb through the railings to look at the outside world.

To try and curb this behaviour, Xiang Bing's mother, Bing Bing, picked her up and held Xiang Bing in her mouth. Xiang Bing tried to escape by wiggling around, but after a while, she stayed still and let her mother carry her around without resistance. Bing Bing, believing she had shown her daughter who was boss, then put her down.

However, once Bing Bing had moved away, Xiang Bing turned over and got up. She made a beeline straight for the fence and stuck her head through it. Bing Bing returned at once, and dragged Xiang Bing back to safety. Then Xiang Bing seemed to calm down once again, but as soon as Bing Bing left her, Xiang Bing raced to the edge of her enclosure. This went on many times, leaving the keepers bemused, as they had never seen a young panda so adamant to explore.

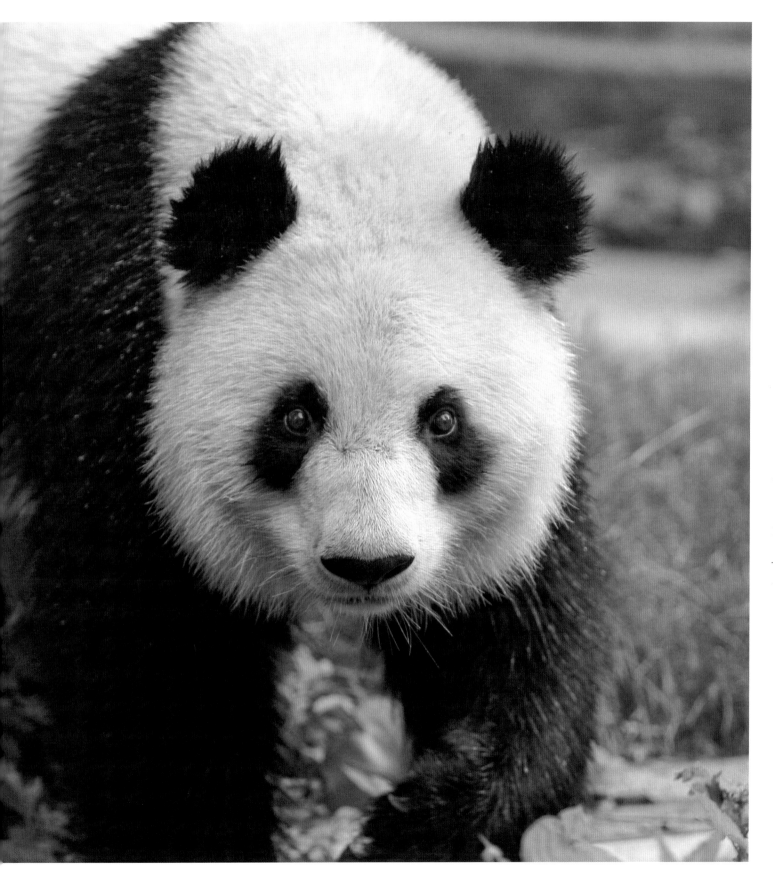

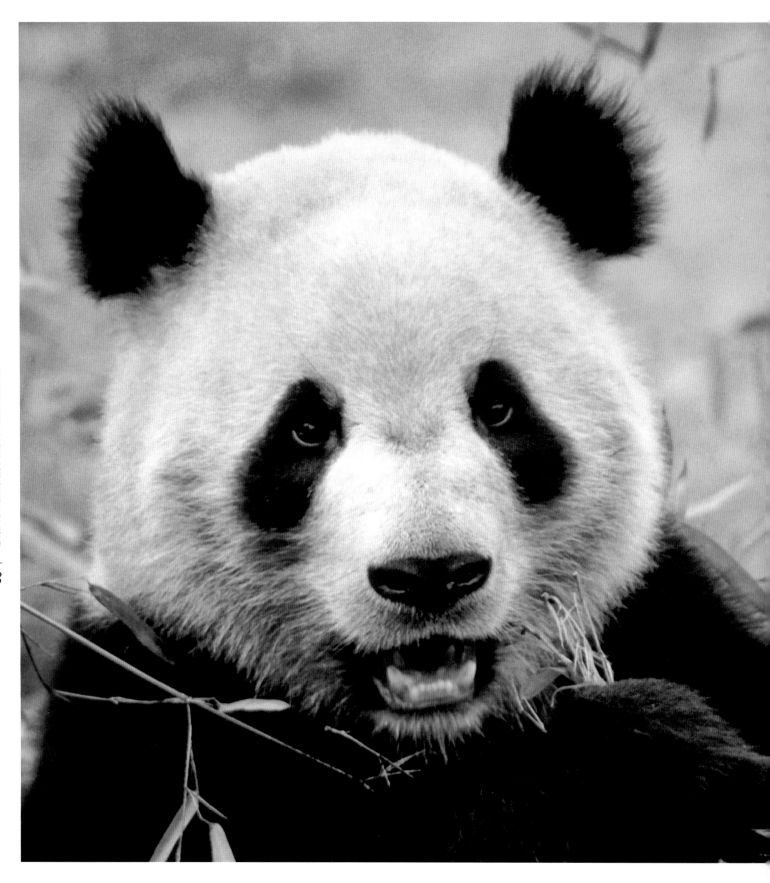

Shi Shi

Shi Shi was born on 10 September 1998 to his mother Cheng Cheng and his father Ha Lan. Shi Shi is strong, independent and wise. He had a wonderful upbringing by Cheng Cheng, staying with her for eleven months, much closer to the normal time cubs spend with their mother in the wild. He is incredibly important to the captive population because he is one of the few captive males alive today who will naturally mate and the only captive-born male who successfully mated at 4.5 years old, the earliest age that has been observed that males can mate naturally.

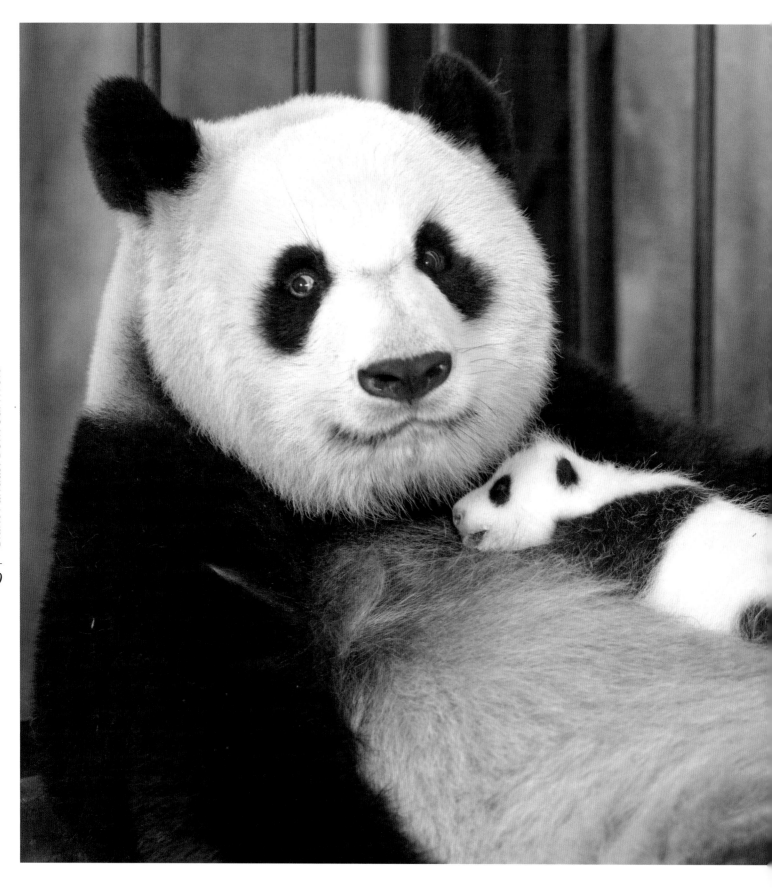

Qi Zhen

Qi Zhen was born on 4 August 1999 to her mother Mei Mei and her father Ha Lan. Mei Mei was a first-time mother and was actually frightened of Qi Zhen's loud crying immediately after her birth. Mei Mei was so scared that she tried to bat Qi Zhen away with her huge paw. Her swipe caused a cut on Qi Zhen's chest and there was concern she would die. Her keepers quickly removed Qi Zhen from Mei Mei's enclosure, risking their own lives. Veterinary staff were able to stitch up Qi Zhen's injury and named her Qi Zhen, which means seven stitches and, if pronounced slightly differently, rare treasure. As of 2011 Qi Zhen had given birth to four litters with eight healthy cubs, all of whom have survived.

Jing Jing

Jing Jing was born on 30 August 2005 to her mother Ya Ya and her father Kobi. From the start she was treasured as she was the only cub born at the Chengdu Panda Base in 2005. She is a very famous giant panda because she was chosen as the living mascot for the 2008 Beijing Olympics. She symbolised the black Olympic ring and one of the 'Five Friendlies' who represented different endangered species of China. She is an adept climber and at only 4 months old she could climb very tall trees. This is the youngest age known of a panda cub in captivity being able to climb. To read all about her, check out the children's book *Watch Me Grow Panda*, which chronicles her early life growing up with Ya Ya.

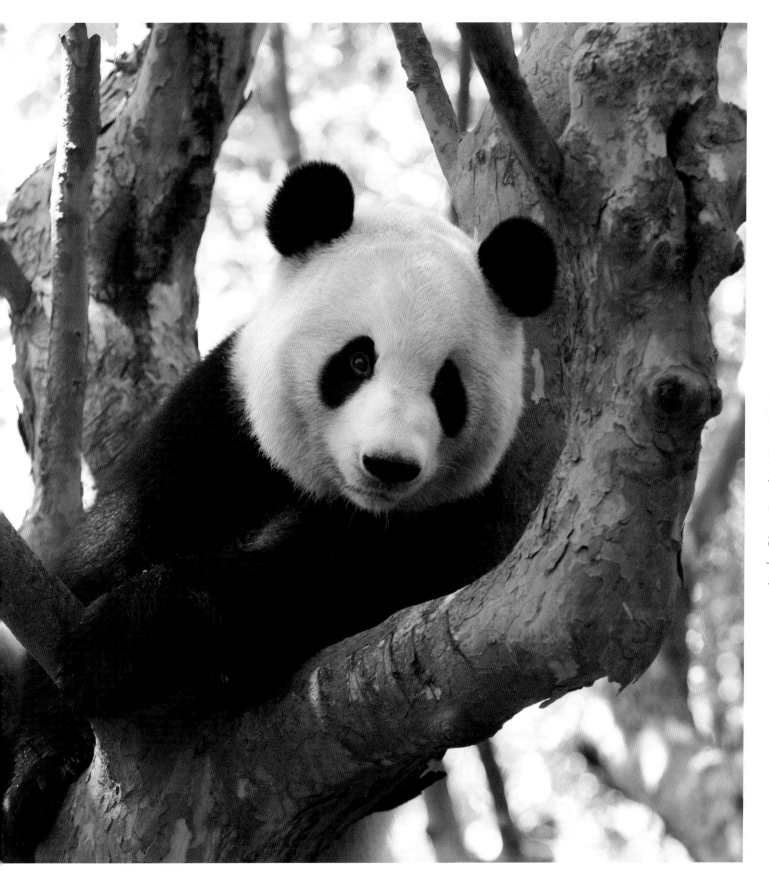

A Matter of Life and Death

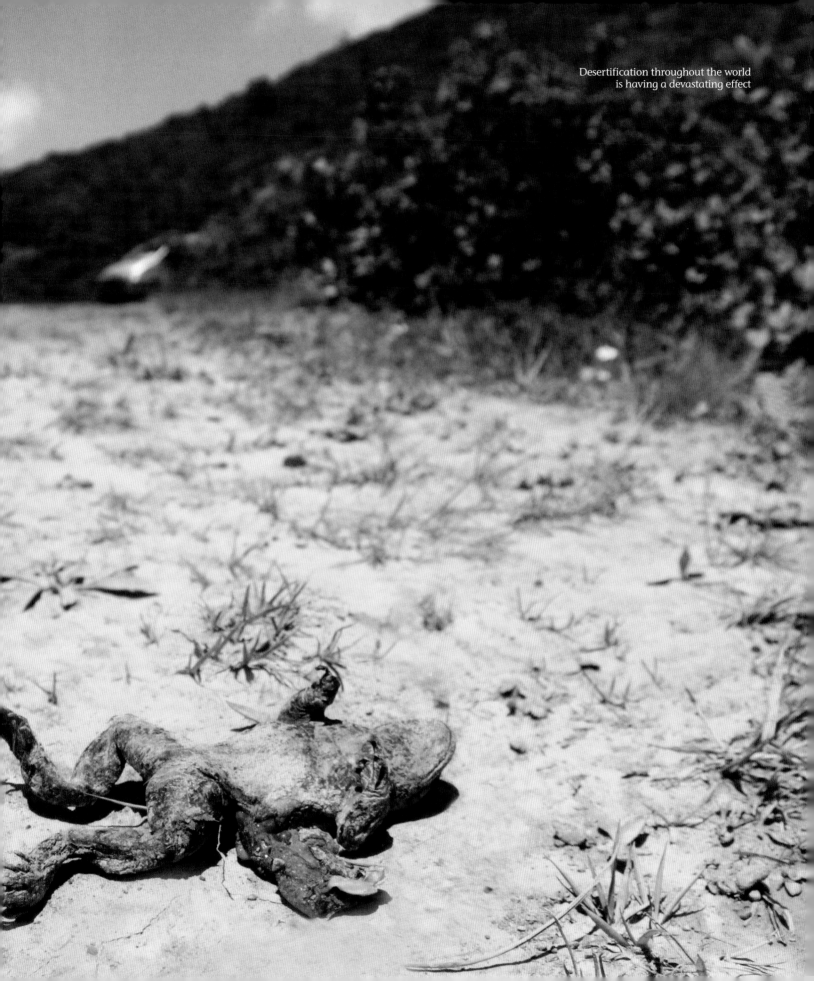

Natural Extinction

Extinction is a natural process, which may cause one to question the rationale behind conserving endangered species. However, current rates of species extinction are greater than anything experienced on Earth since the cataclysmic natural event that caused the eradication of the dinosaurs 65 million years ago.[1] Extinction was once solely a natural phenomenon, and it is widely accepted that more than 99 per cent of all species that have ever lived are now extinct.[2]

Extinction occurs when a species is unable to adapt to its changing environment. Mass extinctions, such as the one we are currently experiencing, are relatively rare events, whereas isolated extinctions are quite common. Scientists estimate that most species that have vanished from our planet have never been documented, and that over half of the currently existing species may become extinct by 2100.[3] Moreover, there is a strong tendency for dismissal by the public of any personal responsibility in species extinction. The public finds comfort in leaving it to the scientists to 'fix' such things as global climate change, species conservation and restoration of biodiversity. You may be thinking, 'well, humans are the superior competitor in this Darwinian survival of the fittest,' and you'd be right to a certain extent. However, it is urgent that humans come to understand that it is biodiversity in all its enormity and complexity that allows for our existence. It is biodiversity that provides

Above and opposite page: Baihe Nature Reserve, Sichuan Province

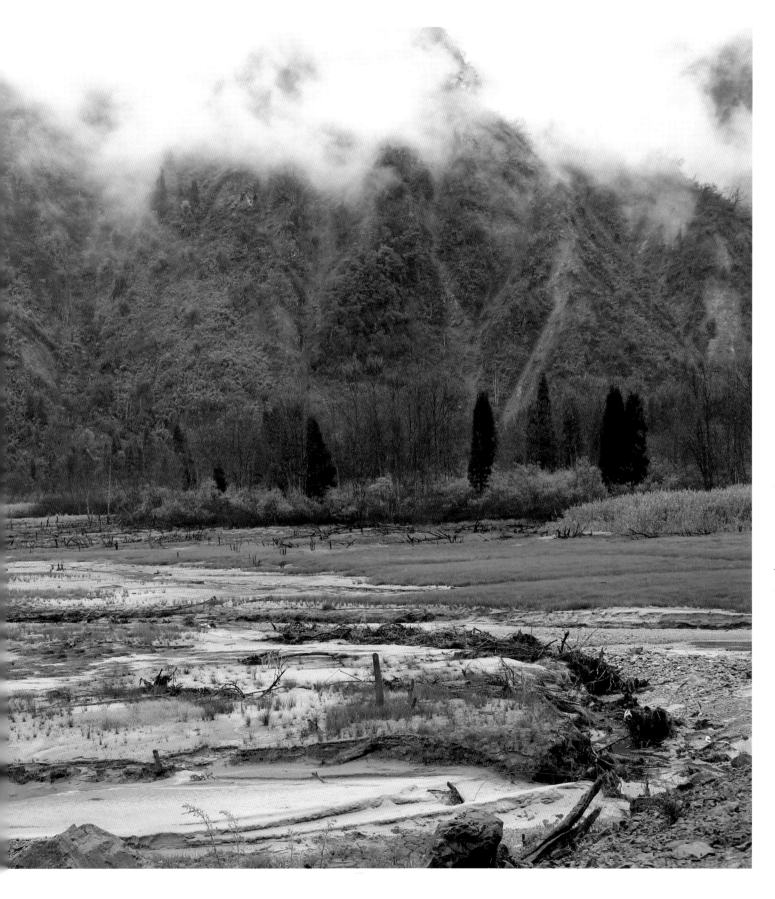

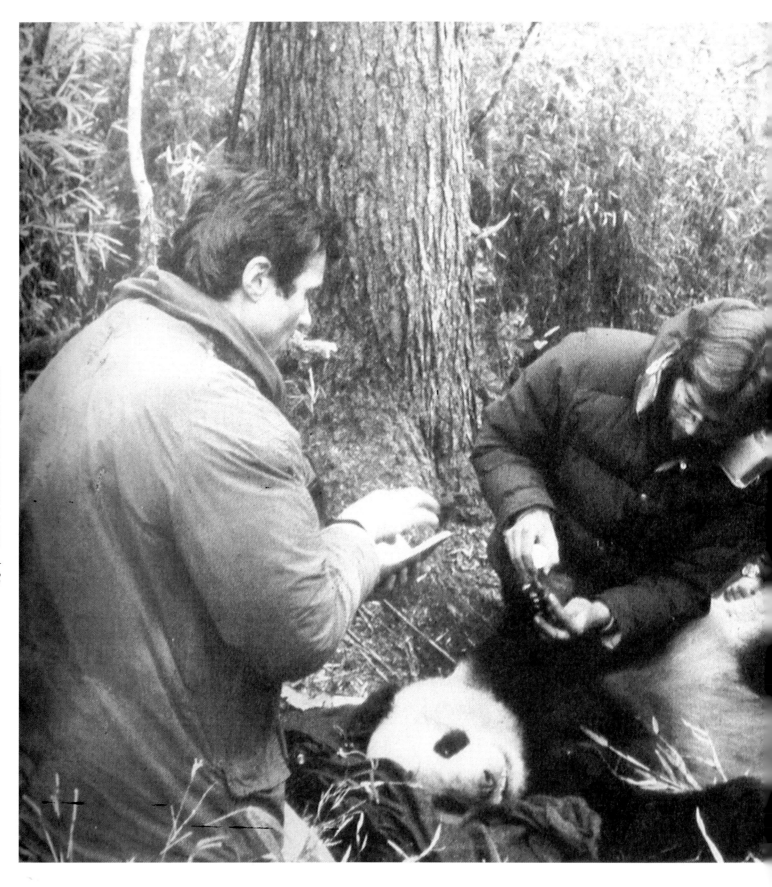

Above: Panda conservationist Yong Yan'ge and his field assistant in Foping Nature Reserve
Left: Renowned panda specialists, George Schaller (left) and Hu Jinchu (far right), examining a sedated panda in the wild

and cleans our air and water, gives us food, protects us from disease, buffers our storms and provides us with beauty and places of solitude. Our species cannot survive without biodiversity. Therefore, it is imperative that we are wise and compassionate and take a look at the bigger picture.

As early as 1946, the people of China became aware that the giant panda's existence was threatened, when the headline 'Panda on the Brink of Extinction' appeared in the *Ta Kung Pao* newspaper. At that time, the decline was attributed to intensive capture and it was predicted that if this behaviour continued, giant pandas would become extinct.[4] This threat to the giant panda's existence ushered in a new era of thought regarding giant pandas. Previously they were appreciated only for their valuable pelts and as zoo specimens, but as a result of this news, authorities began to think about the establishment of nature reserves. Nature reserves are the crucial basis of giant panda conservation. The first four giant panda nature reserves, Wolong, Wanglang, Baihe and Labahe were established between 1963–65. Initially, the combined protected areas of these four reserves equalled 918.97 square kilometres. Since then, over sixty giant panda nature reserves have been established in Sichuan, Gansu and Shaanxi provinces primarily for the protection of giant pandas.

Biodiversity Crisis

'ie predicament

You might be asking yourself why we are discussing something as horrifying as global mass extinction in a book dedicated to giant pandas. Pandas are one of the countless species that is a victim of human behaviour. In order to understand the dire predicament we have forced giant pandas into, it is only ethical to put their situation into a global context. It is also imperative that conservationists help people understand that their behaviour has an impact on giant pandas and all the other plants and animals. If the problems are not discussed, how can caring individuals help?

Biodiversity is a term that encompasses the total amount of living organisms on Earth at the genetic, species and ecological levels.

The biodiversity crisis that we face today is partially the rationale for the production of this book. In the past, the main driving force behind environmental conservation was ethical. Scientists now believe that biodiversity loss may pose the greatest threat to human survival and that this issue requires our urgent attention. Biodiversity loss causes the biosphere to destabilise, which interferes with the recycling of vital elements such as carbon, nitrogen and phosphorus. The result of accelerating an irreversible extinction could lead to wholesale ecosystem collapse.[5] If at this point there is any doubt as to whether or not you should be concerned, we will be blunt: we depend on Earth's ecosystems for survival. Earth *is* our life support system.

Another concern of conservationists is the commonly held misconception by the public that science and technology can overcome the environmental degradation we see all around us. As early as 1992, the US National Academy of Sciences and the Royal Society of London issued a joint statement warning against this way of thinking. It is difficult to grasp what is at stake, and it is critical that awareness and action campaigns, as well as education programmes are developed to affect human behaviour on a global scale.

We may also need to remember the intrinsic value of organisms and their right to exist, as well as human need for natural areas and a connection with animals. Scientists such as Stephen Kellert and Edward O. Wilson have written about the human requirement for natural places, while scientists such as Gene Myers and Gail Melson have written about our need, and especially children's need for animals in our lives.

The strength of global biodiversity today is the result of 3.5 billion years of organic evolution, and even with unique human ingenuity, those processes cannot be replicated.[6] If, as some predict, two-thirds of living species are lost over the course of the next century, that proportion will be more or less equivalent to

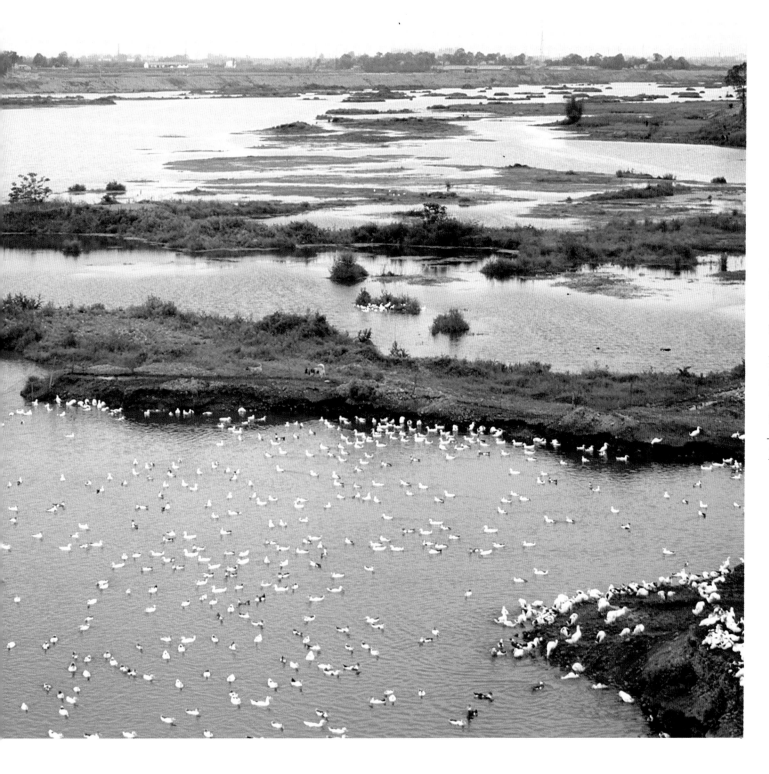

Industrial scale duck farming causes severe
pollution of its nearby rivers and lakes

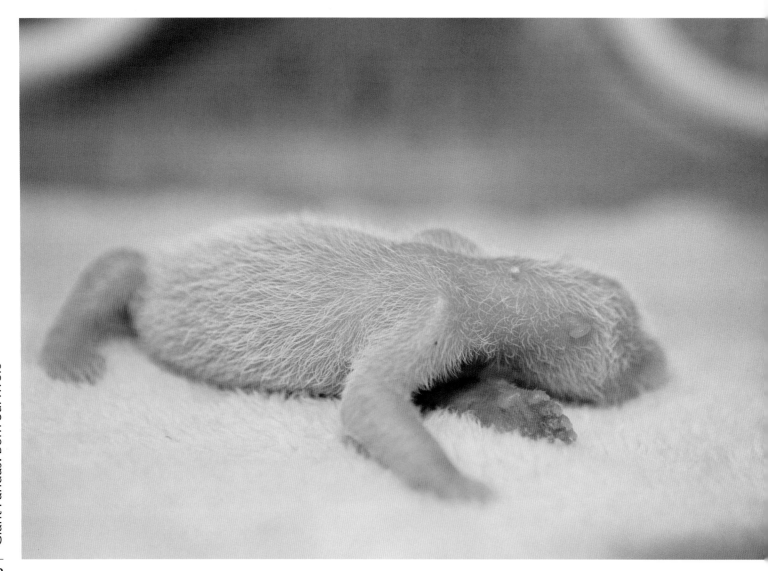

that which disappeared by the end of the Cretaceous period, the age of the dinosaurs. The dramatic changes at the end of this period were caused by severe climate change, a fall in sea levels and high volcanic activity. It took more than 5 million years for Earth to regain its current ecological equilibrium, more than ten times the length of human history. [7] This loss of biodiversity should be of concern as it will greatly limit our options in the future for necessities such as clean water and air, secure food sources, fibres for clothing and structures and healthy soil.

There is an ominous lack of awareness of biodiversity loss around the globe. If the majority of people are unaware of a problem, gathering an organised collective to address the issue will be nigh on impossible. Researchers from various fields have suggested that an international initiative is needed to make humans aware of this loss of biodiversity and to take immediate action to reverse our course. We need to work together.

Above: A new bor giant panda
Opposite page: A young cub roaming in the wi

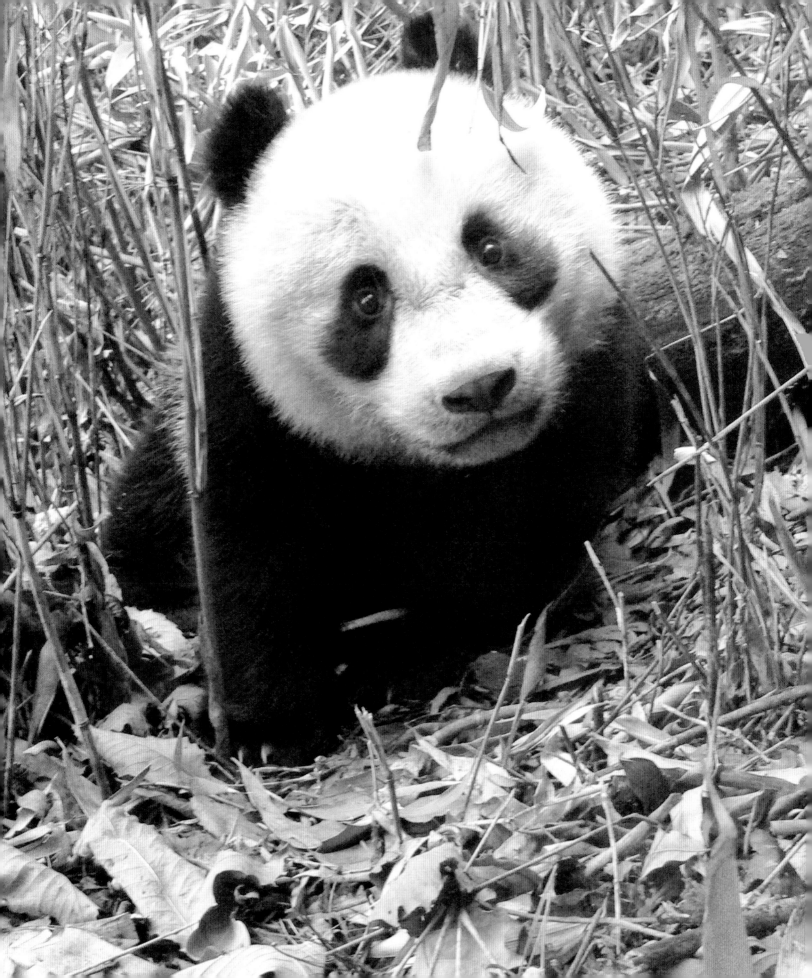

China and the Biodiversity Crisis

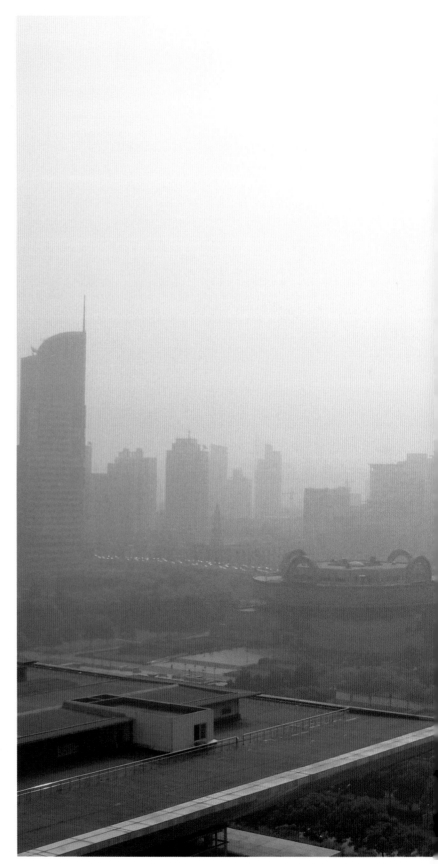

Over the past forty years, China has transitioned from a centrally planned economy to a socialist market economy, which has lifted millions of people out of poverty. However, these benefits have brought with them extraordinary environmental damage. The condition of China's natural environment today is extremely sobering. The cost of supplying the world with cheap resources, goods and labour has been the dramatic degradation of the environment. However, the origin of the environmental crisis in China predates modern times. The country's history has been intimately interwoven with its environment, and citizens have garnered a living from nature just as in other societies. Urbanisation and globalisation have allowed citizens to live separate from the Earth and, as a result, traditional land ethics have been lost throughout most of the world.

Problems such as desertification, salinisation, acid rain, climate change and the damming of rivers have long plagued China. At present, the effects of pollution on human and environmental health are pervasive problems globally, and are highly exacerbated in China. Rapid developments combined with a surge in human population are root causes affecting the country's environmental and biological health. It would be unfair to forget the international pressures on China's environment. When we purchase

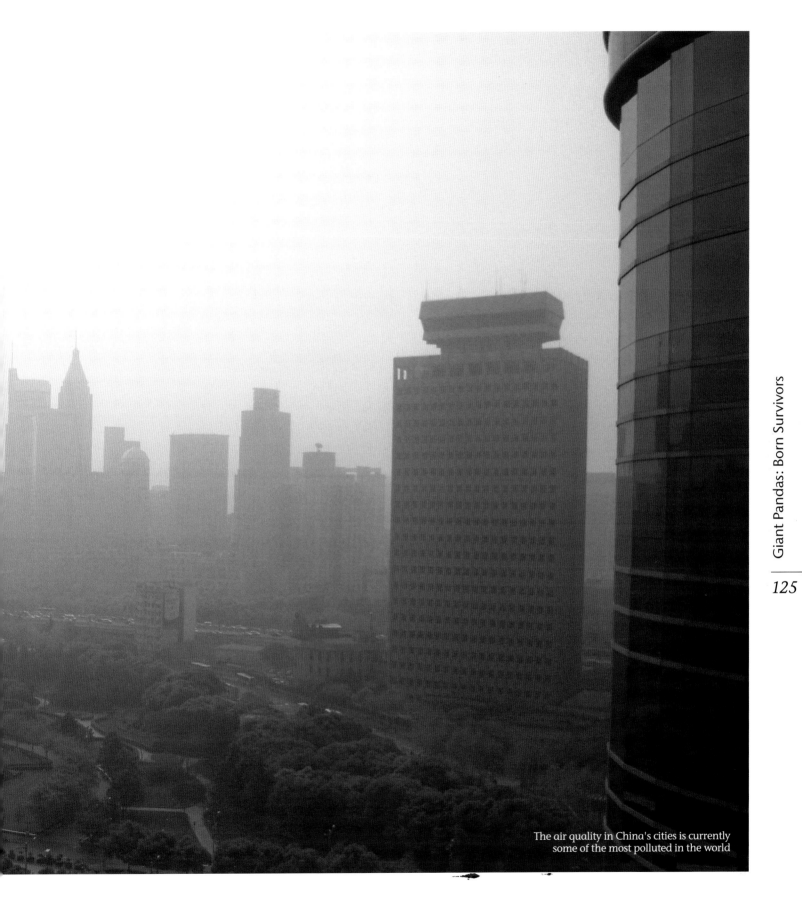

The air quality in China's cities is currently
some of the most polluted in the world

Traditional farming in Shaanxi Province

inexpensive goods made in other countries, we all contribute to environmental damage. China's natural areas are protected. However, local people have always depended on natural resources such as bamboo, wild vegetables and wood for heating and cooking – as has been the case worldwide. Protecting these natural areas is difficult because they are already in a highly depleted state, with pressures mounting for more development. It is not only wildlife that suffers but also the poorest people and those already marginalised. Unfortunately, nature reserves are often viewed as a barrier to local resources rather than as a source of pride.

A major issue facing China, as well as the global populace, is not only ignorance of the extent of environmental issues we all face, but also the effect these issues have on individual health. No solution to Earth's environmental problems is possible without the inclusion of China. In the interests of a balanced discussion, the West is also an instigator of tremendous

pollution, such as large, inhumane and grossly polluting factory farms that produce meat, eggs and dairy products.

Another growing concern is China's impact on wildlife in other countries, such as the consumption of wildlife for anything from food and medicine, to luxury items like fur and skins, and the entertainment industry including zoos, circuses and wildlife parks. Threats also come in the form of the natural resource needs of China's expanding human population, and the growth in wealth that is fuelling new consumption patterns toward more western lifestyles. The global media, economists, politicians and environmentalists are watching as China searches the globe in order to secure access to these natural resources. This trend should drive Western nations to start setting a better example of sustainable living for countries that simply want to have the luxuries and lifestyles that are enjoyed in developed areas of the world.

Left: Biodiversity provides healthy soil and fresh water for rural villagers, such as these in Shaanxi Province
Right: This abundant harvest is due to hard labour, healthy soil and sufficient freshwater

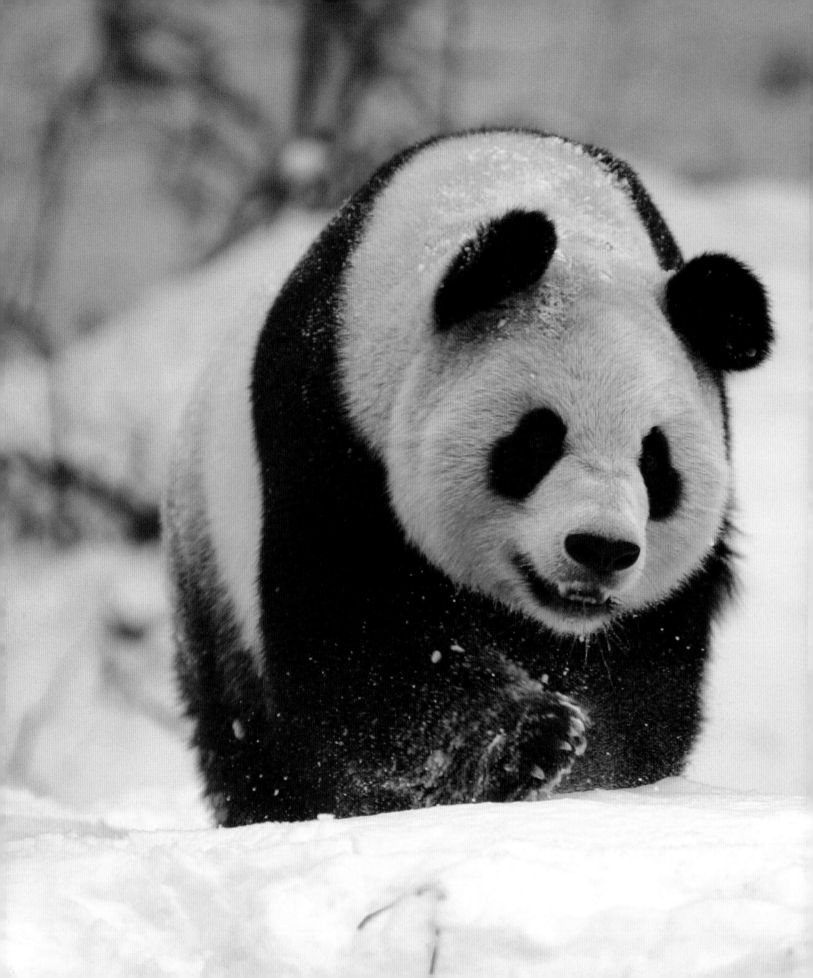

An adult giant panda running through the snowy landscape in Southwest China

Stoic
Survivor

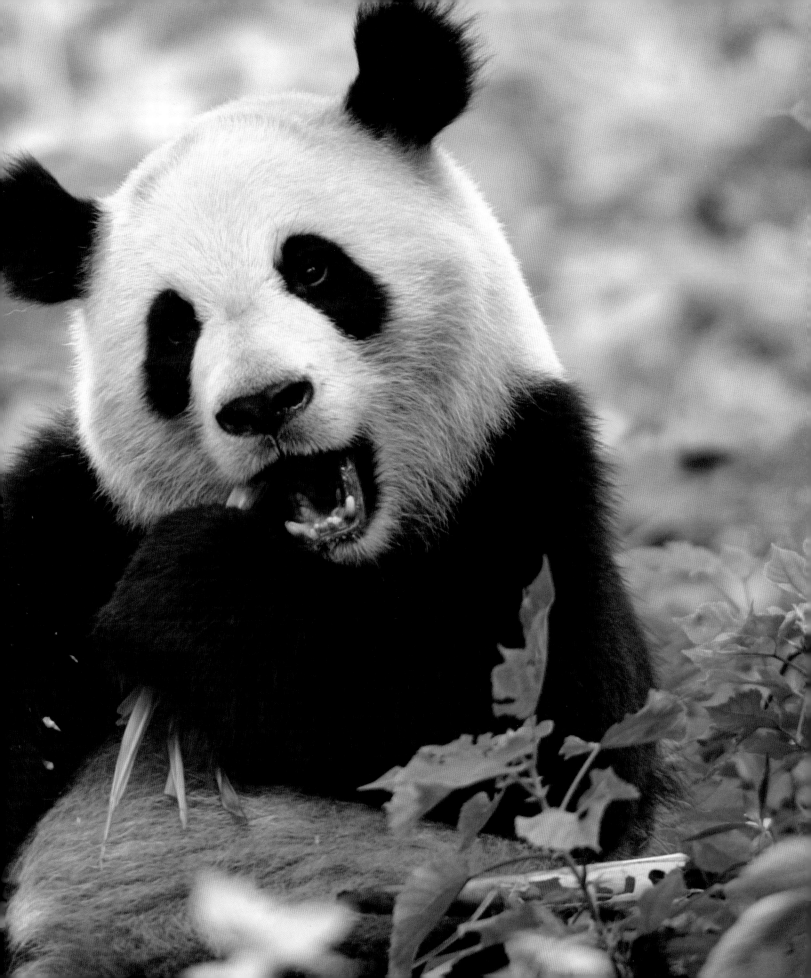

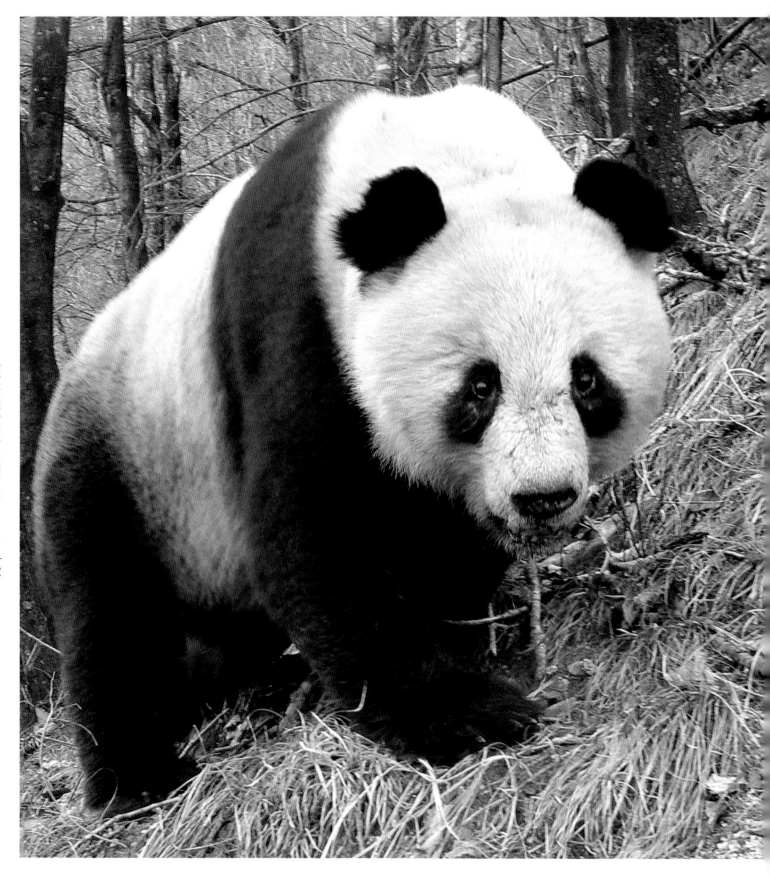

What does our Treatment of Pandas say about us?

On the one hand, we regard giant pandas with great esteem and adoration, while on the other hand we are the architects of their demise. It is fairly clear that human behaviour is the main obstacle in our attempts to save giant pandas and many other amazing forms of life on Earth, such as elephants, whales and gorillas, to name but a few. If you are reading this book, it is likely you love and respect all of these life forms and want to protect them from harm. You most likely also enjoy the time you can spend in natural surroundings – a luxury and blessing that fewer people around the world have.

However, if you were to examine your own lifestyle and learn about the connection between your daily acts and the damage to the environment, you may be shocked by what you find.

Take, for example, the simple act of buying a hamburger. First, the bun: In almost every case the flour and sugar are produced on an industrial scale that is unsustainable and in soil that is tired and in need of fertilisers. To protect these crops from 'pests' they are sprayed with herbicides and pesticides – killers not just of the pests they are intended for. Another harmful aspect is the enormous amounts of water needed for these crops to grow. To top it off, all these items are shipped to the factory – using fossil fuels – then more energy is needed to make and cook the buns. The lettuce and tomato on your burger may seem the most innocuous components. However, if they were not grown locally and organically, they'll require shipping, herbicides, pesticides and fertilisers. Now, for the actual flesh on your burger (this is not for the squeamish). Much of our inexpensive meat today is from factory farms or from cows raised on cleared rainforest land. In a factory farm, cows and their calves live a life that is inhumane and cruel. In fact, it is common for people who have visited them to refrain from eating meat again. Even if you are not sympathetic to these innocent animals you would be appalled by the amount of damage these factory farms do to the environment through pollution and the draining of important local resources. If your burger came in some kind of disposable container ... well, we think you get the point. All of this for you to eat something that increases your risk of heart disease, cancer, obesity and diabetes. What have we been thinking? Well, in truth, we haven't been, and some media and advertisers would like to keep us this way. Buying a hamburger is just one example of how our behaviour affects the lives of plants and animals. Everything we take from the land takes away from others. There are always more responsible, humane, compassionate and healthy options for us in our daily lives that we need to choose before it is too late.

Opposite page: , wild panda who as survived hard mes in Foping Jature Reserve

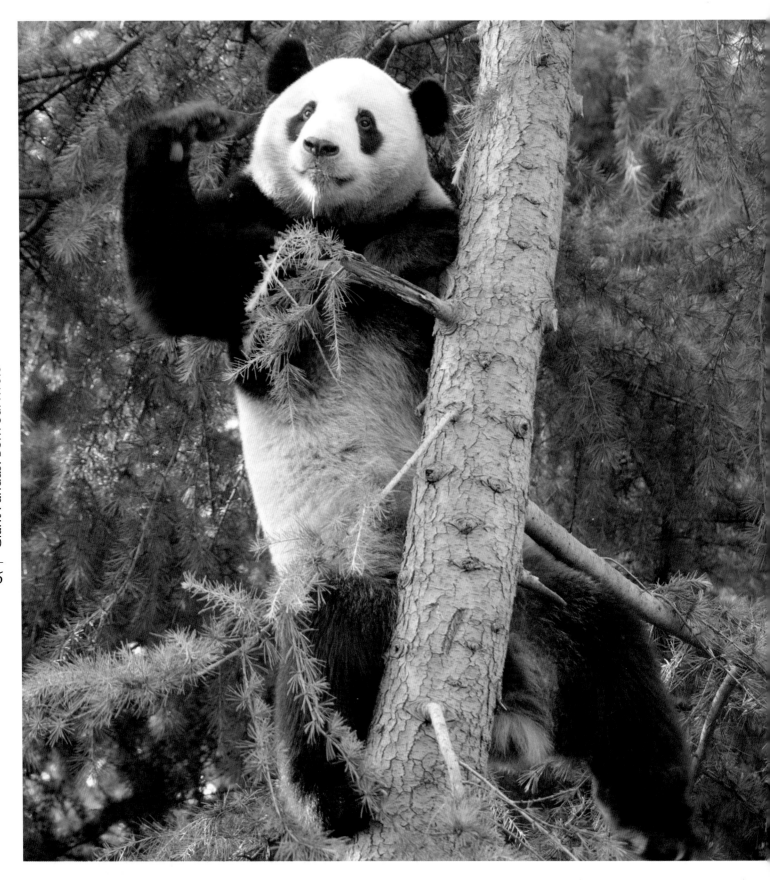

Threats to Giant Pandas

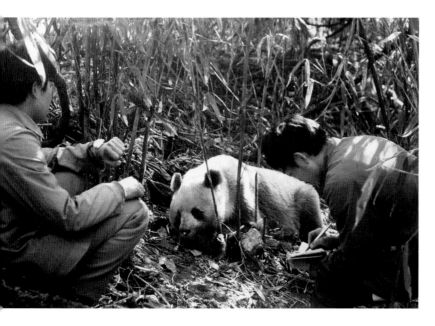

bove: A panda
found dead in
e wild
pposite page:
captive panda
imbing in its
closure

Ever-expanding human settlement is undoubtedly leaving its mark on giant panda habitat. The region pandas inhabit was especially devastated by deforestation prior to a government ban on commercial logging in 1998, which is still enforced today. Thankfully, a few remote areas were spared and these harbour some of the most universally recognised species on the planet. As discussed earlier, other rare and endangered mammals such as takin, red pandas and golden snub-nosed monkeys also dwell in the region. The area also holds a diverse range of birds, amphibians and reptiles, including the Himalayan griffon vulture, golden pheasant, Chinese giant salamander and the pearl-banded rat snake.

Due to its steep terrain and inaccessibility, the region once held great expanses of intact land with virgin forest and unique traditional human cultures whose impact on the land was sustainable. However, it is currently under severe threat from economically driven human activities spurred on by external demand for natural resources, as well as the increasing desire of locals to better their lives.

Broadly speaking, local people are simply trying to make a living or raise their standard of living, while the real devastation comes from global industries that are supplying our ravenous appetite for natural resources. We are failing to make the link between our demand for material goods – the vast majority of which we do not need – and the reality that everything we purchase uses natural resources that others depend on for survival.

Mining

Mining poses a series of problems for giant pandas and their habitat. Degradation of vegetation as well as toxic soil, water, air and noise pollution all threaten the area's biodiversity.

Dam construction

Dam construction blocks the natural path of a river. Once a dam is completed, habitat in the upper region of the river is submerged, while the flow of the river in the lower region is greatly reduced. Dam construction also forces human and non-human immigrants to move into areas with rich natural resources, which often leads to new habitat destruction.

Mass tourism and excessive development

The development of mass tourism is like a raging fire in the region. It seems there are no plans to slow down the scale of expansion in the future. It is indisputable that mass tourism drives economic development.

However, it also brings obvious damage such as abundant consumption of natural resources – often threatened and endangered species – serious pollution, destruction of wildlife habitat and degradation of indigenous cultures.

Transportation infrastructure
Infrastructure such as roads, railways and airports are reducing the isolation of western China. However, the destruction caused by the lack of conscientious design cannot be underestimated. Highway construction, for example, separates plants and animals on either side of the road from each other, causing habitat fragmentation. Additionally, on the steep and fragile mountainous landscape, building roads can increase the risk of landslides and cause serious soil erosion. Finally, roads provide poachers, illegal loggers and collectors of medicinal plants with access to natural areas they might not otherwise have been able to reach.

Poaching and excessive collection of wild plants
The abundant natural resources of the region were once fundamental elements for the survival of the local population. Unfortunately, today these natural resources are the target of poachers for huge profits. There is increasing demand from tourists and wealthy urbanites, which is stimulating these illegal activities.

The vicious cycle casts an even bigger shadow over the plummeting biodiversity of southwest China.

Some of the localised and primary threats to the biodiversity of the region that can be addressed through multi-level conservation education, sustainable community development projects and political will include:

- collection of firewood from nature reserves
- hunting of wildlife
- overgrazing by domestic livestock
- collection of medicinal plants
- collection of wild vegetables, mushrooms and bamboo shoots
- waste disposal
- use of pesticides and excessive chemical fertilisers
- unsustainable tourism
- human-wildlife conflict – especially with Asiatic black bears and wild boars
- wild-domestic animal interaction – diseases such as rabies and distemper can spread and harm wildlife too
- energy use
- water use and pollution
- intentional or inadvertent introduction of a new species that does not naturally reside in a given area.

Top left: Transpor infrastructure in panda habitat
Above: Dam construction disrupts river and adjoining forest ecosystems
Opposite page: Modern means of transport infrastructure mean easier acces into panda habito

Sarah's Soapbox

The final blow came to me during the summer of 2010 while visiting one of our partner nature reserves. Our team was held up by a market along the side of the road that had spontaneously appeared due to the large number of people making a crossing. While we waited, trucks started to rumble past. At first I didn't think much of this, I had seen many such large, blue shipping trucks during my time in China, but then truck after truck came barrelling by. Seeing so many was like a painful slap in the face.

Years ago it dawned on me that the depletion of nature reserves was from wealthy city folk the world over, wanting new furniture, clothing and even exotic wildlife and plants for the dinner table. Throughout my career I had worked with teams to devise several education programmes in a feeble attempt to try to help. But the issue has become too unwieldy and it is simply terrifying. These trucks were within the Liang Mountain region, one of the smaller of the last six giant panda strongholds, one that most conservationists consider the least disturbed, and as such, it retains much of its conservation appeal and hope. What I saw on that trip were resources leaving the areas under 'protection'. Also, more people appeared to be coming to help with the extraction of resources, thus contributing further to the devastation.

I could hardly point the finger at the local people

trying to feed their families; nor could I blame the rich people in Chengdu, Chongqing or Beijing; I couldn't even condemn rich countries that were raping China for its natural resources. I could only close my eyes and think of humanity's combined drain on this little planet. It caused me a moment of doubt. I realised just about my entire career thus far had been for naught and that we conservationists needed to up our game. We are a species gone astray, too full of ourselves to see what we have done: the pain, the suffering, the injustices.

Above: Local education programming is vital to conservation success
Above right: River valleys are common in panda habitat
Right: Downtown Chengdu

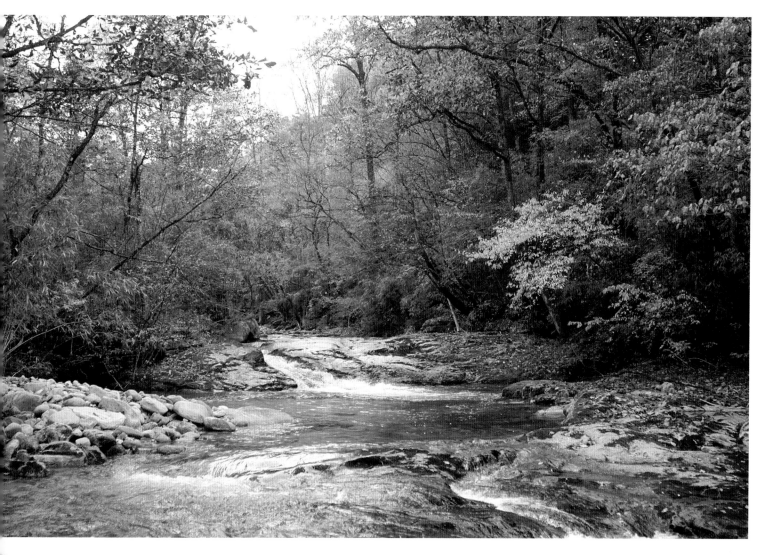

I will never forget that moment. We need your help. This is a global collective problem of which we are all a part regardless of citizenship, religion, political view, or gender. Nothing separates us or excludes us from this problem. The fact is, we are surpassing our carrying capacity, a law of ecology we accept for all species but our own.

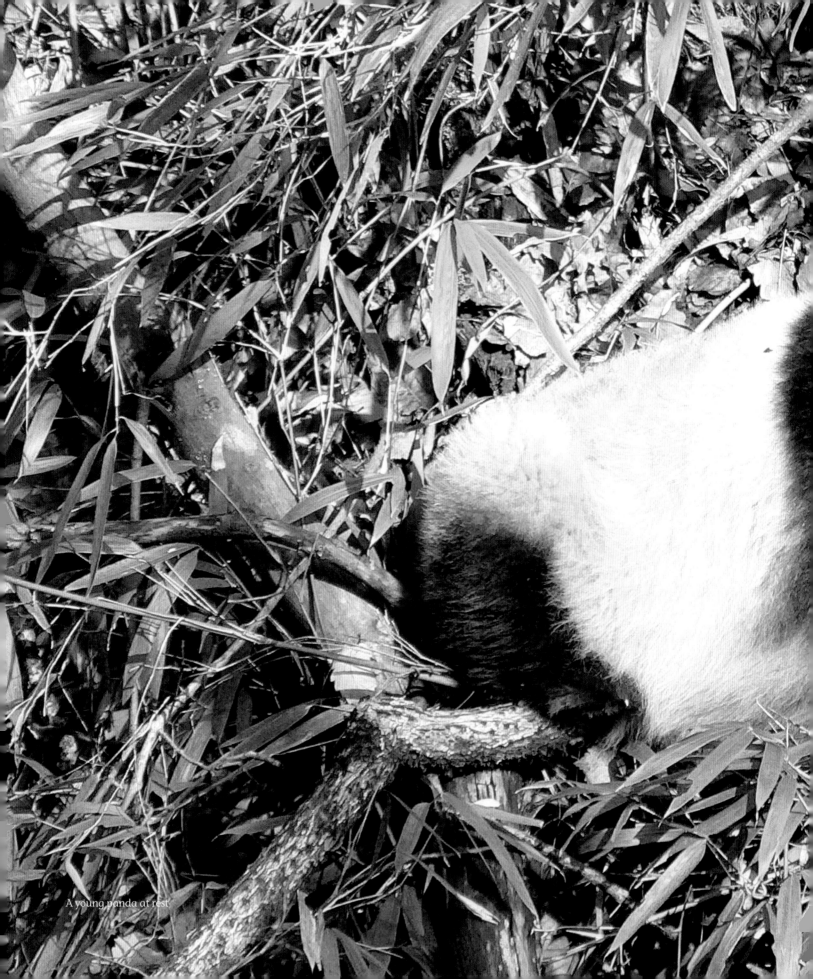

A young panda at rest

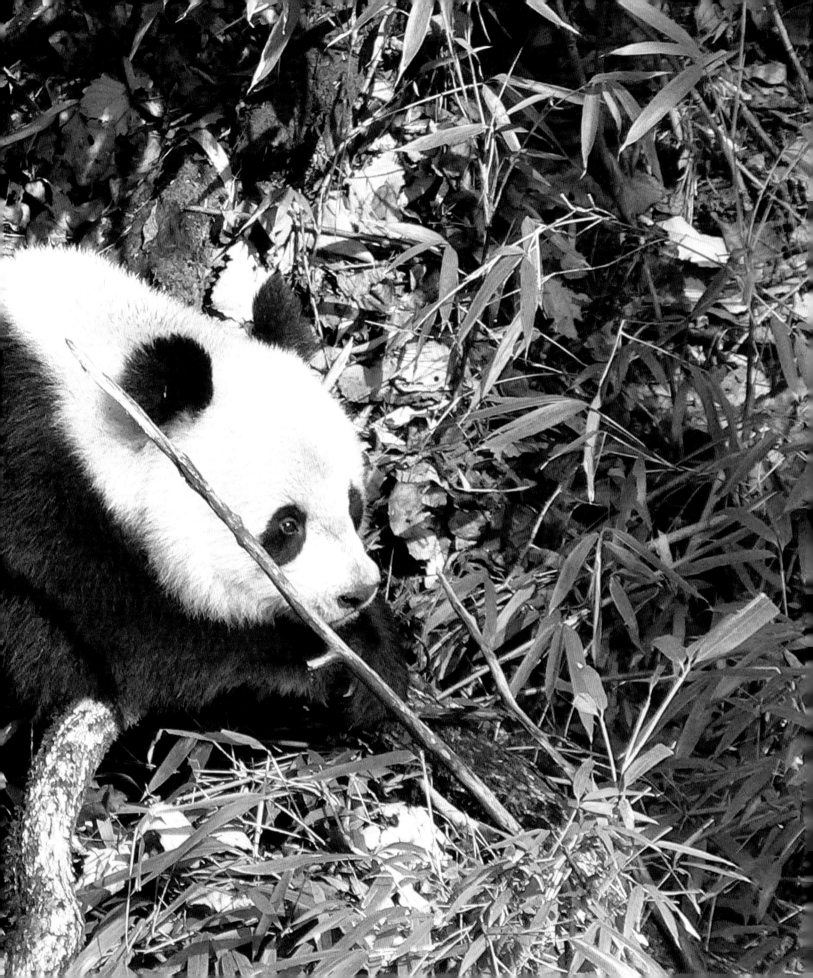

Preservation of the Giant Panda

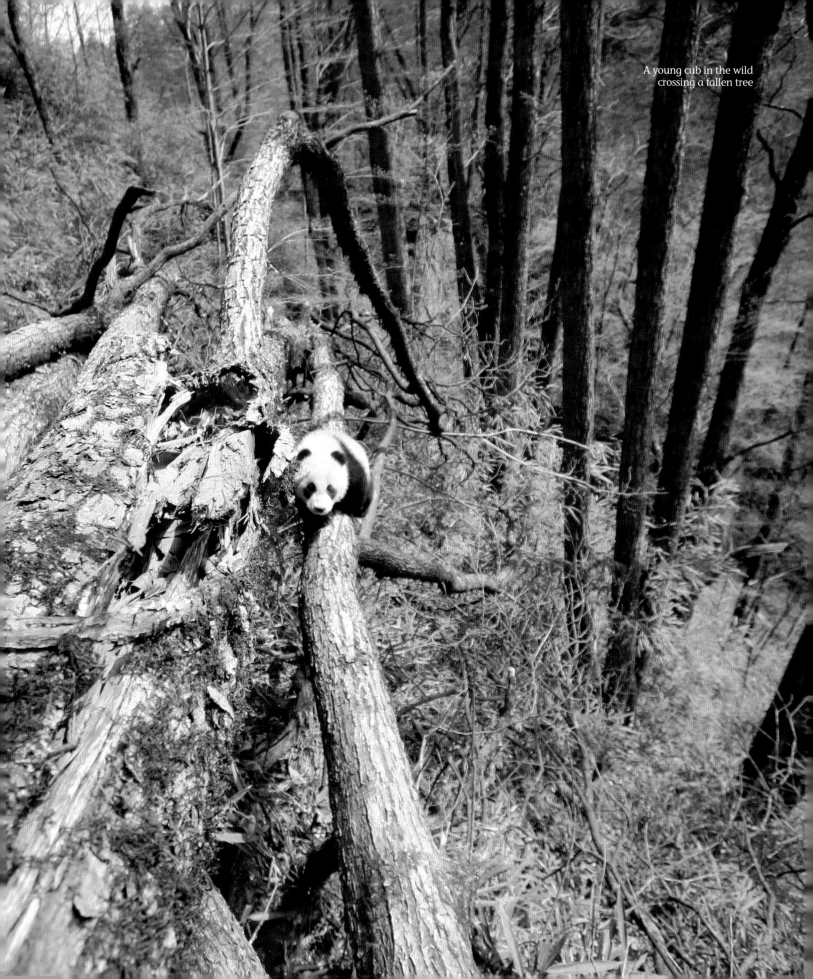
A young cub in the wild crossing a fallen tree

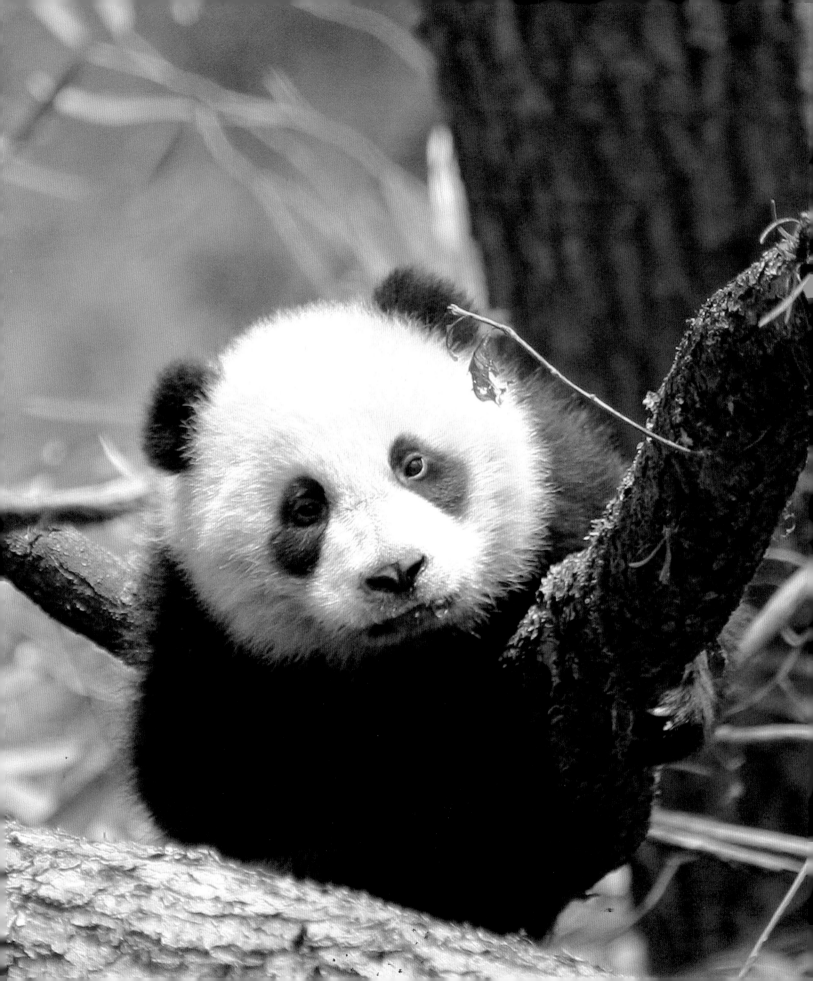

Road to Recovery

Decades of research and conservation efforts have gone into trying to save the giant panda from extinction. As discussed earlier, the first phase of conservation efforts to save the giant panda began with the establishment of nature reserves in 1963. Soon after, the first scientific studies in the wild began in 1968.[1]

After the flowering and subsequent die-off of many varieties of bamboo in the seventies and early eighties, the government decided to invest in two captive breeding sites as a hedge against extinction. The China Conservation and Research Centre for the Giant Panda at Wolong was established in 1980, and in 1987, the Chengdu Panda Base was established. George Schaller did a great job of describing the history of the China Conservation and Research Centre for the Giant Panda at Wolong in his book *The Last Panda*. Meanwhile, the Chengdu Panda Base was established with the foresight and dedication of Professor Zhang Anju. One of his most important legacies is his commitment to providing humane and naturalistic housing for giant pandas. Today, the Chengdu Panda Base has the largest, most sophisticated and naturalistic yards for giant pandas of all captive animal facilities in China. It began with six individual pandas that had been rescued from the wild. After many stressful years of mastering captive breeding techniques, we now have seventy-four individuals at the Chengdu Panda Base, sixteen of

Chengdu Panda Base

our pandas are living in other zoos across China and eighteen individuals are living abroad on research and educational loans.

Most importantly, while China was investing in captive breeding technology and the housing of giant pandas, the country was also investing in expanding the nature reserve system for giant pandas. Today, there are sixty-two nature reserves in China, covering about 85 per cent of the remaining suitable habitat and 57 per cent of the habitat of wild individuals, an unprecedented step forward in conservation.[2]

Reintroduction

As the world is watching the captive population of giant pandas grow and seemingly thrive, the next logical question is, when will they be reintroduced into the wild? This is a very valid question. Unfortunately, reintroduction and the perception of it is fraught with misconceptions and over-simplifications, primarily as a result of misleading or unbalanced media coverage, and a lack of education about this risky process. Reintroduction is neither an easy process nor a panacea for wildlife conservation. Of all such programmes that have been attempted over the past century, only 11 per cent are considered to have been even marginally successful.[3] Also, many of those programmes once thought to be successful no longer are, due to new threats to the population or dangers that were never removed in the first place.

Therein lies the issue for giant pandas, the hazards that have brought them to the brink of extinction not only still remain, but have grown significantly over the past forty years. Just think about it: human habitat expansion and population growth; the need for agricultural land, energy resources, trace minerals for new technology; the collection of firewood and medicinal plants – none of these has been reduced. Therefore, reintroduction is not yet a valid or ethical option. However, plans are in the pipeline to develop the science of reintroduction, a process that may take a

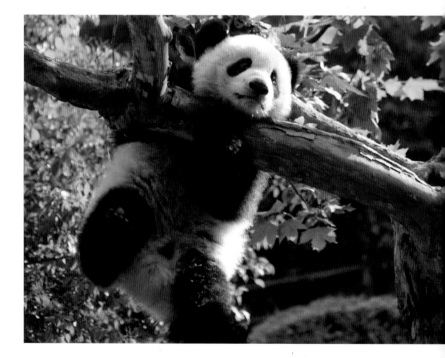

decade or more to develop.

Before we can figure out how best to protect habitat suitable for reintroduction, there are a number of other issues that need to be studied first, including disease transmission between captive and wild populations; behavioural preparation of the animals (captive animals lose many of their wild skills); the need for public education at the local and international levels regarding

Left: Panda cub, Jing Jing, climbing the trees of her enclosure
Opposite page: Bamboo forest in Tangjiahe Nature Reserve

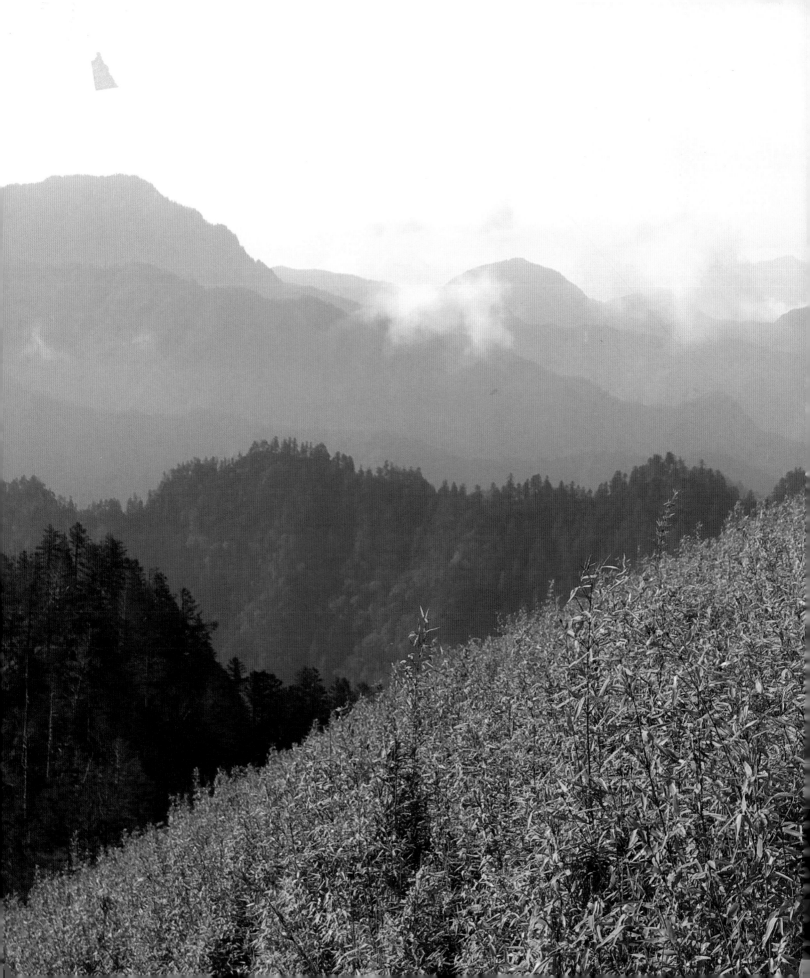

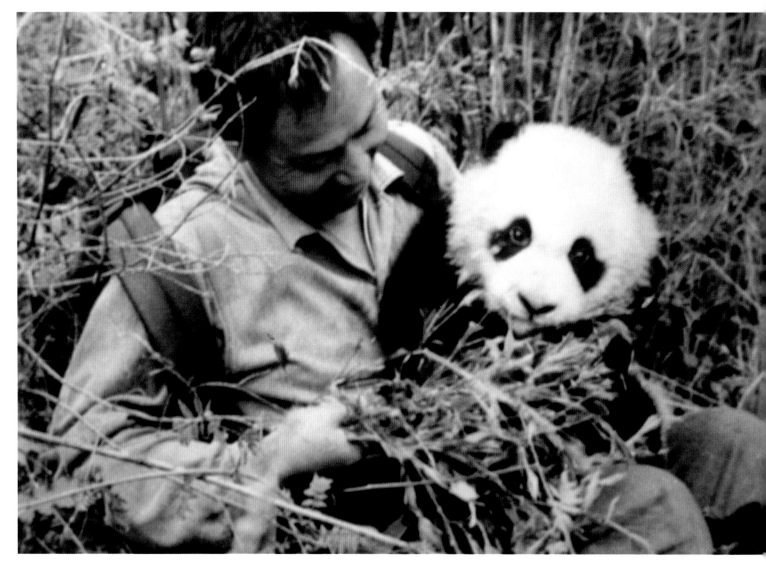

Left: A keeper caring for a cub in the early days of captive rearing
Right: The mayor of Chengdu, Hu Maozhou, breaking ground on the Chengdu Panda Base in 1987

reintroduction and the training of specialists for monitoring and genetic screening.

As pandas that have lost some of their natural behaviours can hamper the captive population – and because of possible implications of early socialisation on later competence – a better understanding of young panda development is critical prior to reintroducing individuals that have a chance of surviving and reproducing. Reintroducing animals that don't have the behavioural capacity to reproduce is of little value beyond the initial test to see if they can survive in the wild on their own. The key goal of putting animals back in their native habitat is to increase their population. If they do not know how to successfully reproduce, they use up limited habitat and resources without providing any stability for the growth of the wild population.

We have made tremendous strides to get to the point where we can even entertain the thought of reintroduction. We hope that you will watch our progress in developing the science of reintroduction for giant pandas and learn with us in this endeavour. Most of all, we hope you will want to adopt lifestyle choices that prevent the threat to giant pandas and the environment from worsening and happening to other species.

Above: Scientists braving the icy conditions to carry out research
Far left: The Chengdu Panda Base in the eighties
Left: Researcher tracking pandas in the wild
Opposite page: Giant pandas sent abroad in the early part of the twentieth century to France, Mexico, Germany and England

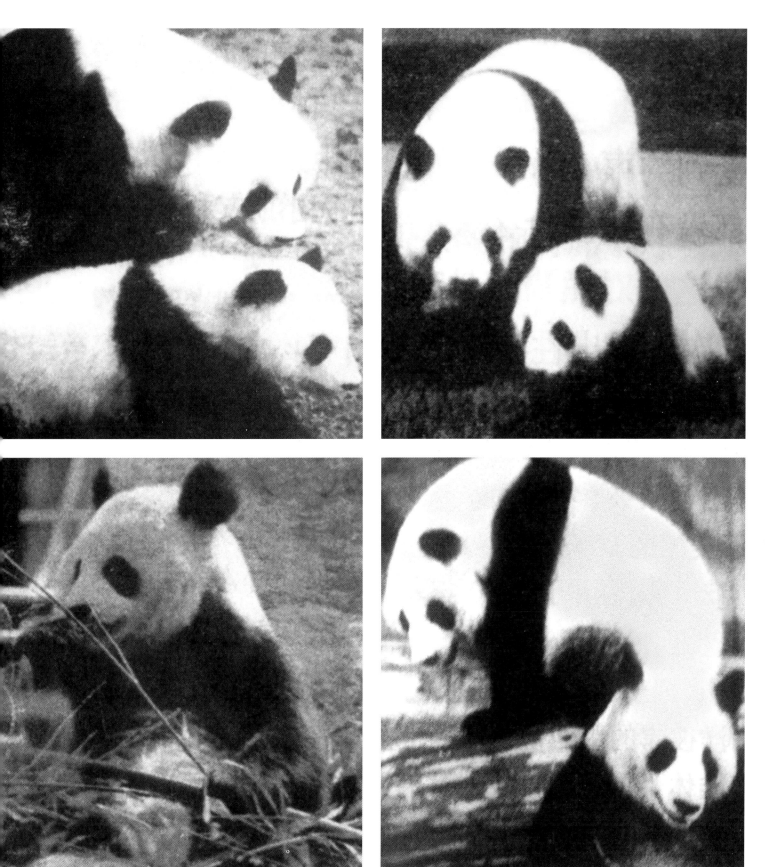

A captive
panda yawning

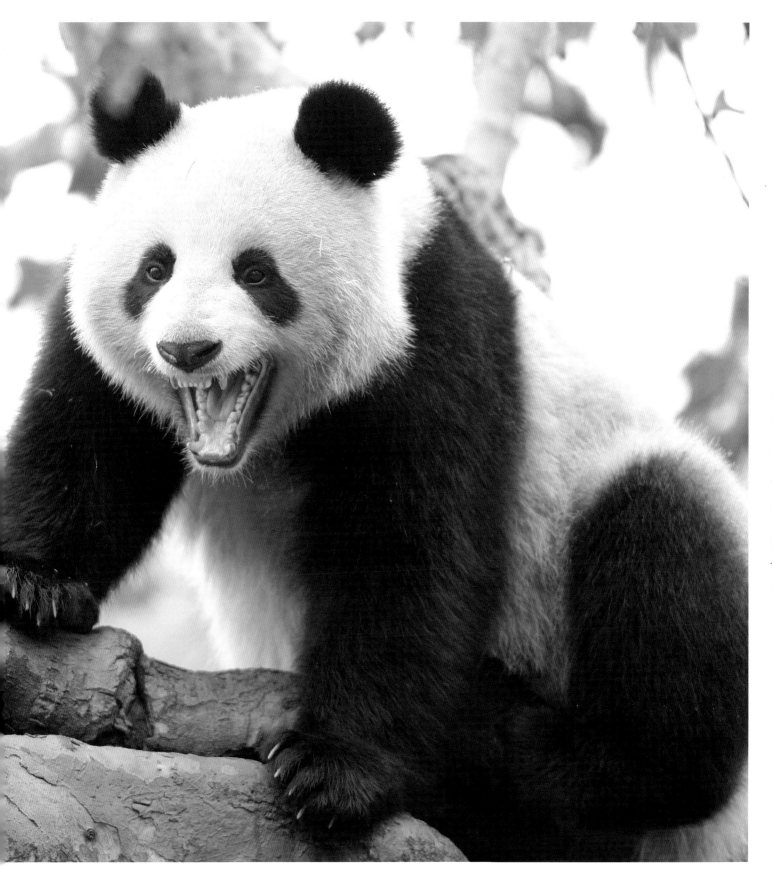

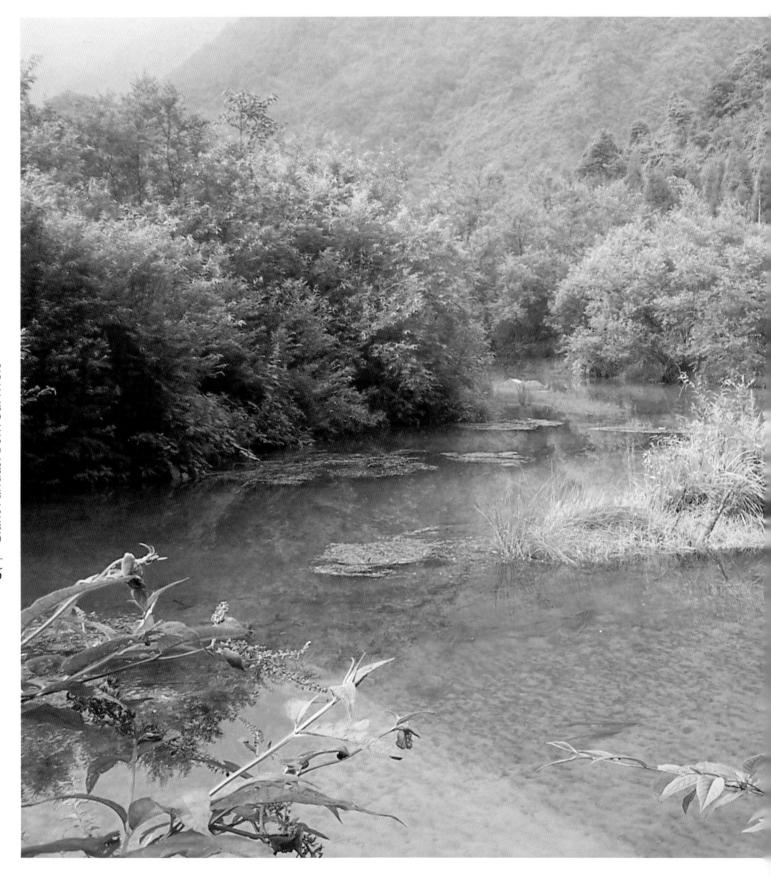

Giant Pandas: Born Survivors

Under the Panda Umbrella

There is a common mistaken belief that if we can protect giant pandas, then many other species will benefit as a result. Statements like this must be considered carefully. While this kind of all encompassing conservation sounds good in theory, the reality is that in our daily consumption habits, we place steep demands on Mother Nature that prevent this from happening.

In the case of giant panda habitat, many species may have already become regionally extinct, including clouded leopards and dholes. The population numbers of many other species are unclear, including golden snub-nosed monkeys, red pandas and Asiatic black bears (according to best estimates from global experts), but all are known to have populations that are in decline. However, the story is not entirely bleak. We still have a little time. With concerted effort we can bring a few species back from the brink of extinction, but we must do this while preventing others from getting to this point as well.

Left: Autumn in Changheba

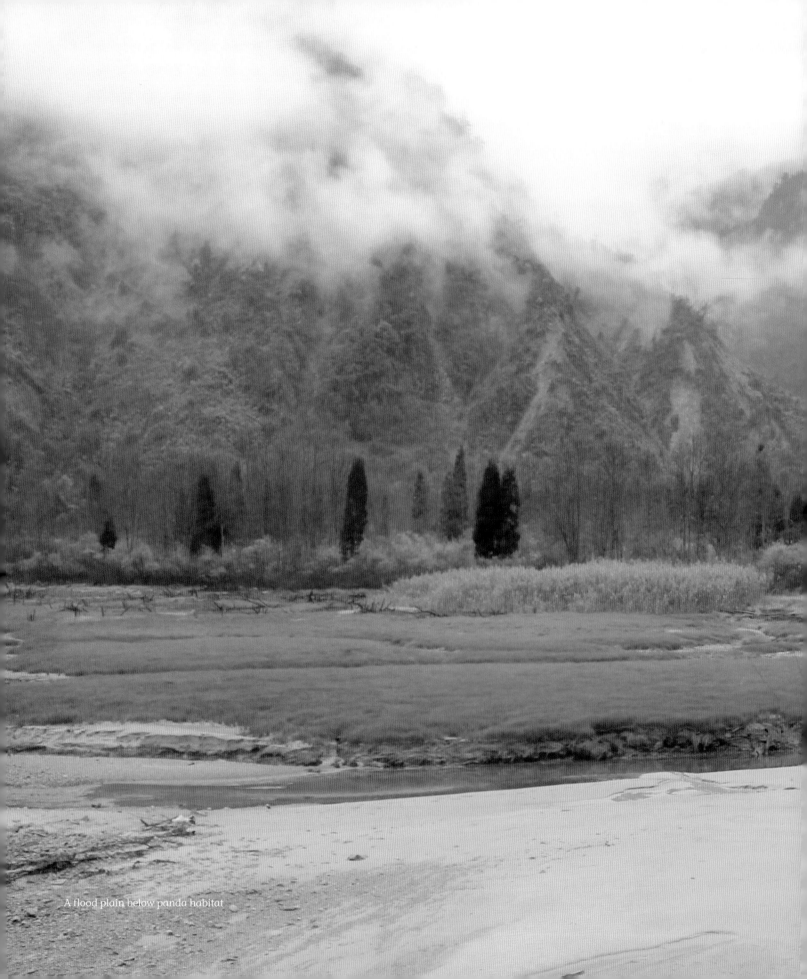

A flood plain below panda habitat

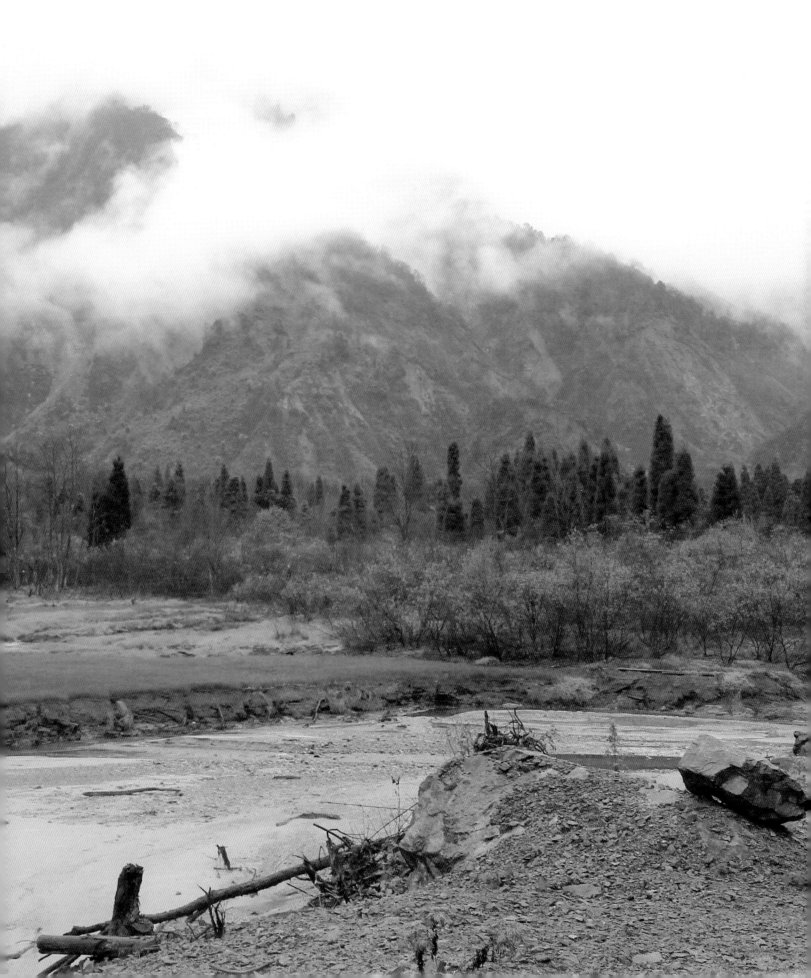

Survivors:
Viable
Species

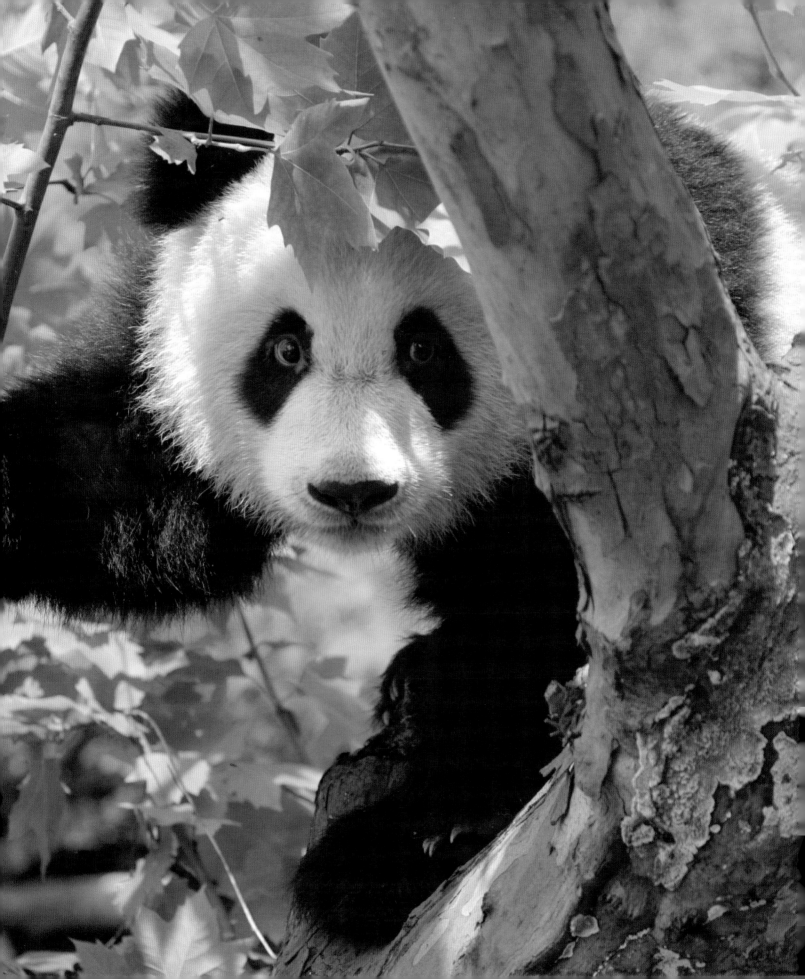

Their future is up to you

When we discuss our fellow animals, we often refer to them as an 'it'. Sadly, this inhibits our understanding, respect and admiration for other living creatures. From the cockroach, spider and poison ivy that scare us, to the elephant, whale and butterfly that charm and dazzle us, each plays an important role in the intricate web of life on Earth. Please don't fall into the dangerous trap of thinking that any of them are irrelevant. It is hard for us to accept, but we are most likely the only species on Earth that is completely disposable. In fact, Earth would once again thrive if we could let her and her inhabitants live in peace. In developed nations in particular, we take more than we need, not just at the expense of other species, but also to the detriment of the majority of other humans on Earth. Our actions hopefully give us cause for reflection and ample impetus to reform our behaviour as a species. Yet the message is not getting through. Once we see animals for who they are, it is nearly impossible to 'un-see' them. Once we see others, we care about them and do not wish them harm. We can make changes that do not only make our lives better and healthier, but also more enriched by giving us more time to focus on truly important things in life.

Above: An infant giant panda in an incubator at the Chengdu Panda Base
Opposite page: Two peer-reared pandas play in the snow

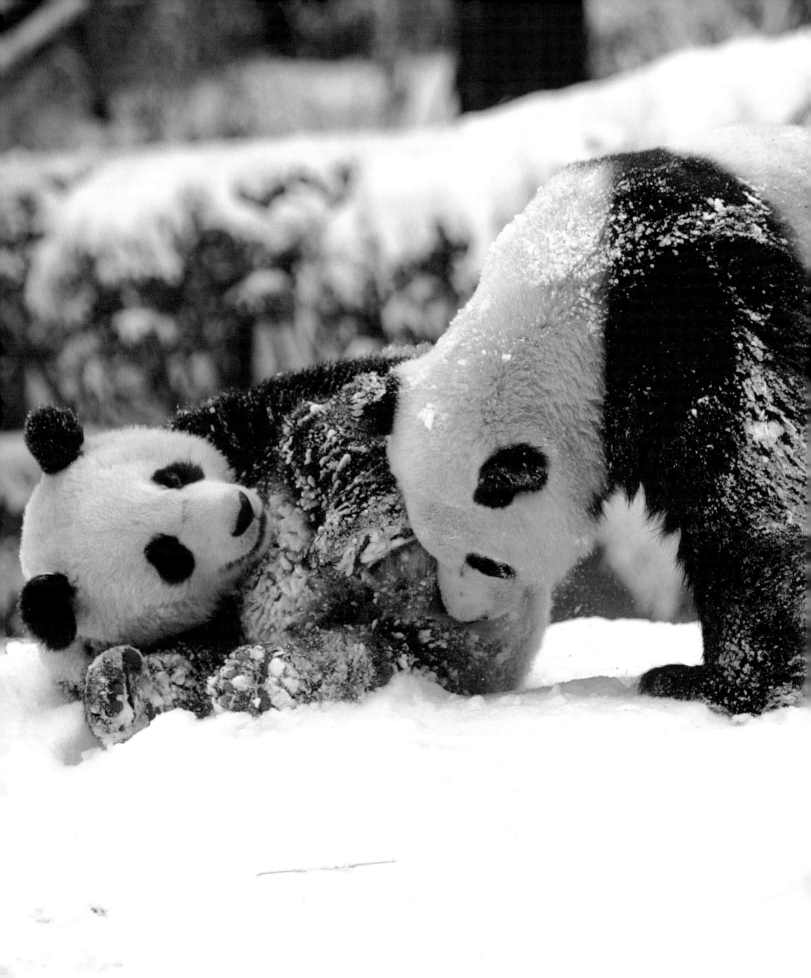

Improving Your Life, Not Compromising

Conservation of resources does not mean living an impoverished life because suddenly you have to feel guilty for eating meat, buying new clothes, going to the mall or spoiling your child. Giant pandas are easy to love and we are still able to save them, but we all have to do our part by acting with more prudence and benevolence. Somewhere down the line we went off course. We need a shift in humanity towards a global social movement in order to save the animals we love, including ourselves.

So, we desperately hope that you are now asking, 'What can I do?' For starters, learn about where each product you use comes from, and before buying something new, find out the damage it has caused in getting to stores near you. Again, it may be hard to comprehend, but everything we buy has an impact on the environment.

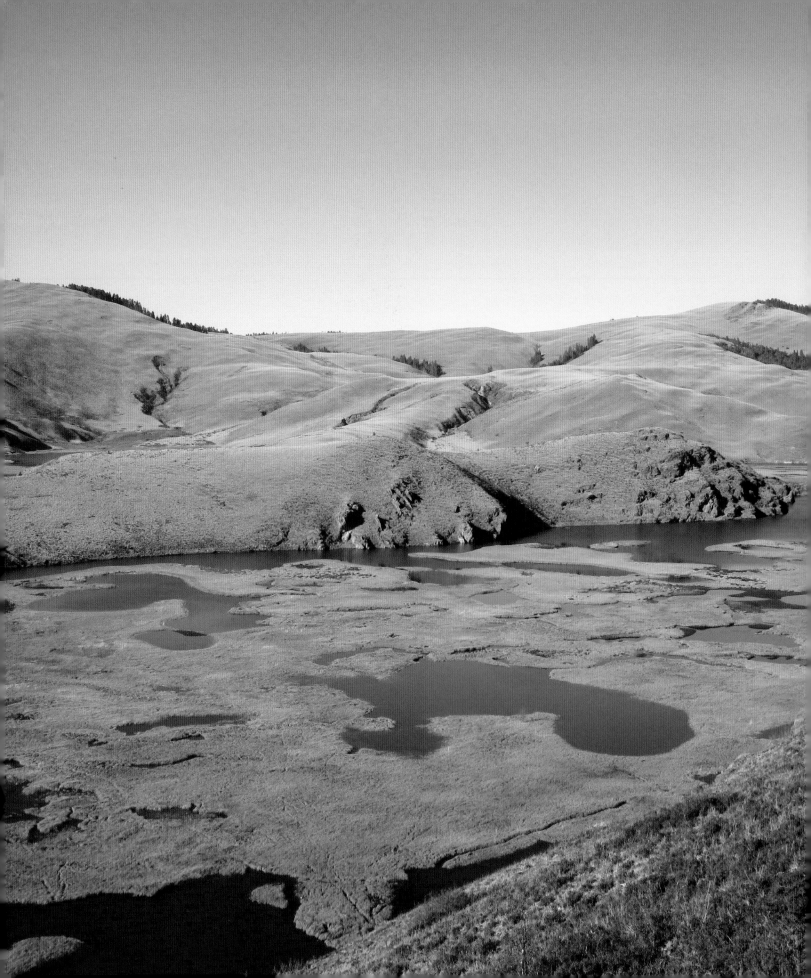

ight: The clear
ools of Jiuzhaigou
ature Reserve
pposite page:
aozuo Nature
eserve

Briefly, here are some easy things you can do to help:

- Buy locally-produced organic groceries and cut down on processed food.
- Support green policies and politics.
- Decrease your meat consumption. The rearing of animals is a major cause of global climate change.
- Refrain from unnecessary energy use, such as ironing or overcharging your mobile phone, and make sure you turn the lights off when not in use.
- Wash your clothes in cold water, use biodegradeable, non-toxic soap and hang your clothes to dry in appropriate seasons.
- Buy used goods whenever possible and share items when you no longer need them.
- Reduce your living space.
- Travel by bicycle, foot or public transport.
- Learn about transition towns at www. transitionnetwork.org/
- Support reform of current economic models: endless growth on a finite planet is impossible.

- Consider family planning and support initiatives to allow people access to reproductive healthcare and education.
- Support neuter programmes for pets in your community.
- If you own a cat, please do not let them go outside. They are highly skilled predators and decimate local wild life.
- Use less cosmetic, beauty and hair products.
- Drink more water to reduce your intake of juice, energy drinks or soda.
- Try and see crafty marketing and advertisements for what they are: ways to make you consume more than you need.
- Rather than visiting shopping malls and movie theatres, try taking part in more outdoor activities.

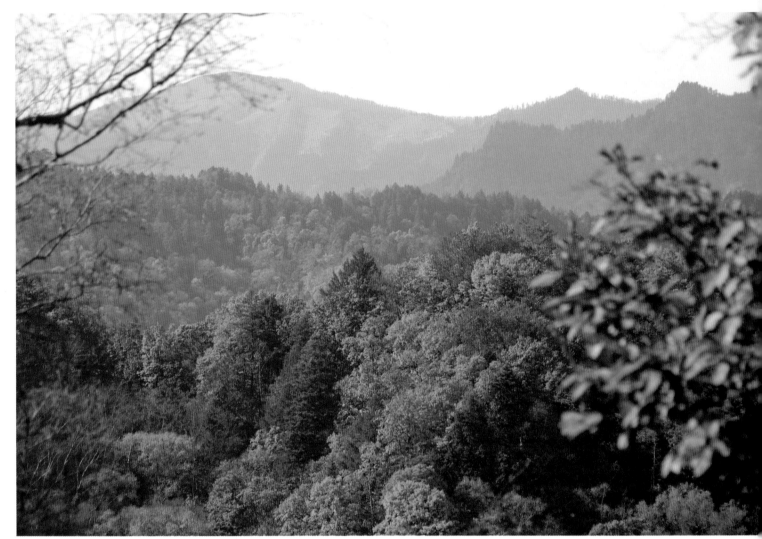

Above: The autumn forest in the Qinling Mountain range
Right: A cub take refuge in the cold winter

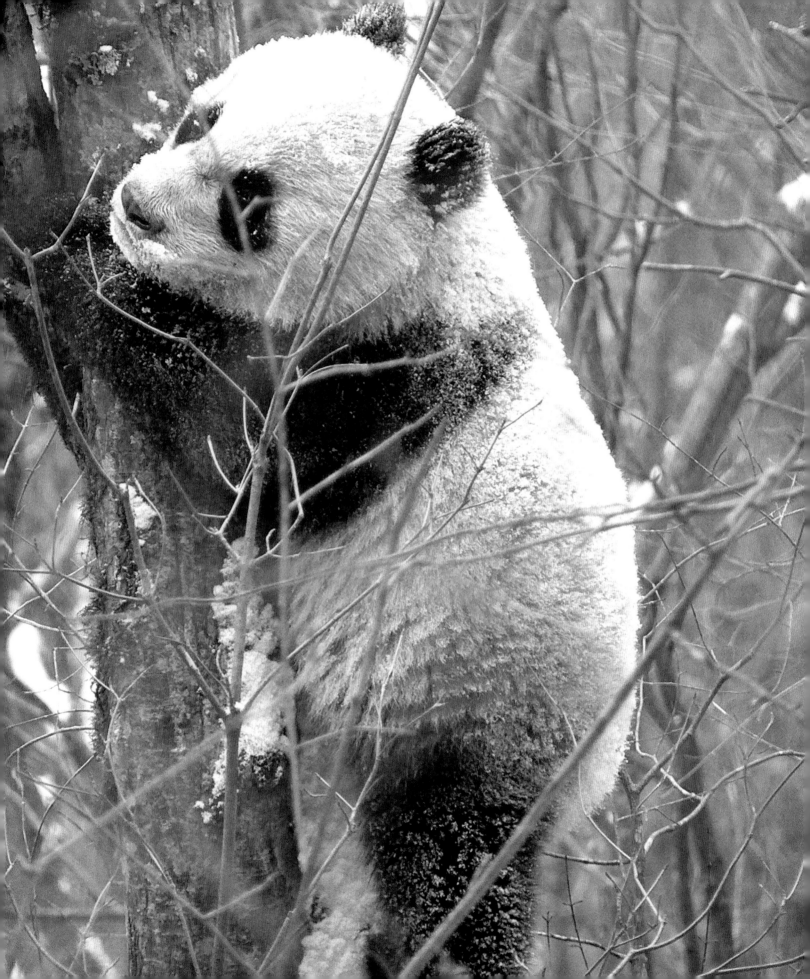

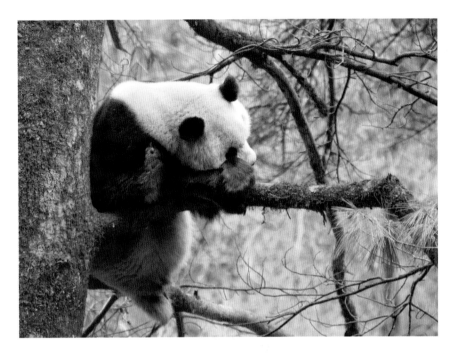

So, you can see that when people ask us, 'What can I do to protect giant pandas from extinction?' it is actually easier and thriftier than you think. We don't ask for donations. We merely and humbly ask you to live lightly so that others can live and thrive. There are up to 30 million other species on Earth and almost all were here before us. It is time that humans start being empathic and compassionate creatures. We ask people to get to know animals. Their minds and emotions are not hidden from us, we just have to pay attention. And if you are inclined to get to know one of our giant pandas, please pay us a visit. If China is too far away, step outside and spend time watching your non-human neighbours. They have lives as complex and intriguing as yours and they don't mind sharing provided you do not intrude.

Above: A wild panda rests in a tree
Right: Winter in Foping nature reserve

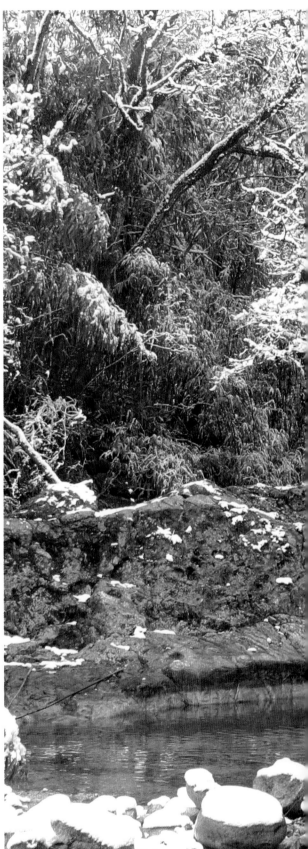

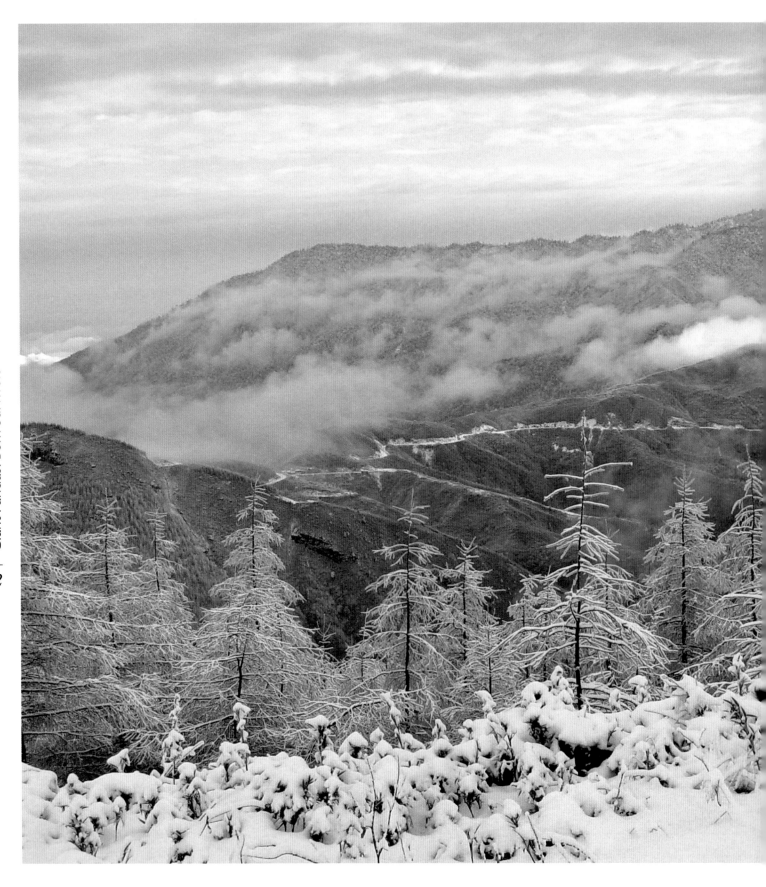

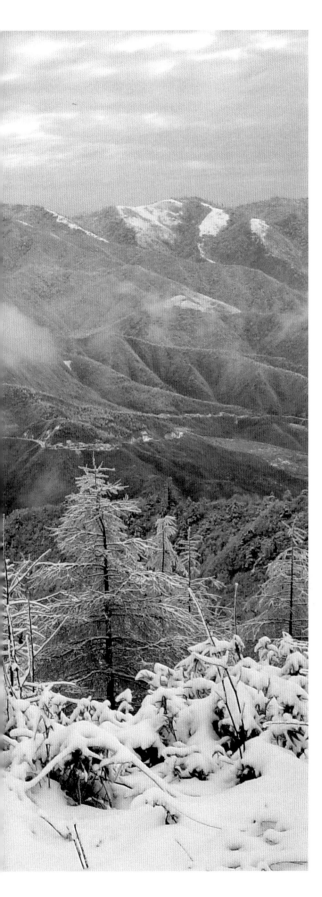

Snow is common
during winter in
the high mountains
of Sichuan Province

Tangjiahe Nature Reserve

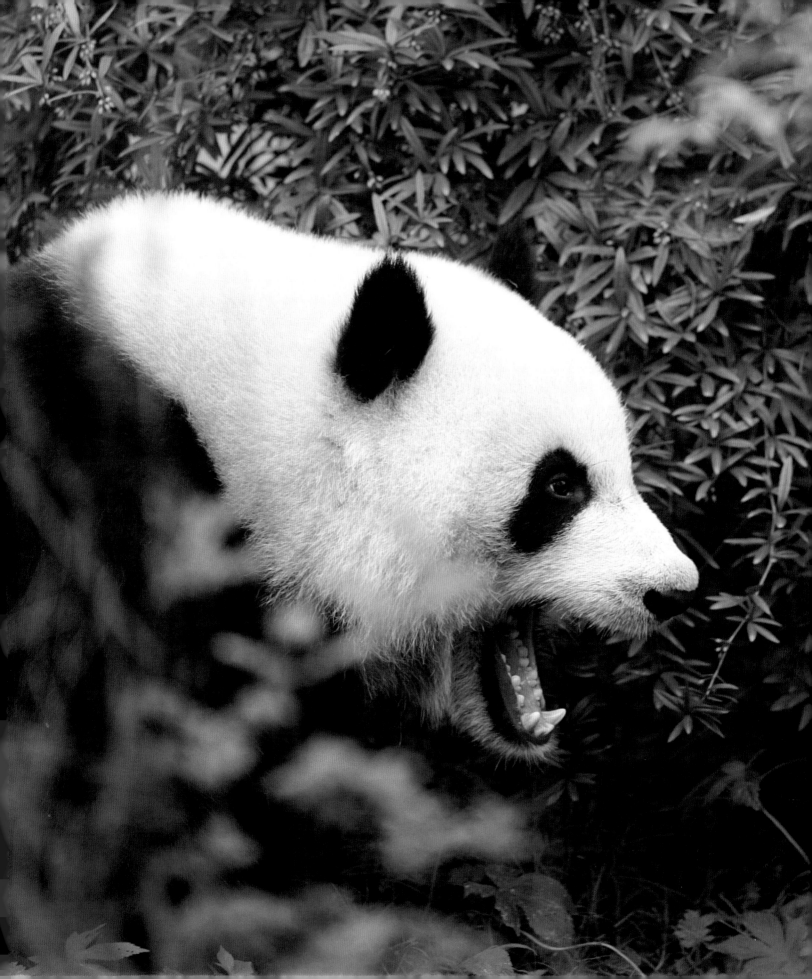

Further Resources

Global Economic Reform
Centre for the Advancement of a Steady State
Economy (CASSE)
www.steadystate.org/

Transition Towns
The concept of transition towns is growing and
includes creating truly sustainable urban areas
in which community sustainable agriculture,
economics and fresh water supplies play a central
role.
www.transitionnetwork.org/

Dietary Choices
Healthy diet for you and for Earth
www.earthsave.org/

Human Population Crisis
Global Population Speak Out
www.populationspeakout.org/

International Family Planning
www.pathfind.org/

Fair Trade
www.greenamerica.org/programs/fairtrade/index.
cfm

Media
Protect your children!
www.consumingkids.com/

Nature Appreciation
For child and global health, read *Last Child in the
Woods* by Richard Louv
richardlouv.com/

Healthy Planet
www.worldwatch.org

References

Exploding Myths

1 Schaller, G. B., Hu, J., Pan, W., & Zhu, J. (1985). *The Giant Pandas of Wolong*. Chicago: University of Chicago Press, p. 130.

2 Gittleman, J. L., & Webster, A. J. (2004). The legacy of extinction risk: lessons from giant pandas and other threatened carnivores. In D. Lindburg & K. Baragona. (Eds). pp. 236–245. *Giant Pandas Biology and Conservation*. Berkeley: University of California Press. p.243.

3 O'Brien, S. J., Nash, W. G., Wildt, D. E., Bush, M. E., & Benveniste, R. E. (1985). A molecular solution to the riddle of the giant panda's phylogeny. *Nature 317*, 140–144. P. 143.

Natural History of the Giant Panda

1 Morris, R. & Morris, D. (1966). *The Giant Panda*. London: Penguin. p. 18.

2 State Forestry Bureau. (2006). *The third survey report on giant pandas in China*. Beijing: Science Press. p. 4.

3 Schaller, et al. p. 11.

4 State Forestry Bureau. p. 18.

5 Schaller, et al. p. 13.

6 Ibid.

7 State Forestry Bureau. p. 256.

8 Ibid., p. 24.

9 O'Brien, et al., p. 143.

The Life of a Giant Panda

1 Swaisgood, R. R., Wei, F. W., McShea, W. J., Wildt, D. E., Kouba, A. J., & Zhang, Z. J. (2011). Can science save the giant panda (Ailuropoda melanoleuca)? Unifying science and policy in an adaptive management paradigm. *Integrative Zoology 6* (3), pp 290-296. p. 291.

2 Schaller, et al. p. 187.

3 Snyder, R. J., Zhang, A. J. Zhang, Z. H. Li, G. H., Tian, Y. Z., Huang, X. M., Luo, L., Bloomsmith, M. A. Forthman, D. L., & Maple, T. L. (2003). Behavioral and developmental consequences of early rearing experience for captive giant pandas (*Ailuropoda melanoleuca*). *Journal of Comparative Psychology 117* (3), 235–245. p. 236.

4 Schaller, et al. p. 235.

5 Ibid. p. 191.

6 Snyder, et al. p. 235.

7 Ibid., p. 240.

8 Zhang, Z. H. & Wei, F. W. (2006). *Giant panda ex-situ conservation theory and practice*. Beijing: Science Press. p. 143.

9 Snyder, et al., p. 240.

10 Ibid., p. 241

11 Ibid.

Habitat

1 Yongcheng, L. & Richardson, M. 2008. *Rhinopithecus roxellana*. In: IUCN 2010. IUCN Red List of Threatened Species. Version 2010.1. www.iucnredlist.org. Downloaded on 16 June 2010.

2 Wang, X., Choudhry, A., Yonzon, P., Wozencraft, C. & Than Zaw 2008. Ailurus fulgens. In: IUCN 2010. IUCN Red List of Threatened Species. Version 2010.1. www.iucnredlist.org. Downloaded on 16 June 2010.

3 BirdLife International 2009. *Chrysolophus pictus*. In: IUCN 2011. IUCN Red List of Threatened Species. Version 2011.1. <www.iucnredlist.org>. Downloaded on 20 June 2011.

4 BirdLife International 2008. *Nipponia nippon*. In: IUCN 2010. IUCN Red List of Threatened Species. Version 2010.1. www.iucnredlist.org. Downloaded on 16 June 2010.

5 Duckworth, J.W., Steinmetz, R. & Pattanavibool, A. 2008. *Capricornis milneedwardsii*. In: IUCN 2011. IUCN Red List of Threatened Species. Version 2011.1. <www.iucnredlist.org>. Downloaded on 20 June 2011.

6 Song, Y.-L., Smith, A.T. & MacKinnon, J. (2008). *Budorcas taxicolor*. In: IUCN 2010. IUCN Red List of Threatened Species Version 2010.1. www.iucnredlist.org. Downloaded on 16 June 2010.

BirdLife International (2011) Species factsheet: *Arborophila rufipectus*. Downloaded from http://www.birdlife.org on 06 June 2011.

Garshelis, D.L., & Steinmetz, R. (2008). *Ursus thibetanus*. In: IUCN 2010. IUCN Red List of Threatened Species. Version 2010.1. www.iucnredlist.org. Downloaded on 16 June 2010.

Abramov, A., Timmins, R.J., Roberton, S., Long, B., Than Zaw & Duckworth, J.W. 2008. *Martes flavigula*. In: IUCN 2011. IUCN Red List of Threatened Species. Version 2011.1. <www.iucnredlist.org>. Downloaded on 20 June 2011.

0 Schaller, Hu, Pan & Zhu, p. 101.

1 Oliver, W. & Leus, K. 2008. *Sus scrofa*. In: IUCN 2011. IUCN Red List of Threatened Species. Version 2011.1. <www.iucnredlist.org>. Downloaded on 22 June 2011.

Matter of Life and Death

Leakey, R., & Lewin, R. (1995). *The Sixth Extinction: Patterns of Life and the Future of Humankind*. New York: Doubleday.

Jablonski, D. (2004). Extinction: past and present. *Nature 427*, p. 589.

Leakey, R., & Lewin, R. (1995). *The Sixth Extinction: Patterns of Life and the Future of Humankind*. New York: Doubleday & Wilson, E. O. (2002). The Future of Life. New York: Knopf Publishers.

Schaller, et al., p. 8.

Brown, L. R. (2006). *Plan B 2.0: Rescuing a planet under stress and a civilization in trouble*. New York: W. W. Norton & Company.

Dirzo, R., & Raven, P. H. (2003). Global state of biodiversity and loss. *Annual Review of Environmental Resources, 28*, pp. 137–67.

Ibid.

reservation of the Giant Panda

Schaller, et al., p. 17.

Swaisgood, et al., p. 291.

Beck, et al., p. 278.

Index